What
lesson.

e's
sso

THE ANXIOUS OBJECT

HAROLD ROSENBERG

The University of Chicago Press
Chicago and London

ACKNOWLEDGMENTS

My thanks to the following magazines in which the chapters of this book appeared as articles and essays: *Art in America, Art News, Book Find News, Encounter, The Oberlin Quarterly, Partisan Review, Portfolio-Art News Annual, Vogue*—and especially to *The New Yorker* in which thirteen of the chapters were published.

The University of Chicago Press, Chicago 60637
The University of Chicago Press, Ltd., London

© 1964, 1966 by Harold Rosenberg
All rights reserved. Published 1966
Phoenix edition 1982
Printed in the United States of America

89 88 87 86 85 84 83 82 1 2 3 4 5

Library of Congress Cataloging in Publication Data

Rosenberg, Harold.
 The anxious object.

 1. Art, Modern—20th century. I. Title.
N6490.R59 1982 709'.04 82-13365
ISBN 0-226-72682-7 (pbk.)

This book originally appeared under the title *The Anxious Object: Art Today and Its Audience.*

FOR HANS HOFMANN

to whom art was never in question

CONTENTS

7

ILLUSTRATIONS

FOREWORD

TOWARD AN UNANXIOUS PROFESSION

Changes in art have been taking place at such lightning speed that compared with even three years ago the current scene is virtually unrecognizable. Then, neo-dadaist and Pop art were crowding Abstract Expressionism and it seemed pertinent to discuss which was really newer and might have greater staying power. Today, both Pop and Action Painting, as well as two or three subsequent "vanguards," have passed into the swelling reservoir of modernist modes and *no* discussion seems pertinent. Works intended to shock or startle scarcely stir up a query at a provincial panel discussion. Attitudes, styles, moods, casts of character replace one another without a struggle. All the art movements of this century, and some earlier ones, have become equally up to date. It is as if art history had decided to turn over on its side and go to sleep. One is reminded of the situation in American writing fifteen years ago when the leading issue was, "Where are the issues?"

Is it, then, permissible still to speak of the work of art as an "anxious object?" Has not the ghost that haunted painting and sculpture in the forties and fifties been laid—perhaps forever? A lonely and doubting spirit can hardly be said to personify the crackling art world of the second half of the sixties. Indisputably, Josef Albers, the master of painting conceived as calculated sheets of color, had the facts on his side when he sent me the message last year that "*Angst* is dead."

The entire social basis of art is being transformed—to all appearances for the better. Instead of being, as it used to be, an activity of rebellion, despair or self-indulgence on the fringe of society, art is being normalized as a professional activity within society. For the first time, the art formerly called vanguard has been accepted *en masse* and its ideals of innovation, experiment, dissent have been institutionalized and made official. Its functions are being clarified in relation to accepted practice in decoration, entertainment and education, and the rewards to be won in art by talent and diligence are becoming increasingly predictable.

Along with changes in the social situation of art has come a metamorphosis in the temperament of the artist and in what he

13

seeks to achieve through his work: in a word, a change in actual values, though often under cover of the old slogans. No longer does the American artist tend to be a first- or second-generation outsider lost in a metropolis or suburb and accumulating his art experience through random insights and chance meetings. Today, he is an all-American youth from farm, village or town who has been through a university art department and surveyed the treasures of art through the ages and its majestic status as the darling of power and wealth. Instead of resigning himself to a life of bohemian disorder and frustration, he may now look forward to a career in which possibilities are unlimited. In short, painting is no longer a haven for self-defeating contemplatives but a glamorous arena in which performers of talent may rival the celebrity of senators or TV stars.

Given these transformations, inner and outer, anxiety as a psychological state is today no more typical of artists than of doctors, truck drivers or physicists (though it is typical of all of them). Noting the comfortable prospects for painters and sculptors, some critics have concluded that the disturbance of art is a phenomenon of the past; it is a mood, they tell us, that belongs to the decade following the war. Anxious painting in this view is the kin of Existentialism and the Theatre of the Absurd. It is an aspect of the life style of dusty lofts, blue jeans, the Cedar Tavern (at its old address), no sales, tumescent paint letting go in drips. Today, this stereotype continues, anxiety is no longer a reality in art, which is at last properly concerned with its own development. To mention anxiety is to arouse suspicion of nostalgia or of a vested interest in the past, if not of a reactionary reversion to the middle-class notion of genius suffering in a garret.

In this capsule wisdom the problem of contemporary civilization is mistaken for an episode in the history of fashion. Only the grossest materialism, such as pervades American cultural journalism, could equate poverty with anxiety, high income with serenity. Psychologically, Action painters twenty years ago were no more anxious than Pop artists or kinetic geometers are today. All indications are that they were probably much *less* anxious. They were resigned to being who they were and where they

were. Spending most of their time with other artists, they led a far more relaxed and vivacious social life than the lions rampant of today's art world. Most important, in Action Painting the act of painting is a catharsis—theoretically at least, it is able to reach the deepest knots of the artist's personality and to loosen them. By contrast, in the recent cool modes of painting and constructing, process prevails, and the unexcited artist performs the necessary steps without upsetting his normal condition of uneasiness.

The story that there was a period in American art—say, between 1942 and 1952—when anxious painters painted anxious pictures is a fable, useful mainly for the education of instant art historians. *Angst* may be dead in the minds of the majority of artists today, but the anxiety of art has nothing to do with prevailing quantities of worry about careers, rent bills, publicity or girl (boy) friends.

In connection with the pioneers of post-war New York art, I found it appropriate some fifteen years ago to denote the new spirit by quoting from one of Apollinaire's poems a line about making "empty gestures in the solitudes." In the lofts of downtown Manhattan the pathos consisted not only of the social isolation of art but of the painful awareness of the artist that art could not reach beyond the gesture of the canvas without entering into a complex of relationships alien to his deepest feelings. The artist of the 1930's had dedicated his work to movements designed to change those relationships; he had ended by finding that the ideologies of both revolution and reform led to consequences that were humanly questionable, emotionally frustrating and a drag upon creation.

Must one remind budding art historians that the uneasiness of art in the face of its own situation was not adopted by artists as a manner, in the way that one adopts a leather jacket or a hair-do that covers the eyes? Anxiety was forced upon art as the experience that accompanies the rejection of shallow or fraudulent solutions.

I have spoken, as is common, of "the artist." I mean, of course, "some artists." Already at the opening of the 1950's it seemed necessary to append underneath the verse of Apolli-

naire on solitude the cool verdict of Wallace Stevens: "The American will is easily satisfied in its efforts to realize itself in knowing itself." Already all but a handful of the leaders of the new art had entered into the pantheon of the "easily satisfied" and were proclaiming a revived faith in the sufficiency of art. Already the new vanguard audience, though still in the process of formation, had begun to give birth to its own species of artist happy to be the clown of its dictionary of repeated ideas.

No sector of a culture can avoid taking on to some degree the features of the culture as a whole. In the United States professions attain stability when their practices are accepted as rituals beyond the need of justification. Having reached this stage, art today resists discussion as to its content and function, as the police resist civilian review.

The anxiety of art is a peculiar kind of insight. It arises, not as a reflex to the condition of artists, but from their reflection upon the role of art among other human activities. Where this anxiety is absent, nothing that befalls the artist as a person, not even the threat of physical extinction, will bring it into being. There is a craftsman's pleasure in doing, and delight in the work of one's hands, that some people find entirely adequate to satisfy their minds. The world may fall apart, it will interest them less than the discovery of a new brand of crayon.

Albers himself excellently illustrates the type of faith in the self-sufficiency of art that excludes from painting everything but the statement and solution of its own technical problems. For him anxiety has not just now ceased to be a factor in painting; properly speaking, it never was one, however much artists might have been misled by so irrelevant a sentiment. In a recent interview in *Art News* Albers was asked about his frame of mind during the rise of the Nazis—did he, for example, feel impelled to join in the demonstrations of his fellow artists in Germany? "*Nein*," exclaimed Albers. "I was determined not to follow anything. For me it was glass [the material he was then working with]. I was completely one-sided. I never went when the Constructivists and Surrealists assembled. It was for me just glass." For artists like Albers the "realm of art" is permanently insulated against the unrest of this century of crises.

The anxiety of art is a philosophical quality perceived by artists to be inherent in acts of creation in our time. It manifests itself, first of all, in the questioning of art itself. It places in issue the greatness of the art of the past (How really great was it? How great is it for us?) and the capacity of the contemporary spirit to match that greatness. Anxiety is thus the form in which modern art raises itself to the level of human history. It is an objective reflection of the indefiniteness of the function of art in present-day society and the possibility of the displacement of art by newer forms of expression, emotional stimulation and communication. It relates to the awareness that art today survives in the intersections between the popular media, handicraft and the applied sciences; and that the term "art" has become useless as a means for setting apart a certain category of fabrications. Given the speed and sophistication with which the formal characteristics of new art modes are appropriated by the artisans of the commercial media and semi-media (architecture, highway design, etc.), the art object, including masterpieces of the past, exists under constant threat of deformation and loss of identity. Today, there is no agreed-upon way of identifying works as art except by including them in art history. But art history is constantly being expanded to comprise such new species as photography, TV, cinema, comic books. Moreover, the historical qualification of works as art is today threatened by the transformation of the museum and the art book into media of mass communication.

Confronting this situation, the anxiety of art embodies the freedom of art to remake itself at will. It is present in the recurrent resolve of artists of this century, and especially of the post-World War I vanguard movements—dada, Surrealism, Action Painting—to liquidate art as a classification of objects and to re-define it in terms of the intellectual acts of artists. Thus "art" has been opened up to include "ready-mades" produced by industry, snapshots of dreams, events on and off the canvas, demonstrations of color relations and tricks of the optical nerve. What is decisive is who does what for what reason.

This can only mean that the art object persists without a secure identity, as what I have called an "anxious object." ("Am I a masterpiece," it must ask itself, "or an assemblage of junk?")

Its nature is contingent upon recognition by the current communion of the knowing. Art does not exist. It *declares itself*.

The anxiety of art represents the will that art *shall* exist, despite conditions that might make its existence impossible. Through constant revision of its aims, its techniques, its scope, modern art has made itself into a discipline rooted in the free development of individuals. All the traditional elements of painting have been reconceived in such ways as to make them completely subject to the will of the artist.

In a speech delivered thirty years ago, Fernand Léger summarized the evolution of modernist aesthetics as follows:

"The entire effort of artists during the past fifty years has consisted of the struggle to liberate themselves from certain old restraints. . . .

"The effort toward freedom began with the Impressionists and has been continually emphasized to this day.

"The Impressionists freed color—we have carried their work forward and have freed form and drawing."

By its conquest of the privilege of freedom within art itself avant-garde art has for the past one hundred years differentiated its activity from other forms of social production, including the craft of the academies. Art alone has been the realm of the free act. It is by this history that the vanguard has reconstituted the concept of art.

With regard to the destiny of the artist's freedom, the current integration of the arts into our society of specialized functions is far from reassuring. The closing of the gap between artist and public has not come about through an expansion of freedom in American occupations generally. On the contrary, it is occurring under conditions in which work and the practice of the intellectual professions are being constantly narrowed and more strictly disciplined. In this environment the present emphasis in art criticism on the end product, rather than on the problematical nature of the art undertaking, opens the way to art produced under direction, as in related professions. Today's socially accepted vanguard already responds to paintings and sculptures executed according to formulas suggested by critics, dealers or collectors without any more surprise or revulsion than

is aroused by a TV drama composed to fit the story line of a program producer. Indeed, efforts are continually under way, both here and abroad, to establish "project" art as the ruling principle for the art of tomorrow.

Given what David Jones has called "the actual civilizational situation," the quieting of art's anxiety is bound to suggest the cheerfulness of a sick room. It is a renunciation of that intellectual and emotional ingredient in twentieth-century art that arises from facing the reality of its situation. The anxiety of modern art is the measure of its historical consciousness and of its appreciation of the stature of the past. It is the condition in which art in our time identifies itself with the destiny of man. No wonder Picasso saw it as central in Cézanne.

The essays that follow present contemporary painting and sculpture as a web of problems, and contemporary artists as engaged in a dramatic struggle with those problems. No substantial problem of art is soluble by art alone (technical problems are soluble). For example, Arshile Gorky could not solve the problem of identity, nor can Barnett Newman solve the problem of the absolute.

Instead of solving his problem—"his" because he has chosen it—the artist lives it through the instrumentality of his materials. By fixing his idea in matter he exposes either the crudeness of his thought or the clumsiness of his art; thus he is led to experiment and refinement. In time, he becomes so adept in materializing his hypotheses, and in manipulating his materials as if they were meanings, that the problem itself is transformed. He has translated it into a unique set of terms; besides, he, the investigator, has through his efforts remade himself into a different man.

The adeptness of the artist's mind, achieved through devouring problems of art, is the ultimate art product—its evidences are what confer value on particular paintings and sculptures. This is one reason why I find it appropriate here to devote more reflection to veteran artists than to newcomers whose ideas, whatever they be, are at the beginning of their enactment. The choice is not based on aesthetic preference for an earlier style over later

ones but on the relative intellectual gravity of the works available for consideration in our period. It matters not in what mode an artist begins, whether with colored squares, a streak of black, the letter "D" or the drawing of a nude. All beginnings are clichés and the formal repertory of modern art was fairly complete by 1914. It is finding the obstacle to going ahead that counts—*that* is the discovery and the starting point of metamorphosis. Uniqueness is an effect of duration in action, of prolonged hacking and gnawing. In the course of engagement a mind is created. Apart from that, every kind of excellence can be copied.

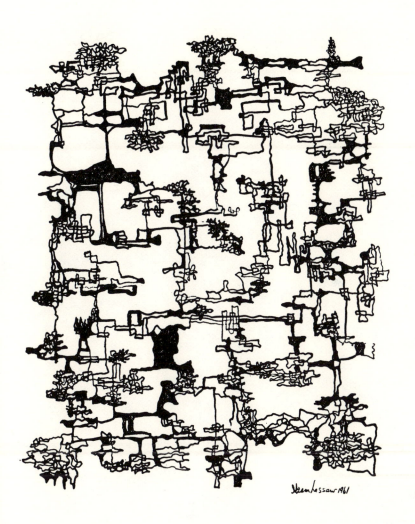

Ibram Lassaw

PART ONE
PAST AND POSSIBILITY

PAST AND POSSIBILITY

Consciousness of art history rules the art of our time and is the key to what takes place in the galleries of New York, Los Angeles, Paris, Warsaw, Tokyo. It affects not only the objective status of new works, the conditions under which they are valued and acquired, but the impulses that enter into their creation, their esthetic meaning, in fact, their very existence as works of art.

In all periods, the sense of tradition governed the responses of artists and their audiences. History-consciousness is something different. Tradition is aware of the past as a single complex of forms extending through the present into the future. In contrast, the modern sense of history recognizes that the past is made up of diverse cultures which by action in our time are being resolved into a future unity, the "one world" of democracy, of science or of The International Style. As tradition was an inescapable ingredient of the art of earlier centuries, proposing both what to paint and how to paint it, the consciousness of history is in a modern painting or sculpture as palpable as its form or motif—often, as in "overall" abstraction, the art-historical reference is the *only* content. Much of the difficulty in grasping contemporary art comes from ignoring this element. To appreciate a new picture it is not enough for the observer to know what trees or women bathing look like. He must have some inkling of the reflections cast upon the painting by other paintings (this is the case even when there are trees or bathing girls in the picture). The old pleasure of seeing "life" inside the frame must be augmented, if not replaced, by the stimulation of recognizing an inspired side glance to, say, "Les Demoiselles d'Avignon." Art history decides what art is. In turn, art decides what shall move us as beauty.

The density of meaning in a modern painting is always to some degree an effect of the artist's engagement with the history of art, including ideas about it. A work with a thin background of visual and intellectual experience of the art of other times will not outlast a prevailing fashion. An historically ignorant painting has no better claim to attention than the

ideas of an economist who never heard of the Stock Market Crash.

This judgment too is, however, subject to being overruled by future events. The public survival, for no matter what reason, of a work or style affects its actual esthetic worth for an indeterminable period. Objects are visually changed by the years, usually for the better, thus coming to justify the opinion, perhaps originally erroneous, that caused them to survive. The glamor of temporal distance, itself an esthetic quality, or the mental equivalent of one, spreads an aura upon styles, whether in a wall decoration, furniture or hairdos, that have won a place in the common memory. By their mere presence in the history of art, even in a state of being overgrown by later forms, works act upon taste to inflect it in their own direction. Art becomes valuable through creating the values by which it is valued. By means of longevity alone a painting may acquire a power of moving us unknown to its creator or its erstwhile admirers. A style once accepted continues to occupy a level of the educated imagination from which it may be summoned to the surface by psychological or cultural circumstances. Thus all preserved works are candidates for revival. Periods of reaction against yesterday's enthusiasms seem to be growing constantly shorter, if we may take as indications the recent fuss about Monet or Art Nouveau.

A new art mode to replace Abstract Expressionism was felt to be long overdue, if for no other reason than that some of the leaders had been with us for as many as twenty years. By all the presumed laws of vanguardism, no innovating style can survive for that length of time without losing its radical verve and turning into an Academy. This is especially the case with a revolution that has succeeded—the high prices and international publicity of Gorky, Pollock, de Kooning, Kline, Hofmann, Rothko, Gottlieb, Guston, David Smith, Lassaw, Motherwell and half a dozen related figures provided additional proof that whatever adventure they may have had in common belonged to the past. Thus for several years upon the closing of the galleries in the spring, Abstract Expressionism was, like Adonis,

> Whose annual wound in Lebanon allur'd
> The Syrian damsels to lament his fate,

prepared for burial. In this instance the loudest among the attendant damsels were the art critics of *The Herald-Tribune* and *The New York Times;* they were assisted by the anonymous commentators and caption writers of *Time* and *Life,* a handful of literary "humanists" urging subject matter versus abstract art, plus dealers and spokesmen for younger or "out" artist groups. As the outcries of farewell to the old new art reached their shrillest pitch, numerous candidates for the succession were watched with the fascination of a tight-rope act. "Beyond" Action Painting appeared neo-dada incorporations of random objects, from fenders of wrecked automobiles to stuffed beasts; high-relief paintings built up with mortar or plastics; motorized sculpture; one-color canvases; paintings produced by rolling nude ladies in pigment; adaptations of the art of children, lunatics, policemen and embroiderers of pillow slips; "happenings" combining visual effects with melodramatic life-situations. Alongside these all-out shock probes came various "back to sanity" manifestations aimed at the restoration of significant social or moral motifs or familiar esthetic concepts: West Coast neo-Impressionist landscape painting; Samuel Beckett-doom-type-Existentialist "images of man," featuring the Chicago School of mutilated torsos; extensions of "pure" painting in hard-edged divisions of the canvas, with flat, clean surfaces and analytically related colors in the Mondrian-Albers-Glarner tradition; soft-edge "imagism" of one or two simple shapes on a bland ground.

Finally, in the next two years the election settled on Pop Art, with its emphasis on mimic mass media (comic-strip blowups and mock advertising displays) but reaching into the entire kitsch environment of present-day public life.

Apparently, however, dissatisfaction of the art audience with the rate of innovation is not enough to force the pace of art history. Certainly, Pop Art earned the right to be called a movement through the number of its adherents, its imaginative pressure, the quantity of talk it generated. Yet if Abstract

Expressionism had too much staying power, Pop was likely to have too little. Its congenital superficiality, while having the advantage of permitting the artist an almost limitless range of familiar subjects to exploit (anything from doilies to dining-club cards), resulted in a qualitative monotony that could cause interest in still another gag of this kind to vanish overnight. Also, and perhaps because of the same superficiality, Pop's roster of individual practitioners was not impressive, even taking youth into account. I shall discuss the accomplishment of Pop Art more fully in a subsequent chapter. Speaking of the current situation in American art, all that can be said definitely is that Abstract Expressionism is no longer the latest mode, though it may well still be the newest in terms of potential originality and depth. It cannot be denied that the most imposing exhibitions of the past few years have been shows of Action Painting and Abstract Expressionism, the retrospectives of Kline, Gorky, Hofmann, Tobey, Guston, Gottlieb, to name a few. The retrospectives make it plain, of course, that the present advantage of Abstract Expressionism is not going to last forever—of the artists mentioned, Tobey is over seventy, and Gorky, Kline, and Hofmann are dead. Younger artists strongly motivated by Abstract Expressionism—painters like Lester Johnson, Hartigan, Held, Joan Mitchell, Bluhm, Elaine deKooning, Frankenthaler; sculptors like Agostini, Slivka, Sugarman, Pavia—appear to have more in common from the past than for the future.

The frustrated search for the new turn, both extremist and conservative, was duplicated throughout the Free World and in some of the Soviet satellites. At international exhibitions as in the United States works aimed at scandalizing taste educed no shock and those directed at elevating it evoked no meaningful trend. One thing had been learned from the notorious mistakes of the past one hundred years, and the lesson was thoroughly confusing. It was that no new work, no matter how apparently senseless, repulsive or visually vacant, could be rejected without running the risk that it would turn up as a masterpiece of the era. The story of the Ridicule Of The Radicals —of the Impressionists, Van Gogh, Matisse, Modigliani, Du-

champ—had become part of the folklore of painting. Today, no one is more conscious of it than the professionals. Some try to make up for the old errors by coming out uncritically for each new move. Others shift attention from the bad record by levelling their complaints not against it but against the fact that it has brought about an epidemic of esthetic permissiveness that is even worse than being wrong, and which is presumably curable by returning to the old attitudes that caused it. Cheerleading and stern "values" are, however, equally sham when people refuse either to resist what they dislike or to value their values.

New art is an unlimited risk for the intelligence. It calls upon intuitions that reach past the guide lines of concepts—indeed, this is one of its chief attractions. Nor is the risk any the less with art whose novelty consists in reverting, like the paintings of Balthus or the drawings of Giacometti, to earlier aims of painting, to museum surfaces or to semblances of places, things or people. Denouncing such work for not being "abstract" can be as silly as denouncing Newman for being "empty." History is not safe even for the anti-square. This final judge stands on the side of all artists as a continuing threat to all pronouncers of judgment. It stands also on the side of all charlatans and salesmen as a continuing insult to informed opinion. Modern consciousness of art history throws all standards on the roulette of success, not in money but in survival.

The dependent and shifting nature of art values, not only on the market but intrinsically, is uppermost in the mind of today's art collector, whether he buys for himself or as the representative of an institution. Acquiring a work is acquiring a piece of art history, or it is acquiring nothing (beyond, that is, an object of personal enjoyment in the same class as a cat or a souvenir). In signing his check the collector asserts his belief in the future presence of the work as a significant point attained by art as a whole. History, however, is open to anything and the merit of the chosen painting or sculpture has—at best—only the authentication of a present-day consensus. This con-

sensus is all but certain to be supplanted, as others have been in the past. In the last analysis, committing himself to a painting is the collector's own act. Through it he courageously (recklessly?) affirms not only his esthetic judgment, from whatever source it be derived, but the conviction that he can predict where art is going. Pride in this foresight, rather than the charm of a given painting, is often the motive of the new collector, as indicated by the practice of buying works at a glance or even over the telephone.

A collector who has acted early within a trend that continues to hold has earned the same respect as an investor who bought IBM at 30. But he has gained much more. By his act he has identified himself with the work in its adventure through time, and together with it he will enter into the history of art. In America, the growing popularity of the study of contemporary art history since the War has produced the novel spectacle of the collector as hero. One who landed early on the shores of Abstract Expressionism is invited to lecture on his deed like a Marine colonel in the first wave at Iwo Jima.

While there are still old-style collectors who simply buy paintings they admire, collecting art has become, through the pervasive sensitivity to time and survival, a career with metaphysical overtones, a means to immortality or at least to indefinitely protracted mention in the public record. With this stake in the reputations of "their" artists, collectors are often more passionately positive about art values than artists or critics. To preserve their heroic moment from dilution, some pronounce the ultimate evaluation: that after the works collected by them art entered a lasting decline. "Today," Peggy Guggenheim concluded her revised autobiography, "is the age of collecting, not of creation." Miss Guggenheim's position is, of course, self-defeating, since if there were nothing for new Balboas of the studios to discover the age of collecting would be finished too. To maintain the present impetus of art acquisition, there must be a continual flow of new creations, on each of which one or more discoverers may triumphantly ride the stream of time.

Prophets are notorious manipulators. To anticipate events

is to attempt to control them. The attempt to *make* art history is implicit in the work of every contemporary school of art and in all serious criticism, including that which takes the form of buying art works, exhibiting them, awarding foundation grants. In our time those who are content merely to paint pictures or to contemplate them are out of touch, either through choice or through ignorance, with the dynamics of creation in the arts; their norm is to be found in the canvases and picture gazers at the outdoor shows in Washington Square. Art, including its appreciation, has become an area of conflicting powers.

Can the "art world" be rigged? Since the first appearance of the experimental modes in painting the charge of manufactured support has been advanced innumerable times. After a century of reiteration, it is still repeated with undiminished passion. Someone must be *behind* this art which, obviously, has no appeal to the eye or message for the intellect. To insist on the esthetic value of a head with vertical lips, or a canvas splattered with thrown paint or with nothing on it but a few ribbons of color, one must either be a principal of the conspiracy or one of its dupes. In the nineteenth century proof of the hoax was presented by the Impressionist sunset which a mule painted with its tail; last week the proof was Action Paintings made by chimpanzees. (I am not sure I can explain the switch from the mule to the chimpanzee, unless it signifies that the plot of modern art against humanity has become more ominous, in that what was behind the mule was only its tail while behind the chimp is the menacing figure of the trainer as Big Brother.) The idea of the hidden esthetic string-pullers inspired the Nazi doctrine of the corruption of German folk expression by "degenerate art." In the United States, the continued creation and exhibition of Abstract Expressionist works has been laid to stimulation by a clique of critics, dealers, art editors, museum officials and college art departments. Not long ago the chief art critic of *The New York Times* attributed to Alfred Barr of the Museum of Modern Art the power to turn movements in art on and off at will. Mr. Barr hastily repudiated this apotheosis as the Goddess of Art History.

Since everyone who has to do with art in any capacity is engaged in propelling it somewhere, the question of undue influence is less a problem of morality than of power. It is in regard to the power to define art in accordance with the relativity of values introduced by the historical consciousness that modern painting impinges directly on politics. Totalitarian societies destroy the provisional nature of contemporary art and regulate by edict what art is and shall be. In a democracy influence exists, but there can be no exclusive influence; even the force of a great idea is limited by the democratic right to opinionatedness and ignorance. Art comes to be the result of a balance among the things it is asserted to be by the self-elected individuals who create it and devote themselves to it.

The constant shuffle of powers gives new importance to the art critic and art functionary, particularly those who undertake to predict. It has been claimed that having abandoned nature the creation of art now takes off from critical concepts. It is undeniable that an unprecedented interplay now exists between art and ideas. Yet the importance of the conceptual element can easily be exaggerated. Occasionally, a critic overexcited by the spotlight will lend his weight to some "law" that must prevail in the art to come. Detecting the hint of a torso or a table in an "abstract" painting, one critic happily applauds the inevitable self-reassertion of Nature in painting and warns the stubborn against holding out. Another logician of inevitability, having noted a tendency toward increasing economy of means in painting, declares that from now on good painting will be identifiable by its simple shapes, thin pigments and untouched areas of canvas. In the bewildering outpouring of styles and assumptions, any theory offers a footing, and in the carry-over from the past both critics will be right: the visible world will reappear and so will paintings reduced to finger exercises with the medium. By the same token, however, only artists lacking in vision and intellectual vitality will submit to being directed by the formulas of critics, so that in picking the "right" works the danger of being misguided is as great as ever.

For the artist, the replacement of tradition by historical

consciousness compels a continual choosing among possibilities. The decision to follow one esthetic hypothesis rather than another is a matter of professional life or death. The release of art from the one-way push of the past is inseparable from a permanent uneasiness, related to the anguish of possibility from which all free men suffer. This uneasiness both artists and their audiences will have to learn to endure.

To illustrate the historical sensibility and its problems one might choose three exhibitions running concurrently in a recent season: a retrospective of Tobey, the centennial of Arthur B. Davies, a show of recent Picassos. Of the three, Picasso alone locates himself entirely *inside of history*, while the two Americans, though they recognized the power of change over art, sought points of resistance to it in ideology and mysticism.

In his reanimation of the art of the past, Picasso imitates history's constant metamorphosis of the old into the new. In this practice he seems hardly to distinguish between his own earlier works and those of other artists. The eight paintings shown in the New York exhibition continued to the point of caricature the master's frontal-plus-profile masks that reach back to the first years of this century. In an exhibition presented simultaneously in Paris he returned beyond his own beginnings to undertake a reinvention of Manet. Like events, like language, all art is for Picasso collective property from which the individual is entitled to draw as much as he can use. In carrying out his appropriation of the past, the living artist "flattens out" time by bringing its successive layers forward into a durationless present upon which the contemporary mind can imprint itself, as Cubism reduced space to the two dimensions of the canvas on which the painter acts. With Picasso the painful historical consciousness of the twentieth century attains to metaphysical profundities not exceeded by the art of other epochs.

If Picasso is the darling of historical thought in art, Davies was its victim. As director of the famous Armory Show in 1913 (see chapter 16), he shared responsibility for introducing into the United States the profusion of modern art and its tribulations. For himself, he interposed between his painter's

eye and the American countryside which it had interpreted with unusual sensitivity, the wheel of new styles and theories. With so many strategies for esthetic dreaming to choose from, Davies' dreams became increasingly conceptual. The silent landscapes in which he posed his familiar penumbral nymphs are, like Symbolist art generally, a refuge contrived from the history of art, beyond the reach of events. His early naturalist paintings, free of ideological drive, possess the same mood of quiet withdrawal, but in their simplicity of statement are more attractive as paintings. Davies' remarkable intuition of what art in the century to come would be—he collected Cézanne, Picasso, Seurat, Brancusi, Chirico, Léger, Gris—was more than he could live up to as an artist. Conservative critics have seized upon his creative lag and his nervous borrowings as an example of how much an artist loses in losing his innocence and to raise the old warnings against experimentation and intellectual venturing. By this logic, if Davies' limited talents prevented him from getting where he wished to go, the remedy would have been to blindfold himself. But an intelligence that has once sensed the substance of the time cannot back away from it. Davies' later art was not a mistake; it bears the pathos of his unique response to the lag of American art in his day. To see in his paintings the tensions and quietism that are reflexes of historical transition is to appreciate their larger attractiveness.

An adherent of Bahai, Tobey, like Davies, projects his imagination beyond the temporal. But while Davies' canvases are closed gardens, Tobey's are porous to all kinds of time phenomena. Bahai searches for an underlying Reality, at the same time that it hails "the new day" and the twentieth century; for Tobey immersion in time is therefore a matter of religious conviction. In his retrospective exhibition, which reached back to 1918, susceptibility to developments in art and events during more than forty years was fused with the changeless oddity of the cultist. One met Blake, Hopper, Duchamp, Masson, the Chinese, the Depression, Broadway, Zen, Social Realism, Cubism, the American Indian and Jackson Pollock. Yet Tobey's art is his own even when his derivations are most obvious. Turning with art history he also bends it in his

direction. His "white writing" of 1935 gives him a place among the innovators. Tobey's calligraphic and later spotted and squiggled "overall" canvases are inevitably compared to Pollock's drip paintings. Often resembling them in their handling of space, they differ entirely both in intention and in the action that composes their surfaces. Except in the "Sumi" thrown-ink paintings (less interesting than Pollocks and Klines in that they *look* Chinese), Tobey's hand retains contact with the canvas or paper, and the movement of the line, the dottings and nervous scribbles are used to evoke an image not to enact an experience. The Tobey picture originates beyond the self of the artist, rather than in the endeavor to express, extend, intoxicate or submerge that self. The distinction is obvious in a painting like "Gothic" in which the shooting strokes of an apparent abstraction assemble themselves into the interior of a church. Throughout, Tobey's dominant tone is the chalky tan-gray of scratching on a slate or tablet of stone, as if he wished to fix his twentieth-century experience into a message brought down from the mountain.

Each new generation of artists—they now appear every two or three years—endures the frustrating feeling that "everything has been done." To the avant-garde of the twenties Picasso had occupied all the forward positions in painting, as Joyce had in prose. Today, a detour must be found around de Kooning or Rothko that will not lead into the detour of Rauschenberg. Yet oppressive as these Chinese boxes of styles within styles may at times turn out to be, there is no escape from them either into raw nature or raw phantasy. With Rousseau, Bombois, Vivin, even "primitivism" had entered art history as a self-conscious tendency. More recently, Dubuffet closed again the gates of naïveté by his wide-ranging, sophisticated exploitation of the scrawls of non-artists and the composts formed by natural processes. If thirty-five years ago, poetry was, as Cummings said, in competition with "roses, locomotives [and] the eyes of mice," art today has come to terms with the tracks of crocodiles and the motor and taste im-

pulses of monkeys. Any agency—human, animal, mechanical, chemical—that disturbs a surface is automatically enrolled in the potential history of makers of art. The consciousness of art is thus an expanding consciousness. No wonder the conviction holds that revolutions must keep happening in painting and sculpture and that whatever these bring forth will have a chance of becoming legitimate, once it has entered into the texture of the common imagination.

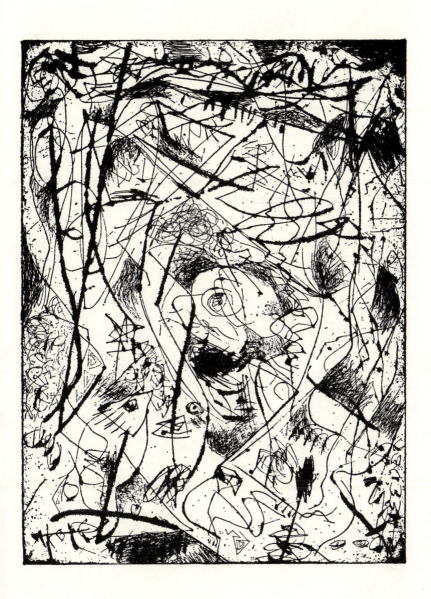

Jackson Pollock

ACTION PAINTING
CRISIS AND DISTORTION

"In Greece philosophizing was a mode of action"—Kierkegaard

Action Painting solved no problems. On the contrary, it remained at its best faithful to the conviction in which it had originated: that the worst thing about the continuing crisis of art and society were the proposals for solving it. In the thirties American art had become active, having gratefully accepted from politics an assignment in changing the world. Its role was to participate in "the education of the masses." Painting and sculpture were to overcome at last their bohemian isolation and gain an audience of ordinary folk in the classical manner. An enticing outlook—except that practice was to disclose that to educate the masses the educator must himself take on the essential characteristic of the masses, their anonymity. For the contemporary mind no prospect holds a deeper dread. In practice the art of the social message found itself shuffling feebly between the action-inspiring poster and the esthetic ideal of personal style.

The war and the collapse of the Left dissolved for the artist the drama of The Final Conflict (the only kind of conflict which, in the realm of the spirit, love or politics, might justify putting aside the conflicts of creation). The social crisis was to have no closing date and had to be accepted as the condition of the era. If it ever did end, nothing would be left as it was now. Thus art consisted only of the will to paint and the memory of paintings, and society so far as art was concerned consisted of the man who stood in front of the canvas.

The achievement of Action Painting lay in stating this issue with creative force. Art had acquired the habit of *doing* (as late as a decade ago it was still normal for leaders of the new art to stage public demonstrations). Only the blank canvas, however, offered the opportunity for a doing that would not be seized upon in mid-motion by the depersonalizing machine of capitalist society, or by the depersonalizing machine of the world-wide opposition to that society. The American painter discovered a new function for art as the action that belonged to himself.

The artist's struggle for identity took hold of the crisis directly, without ideological mediation. In thus engaging art

in the life of the times *as the life of the artist,* American Action Painting responded positively to a universal predicament. Where else but in this crisis would any living individual ever live? Throughout the world, works from New York reached to individuals as possibilities for each. Paintings produced painters—a development greeted with jeers by shallow minds. Painting became the means of confronting in daily practice the problematic nature of modern individuality. In this way Action Painting restored metaphysical point to art.

There was not in Action Painting as in earlier art movements a stated vanguard concept, yet it carried implicitly the traditional assumptions of a vanguard. Devoid of radical subject matter—except for occasional echoes in the titles of paintings and sculptures of prisons, the Spanish Civil War, Pennsylvania coal towns—Action Painting never doubted the radicalism of its intentions or its substance. Certain ruptures were taken for granted. Foremost among these was the rupture between the artist and the middle class. Commercialism, careerism, were spoken of disdainfully as a matter of course. If the antagonism to conventional values had been shifted inward, from, say, the group manifesto to dialogues between husbands and wives, the self-segregation of the artist from the "community" was still the rule. Indeed, the first gesture of the new painting had been to disengage itself from the crumbling Liberal-Left which had supplied the intellectual environment of the preceding generation of artists.

The rejection of society remained unexpressed. This may have deprived Action Painting of a certain moral coherence and reduced its capacity to resist dilution. Its silence on social matters is not, however, decisive either as to its meaning or its public status. Anti-social motifs in art are of doubtful consequence—society calmly takes them in its stride and in time extends its rewards to the rebels who painted them. This has been the case with nineteenth-century Realism, as with Dada, Expressionism, Surrealism, even Social Realism. To explain the success of Action Painting as the pay-off for an opportunistic turning away from the issues of the day requires a blend of malice and ignorance. A rich Action Painter stoically enduring

the crisis of society in his imported sports car makes a good butt for comedy but the loudest guffaws come from cynics for whom sales prices are the ultimate measure.

Another vanguard assumption taken up by Action Painting with fullest intensity was that which demanded the demolition of existing values in art. The revolutionary phrase "doing away with" was heard with the frequency and authority of a slogan. The total elimination of identifiable subject matter was the first in a series of moves—then came doing away with drawing, with composition, with color, with texture; later, with the flat surface, with art materials. (Somewhere along the line Action Painting itself was eliminated.) In a fervor of subtraction art was taken apart element by element and the parts thrown away. As with diamond cutters, knowing where to make the split was the primary insight.

Each step in the dismantling widened the area in which the artist could set in motion his critical-creative processes, the irreducible human asset in a situation where all superstructures are shaky. It had become appropriate to speak of the canvas as an arena (at length the canvas was put aside to produce "happenings").

On the "white expanse" a succession of champions performed feats of negation for the liberation of all. "Jackson broke the ice for us," de Kooning has generously said of Pollock. It is possible, to paraphrase Lady Macbeth, to stand not on this order of the breaking. Be that as it may, behind Pollock came a veritable flotilla of icebreakers. As art dwindled the freedom of the artist increased, and with it the insignificance of gestures of merely formal revolt. The content of paintings became more important than ever before.

Action Painting also pressed to the limit the break with national and regional traditions which, by an historical irony, the political internationalism of the thirties had strengthened. As noted above, the crisis-nature of Action Painting made it a major language of social disaffection wherever experimental art was not barred by force.

To forget the crisis—individual, social, esthetic—that brought Action Painting into being, or to bury it out of sight (it cannot really be forgotten), is to distort fantastically the reality of postwar American art. This distortion is being practiced daily by all who have an interest in "normalising" vanguard art, so that they may enjoy its fruits in comfort: these include dealers, collectors, educators, directors of government cultural programs, art historians, museum officials, critics, artists—in sum, the "art world."

The root theory of the distortion is the academic concept of art as art: whatever the situation or state of the artist, the only thing that "counts" is the painting and the painting itself counts only as line, color, form. How *responsible* it seems to the young academician, or to the old salesman, to think of painting "as painting" rather than as politics, sociology, psychology, metaphysics. No doubt bad sociology and bad psychology are bad and have nothing to do with art, as they have nothing to do with society or with real individuals. And about any painting it is true, as Franz Kline once said, that it was painted with paint. But the net effect of deleting from the interpretation of the work the signs pointing to the artist's situation and his emotional conclusions about it is to substitute for an appreciation of the crisis-dynamics of contemporary painting an arid professionalism that is a caricature of the estheticism of half a century ago. The radical experience of confrontation, of impasse, of purging, is soaked up in expertise about technical variations on earlier styles and masters. The chasm between the artist and society is bridged by official contacts with artists and by adult-education and public-relations programs. Artificial analogies are drawn between features of Action Painting and prestigious cultural enterprises, such as experiments in atomic laboratories, space exploration, skyscraper architecture, new design, existential theology, psychotherapy. An art that had radically detached itself from social objectives is recaptured as a social resource. In turn, society is deprived of the self-awareness made possible by this major focus of imaginative discontent.

As silencing the uneasy consciousness of contemporary

painting falsifies the existing relation between art and society, it also inverts the relation between the artist and art. The exclusion of ready-made subjects and the reduction to the vanishing point of traditional esthetic elements are conceived not as effects of the loss by art of its social functions, on the one hand, and of the artist's sentiment of distance from accepted standards of value, on the other, but as a victorious climb up a ladder of vocational progress. The tension of the painter's lonely and perilous balance on the rim of absurdity is absorbed into the popular melodrama of technical breakthrough, comparable to the invention of the transistor. Sophistries of stylistic comparison establish shallow amalgams which incorporate contemporary art into the sum total of the art of the centuries. By transferring attention from the meaning of the artist's statement to the inherited vocabulary, modern works are legitimized as art to the degree that they are robbed of sense. The longing which Eisenhower recently expressed for art that did not remind him of contemporary life is shared by the functionaries of the art world, who, however, are professionally equipped to prevent *any* art from bringing up this disturbing reference.

The will to remove contemporary painting and sculpture into the domain of art-as-art favors the "expert" who purveys to the bewildered. "I fail to see anything essential in it [Action Painting]," writes Clement Greenberg, a tipster on masterpieces, current and future, "that cannot be shown to have evolved [presumably through the germ cells in the paint] out of either Cubism or Impressionism, just as I fail to see anything essential in Cubism or Impressionism whose development could not be traced back to Giotto and Masaccio and Giorgione and Titian." In this burlesque of art history, artists vanish, and paintings spring from one another with the help of no other generating principle than whatever "law of development" the critic happens to have on hand. Nothing real is "anything essential"—including, for example, the influence on Impressionism of the invention of the camera, the importation of Japanese prints, the science of optics, above all, the artist's changed attitude toward form and tradition. In regard to historical differences the critic's sole qualification is his repeated "I fail to see,"

while name-dropping of the masters supplies a guarantee of value beyond discussion. Yet grotesque as this is, to a collector being urged to invest in a canvas he can neither respond to nor comprehend, it must be reassuring to be told that it has a pedigree only a couple of jumps from Giotto.

Anything can "be traced back" to anything, especially by one who has elected himself First Cause. The creator, however, has not before him a thing, "traceable" or otherwise; to bring a work into being he must cope with the possibilities and necessities of his time as they exist within him. The content of Action Painting is the artist's drama of creation within the blind alley of an epoch that has identified its issues but allowed them to grow unmanageable. In this situation it has been the rule for creative performance to be a phase in a rhythm of confusion, misery, letting go, even self-destruction—as the formula of Thomas Mann had it, of the alliance of creation with sickness, at once moral and physical. The lives of many, perhaps a majority, of the leading Action Painters have followed this disastrous rhythm from which creation is too often inseparable. Who would suspect this inception of their work from the immaculately conceived picture-book biographies and the gasping-with-admiration catalogue notes, in which personalities have been "objectified" to satisfy the prudery of next of kin and the prejudices of mass education?

The suppression of the crisis-content of Action Painting in the interests of promoting it as art has given rise to a counter public-relations which denounces this art as historically inconsequential and as gratuitously subversive of esthetic and human values. The ideological assault against Action Painting reaches the same pitch on the Right and on the Left. The former refuses to acknowledge that its standards are empty abstractions, the latter that its techniques for making history have proven fruitless. The happy fiction that the art of our time is a fulfillment of the art of the ages thus finds itself at war with the fiction that our time could find a fulfillment if it were not for the perversity of contemporary artists—a conflict of echoes in a vacuum. Art criticism is probably the only remaining intellectual activity, not excluding theology, in which

pre-Darwinian minds continue to affirm value systems disso-
ciated from any observable phenomena.

The crisis that brought Action Painting into being has
in no wise abated, though the political surface of the crisis has
grown a bit calmer with the lessening of the threat of nuclear
war. In regard to the trends of mass culture, the situation of
the artist and the position of art itself, all indications are that
the crisis has been deepening. The major change of the past
ten years is that with more buying and selling of art the con-
sciousness of the crisis has been further dulled—perhaps the
spirit of abandonment has been furthered by the increasing
difficulty of dealing with it. With desperation driven under-
ground, the will to act has weakened and the inability to do
so become less disturbing. I am describing the inner reality of
the much-advertised success of vanguard art.

The future of Action Painting, relieved of its original
stress, is not difficult to predict. Indeed, it was already visible
a decade ago, before its acquisition of a name propelled it in
the direction of a Style. "The tremors produced by a few
expanses of tone or by the juxtaposition of colors and shapes
purposely brought to the verge of bad taste in the manner of
Park Avenue shop windows are sufficient cataclysms in many
of these happy overthrows of Art. . . . Since there is nothing
to be 'communicated,' a unique signature comes to seem the
equivalent of a new plastic language . . . etc." With the crisis-
sentiment displaced by the joys of professionalism, it remained
only to make labels of Anguish and Spontaneity. I do not wish
to imply, of course, that artists have any greater obligation to
be troubled or in doubt than other people.

The idea of this "trans-formal" art was never a simple
one, nor would it be wise to attempt, as is often proposed, a
very close description of it. An action that eventuates on a can-
vas, rather than in the physical world or in society, is in-
herently ambiguous. As Thomas Hess has argued, art history
lies in wait for the Action Painting at its beginning, its middle
and its end (what lies in wait for art history?). To come into

being such a painting draws on the methods and vocabulary of existing art; in its process of production it invokes, positively and negatively, choices and references of painting; upon completion it is prized within the category of painting values and "hangs on the wall." In sum its being a work of art contradicts its being an action.

To literal minds the presence of a contradiction invalidates either the description or the object described. Yet it is precisely its contradictions, shared with other forms of action (since all action takes place in a context by which its purpose may be reversed), that make Action Painting appropriate to the epoch of crisis. It retains its vigor only as long as it continues to sustain its dilemmas: if it slips over into action ("life") there is no painting; if it is satisfied with itself as painting it turns into "apocalyptic wallpaper."

I have said that Action Painting transferred into the artist's self the crisis of society and of art. It was its subjectivity that related it to the art of the past, most immediately to that of another desperate decade, the Germany of the twenties, from which it drew the misnomer "Expressionism."

There is also a non-subjective way of reacting to a crisis —perhaps this way belongs to a later phase in which hope and will have been put aside. I refer to the impassive reflection of the absurdities which become the accepted realities of daily life, as well as the emblems of its disorder. The projection of these absurdities according to their own logic produces an art of impenetrable farce, farce being the final form, as Marx noted in one of his Hegelian moments, of action in a situation that has become untenable. It is as the farce of rigid anxiety that I interpret the current revival of illusionism in art through techniques of physical incorporation of street debris and the wooden-faced mimicry of senseless items of mass communication. Here again, however, the crisis-content of the work is already being camouflaged in critical how-to-do-it interpretations which amalgamate the new slapstick art with an earlier esthetic of found materials and popular images.

In that it dared to be subjective, to affirm the artist as an active self, Action Painting was the last "moment" in art on

the plane of dramatic and intellectual seriousness. The painters in this current have kept to the tradition of the human being as the ultimate subject of painting. All art movements are movements toward mediocrity for those who are content to be carried by them. The premises of Action Painting, however, are still valid for individual beginnings.

BLACK AND PISTACHIO

Abstract Expressionism may not be as dead as we keep being told it is but there is no denying the will to see it dead. For professionals of the art world—dealers, museum directors, critics, contemporary historians—the largest flaw in the success achieved by American painting during the past dozen or so years has been the overemphatic presence of the artist and his personality in the work. In the most popular sense of the term, American painting has been excessively "expressionist." Pollock, de Kooning, Kline, Guston have invested their canvases with too much freedom, too much *angst*. Rothko, Still, Gottlieb, Newman have brought to theirs too much of the arbitrary and the absolute. In thrusting himself or his idea into the picture, the artist drags into it also doubts about art, uneasiness about his identity, conflict with the environment, traditional bohemian ambiguity and defiance, even the crisis of contemporary society. The paintings of Adolph Gottlieb are impeccably organized, with every relation of hue calculated with microscopic finesse; yet to Gottlieb these lucid, calm surfaces signify "Blast!" In a "post-Expressionist" adaptation, Gottlieb's image would lose its ominous overtones and be named "Painting" or "Lavender and Blue."

Besides reminding the proud possessor, or the still prouder critical enthusiast, of the world he and the artist share, Expressionist painting also reminds him of the distance between the artist and the art appreciator—a distance of pathos, since the creator of the work has suffered, or even invited upon himself, the injuries of the epoch. As a rule, expressionist painters have failed to live in a manner conducive to the peaceful enjoyment by society of the fruits of their labors. Their canvases and they themselves have been a nuisance both to the esthete who wishes to react to the work of art exclusively as to a pleasure-inducing object and to the history-conscious art expert and collector who seeks to place the work in an objective trend.

Thus, the turn against Abstract Expressionism by proponents of vanguardism has been motivated less by desire for any particular new idea or mode than by a will to reject what has been done—a rejection that had previously manifested it-

self in the systematic nibbling away of the meanings of Abstract Expressionist works through translating them into purely esthetic terms. And the primary initiative for the turn, aside from individual impulses to capture attention by an all-out defiance, has come less from painters and sculptors than from the art press and other powers in the art world. The major objective has been to displace the artist, with his maladies of creation, by a new kind of esthetically sophisticated craftsman content to exhibit his skill in manipulating subject matter or some painting idea. Institutional support for this goal is by now practically unanimous in New York: *Art News* is the only organ that stands against it. Official sponsorship has gone overwhelmingly to the deadpan extracts from the daily scene known as Pop Art and to depersonalized abstraction and emblem-making. Exhibitions have been cleaned up, have become what one might term *mahler-frei*, or artist-free.

The trend in opposition to the artist as creator was solidified in two prominent exhibitions held in 1963.

"Americans 1963," at the Museum of Modern Art, was the coolest show in town in any medium, except for the "Toward a New Abstraction" exhibition at the Jewish Museum, where the paintings themselves added awnings and ice cream. In this assembly of art works there was not an Expressionist stroke or shape, except for two wood carvers, Gabriel Kohn and Michael Lekakis—plus, to confound the doctrinaires, Claes Oldenburg, a leader of the Pop artists, who said he was for an art that "accumulates and spits and drips" and proved it by the surfaces and draftsmanship of his enamelled hamburgers, his sewing machines and his 7-Up lettering. Lekakis's dancing wood whorls and Kohn's leaning and interlocked free forms in laminated wood reminded us that at the present time a vigorous surge of Abstract Expressionism is occurring in sculpture. Its fate in painting had, however, been sealed at the Museum of Modern Art show as elsewhere—had this not been the case it would be hard to explain why half a dozen high-rating painters, such as Esteban Vicente and Jack Tworkov, who had never been included in an "Americans" exhibition at the Museum, should not have replaced some of the persons chosen.

The pictures first met on the gallery floor were exercises in eyeshifting dispositions of crosses, rectangles and circles in variations of color values and size. The statement by the artist, Richard Anuszkiewics, in the Museum catalogue helped put the spectator in the proper tiled-laboratory mood: "My work is of an experimental nature and has centered on an investigation into the effects of complementary colors of full intensity when juxtaposed and the optical changes that occur as a result," and so on. This mood was not disrupted in the cubicle devoted to Sally Hazelet Drummond, whose careful overall diffusions of colored dots that drift toward centers of density bore such titles as "Bluebird," "Hummingbird" and "Drone," and who believes "that all great art is an attempt to reveal the structured, infinite and beautiful order that lies deep within all existence." David Simpson, whose paintings are composed of horizontal bands of color with occasional blottings, is equally objective and equally concerned with the beautiful, while being, of course, mindful of the new. Robert Indiana, an adaptor of signs and stencil markings; Chryssa, a more resourceful sign maker and manipulator of patterns, imprints and lettering; Rosenquist, with his collage effects of advertisements that here tend toward an undisturbing surrealism; Jason Seley, a sculptor who "adds" and "subtracts" auto bumpers into constructions often endowed with art-historical titles; Marisol, whose painted wood and plaster cut-outs can lend the Mona Lisa and George Washington a family likeness to Buster Keaton—all these gave predominance in the show to the idea man and to an art in which there is no one in the picture, or, if there is, someone who is keeping mum.

Lee Bontecou's erotically menacing steel, wire and canvas protrusions, with their 16-inch-gun apertures and smoky crevices, were the only non-neat items in the exhibition. (The enamelled surfaces of the Oldenburgs give his "spit" a sanitary look.) Yet a reverse effect was created by her drawings which have the mechanical precision of the art of the early part of the century. In this art of revivals—for actually there was nothing new either in this show or at the Jewish Museum—Bontecou's reliefs return legitimately to Duchamp and dada;

like Kohn, Lekakis and Oldenburg she escapes neo-esthetic blandness. On the other hand, Edward Higgins' welded-steel-and-painted-plaster sculptures are emblems in three dimensions and might at first glance have seemed to belong with the other contrived images in the exhibition; yet they did not quite meld into the cold decor, for Higgins' conceptions have hallucinatory overtones and suggest that they owe more to imagination than to calculation. Another imaginative artist, Richard Lindner, a well-known Surrealist, whose work was represented by an excellent selection, has been growing bolder and sexier. It is interesting to note in the context of this show that both Lindner and Higgins express doubts about art and deny giving much thought to it.

There are no doubts in the mind of Ad Reinhardt. He knows exactly what art is, and even more exactly what it is not. Reinhardt, who descends to us from the dogma-ridden thirties, is the neo-esthete par excellence. He has combined historical inevitability ("The one direction in fine or abstract art today is in the painting of the same form over and over again") with esthetic objectives purified of all content or reference ("The one subject of a hundred years of modern art is that awareness of art of itself, of art preoccupied with its own process and means, with its own identity and distinction"). His statement in the Museum catalogue, five or six times the length of any one else's, lays down the law that "art-as-art is nothing but art" and the dictum "No Expressionism or Surrealism. 'The laying bare of oneself,' autobiographically or socially, 'is obscene.'" (Reinhardt's quotations are attributed in a footnote to "the ancients"; their application to contemporary painting is of course his own.)

In my opinion, Reinhardt is the intellectual pivot of the new art offered as a replacement for Abstract Expressionism. This painter of evenly tinted, all black, all square canvases of identical size is the link between prewar ideological painting and the current purist products presented both at the Museum of Modern Art and The Jewish Museum. He is also a theoretical focus of Pop Art by way of his war of nerves against contemporary creation, the drive of his own painting toward zero,

and his paralleling of the Orientalism of John Cage, mentor of the Pops. The "new" abstraction is an art derived from an historical self-consciousness about being new and radical, combined with the flight-from-politics impulse of the past fifteen years to exclude from painting all values except those of art. Like Rothko or Newman, Reinhardt conceives an art of one idea, which may be repeated with minuscule variations from painting to painting. (To get rid of all visible variations took only one more logical step.) In this respect, Reinhardt is an Abstract Expressionist, and the fact is that his work has been appreciated in the Abstract Expressionist context. Yet no one has pursued with more fanatical persistence and moral malevolence a program of exorcising the artist from his work and destroying the social and intellectual communion among artists. That his services as the would-be executioner of Abstract Expressionism have awakened not a flicker of appreciation from other enemies of this movement is one of the ironies of his end-of-the-line situation as an Abstract Expressionist. The "black monk" of the anti-Abstract Expressionist crusade, Reinhardt represents to the most extreme degree the ideal of an art dominated by ideology. He calls for a type of painting utterly ruled by concept and executed according to recipe. Of all ideas in contemporary art, Reinhardt's idea is the most powerful, since it does not seek to oppose other ideas or insights but to obliterate them. He is the disciple in art of the spirit of absolutism, as expressed by Lenin when in 1907 he characterised his own attacks on other Socialists as follows: "That tone, that formulation, is not designed to convince but to break ranks, not to correct a mistake of the opponent but to annihilate him, to wipe him off the face of the earth." All of painting is to sink into Reinhardt's black, square trapdoor, below the surface of which close scrutiny reveals a block-shaped cross marking the tomb of modern art. "The one thing to say about art is its breathlessness, lifelessness, deathlessness, contentlessness, formlessness, spacelessness and timelessness. This is always the end of art." On a page of the Museum catalogue following this credo, a profile photo of Reinhardt brooding in shadowy silhouette on the end of a

wooden bench against a square window of his studio reinforces his poetry of self-negation, at the same time that it contradicts it by setting the artist in the foreground of his characteristic square composition.

In the happy galleries of the Museum of Modern Art show the works of this artist had to be roped off as if they might bite. Reinhardt's paintings, a guard told me, had stimulated more hostility than any works since Dubuffet's. I suggested that the Dubuffets looked more aggressive. "These," he replied, "are aggressive enough in their own way." He was right, of course. Yet there is a difference. Dubuffet bites the art public, Reinhardt other artists. "The one struggle in art is the struggle of artists against artists, of artist against artist, of the artist-as-artist within and against the artist-as-man, -animal, or -vegetable." Or, as the Leninist slogan of the thirties put it, "The main enemy is at home."

The Museum of Modern Art exhibition was a fair reflection of official concepts of what is new in art; apart from the effects of its presentation, it made no attempt to intrude any philosophy or program. Quite different in intention was the "Toward A New Abstraction" exhibition at the Jewish Museum, as scandalous a piece of steam-rollering as has appeared even in these days of audience participation in art and planned hero making. Never has mere decoration been presented with more pretentiousness and remained mere decoration. If the Museum of Modern Art selections combined the mind-crushing dogma of Reinhardt with eye-catching froth, the connection between dogma and taste inspiration was exposed in the stage setting of the painters grouped at the recently updated institution on Fifth Avenue. Each artist had a critic to back him up—not a mere statement by the artist himself as in the Museum of Modern Art catalogue. Among the lenders to the show were other critics and art historians. In compensation, and to further certify the cementing of unity between these artists and their public, the Introduction to the catalogue was written by a prominent collector of contemporary art, once devoted to

Abstract Expressionism, but who here in bellicose tones called the turn of current art history a fortunate liberation from the influence of Willem de Kooning. "What was taken to be a revolutionary style was, in reality, the logical extension, final flourishing and summation of an era: the post-Cubist art of Europe." Having thus disposed of the kind of painting that put American art on the first plane of interest throughout the world (I am told that Europeans are marvelling at the sabotage in New York of the painting that made it a global art capital), our collector-prognosticator spoke of "true inheritors and implementors of our new abstract traditions."

The work of these heirs is, we were told, "revolutionary," but "the attitude toward the work is not expressionist; it is ordered, constructed. It is painting of a careful and visibly wrought balance. . . . The painting appears as a preconceived idea and . . . the stress is on the finished work." The ideological and craft essence of the new art apparently made it possible for "those of us who have planned and discussed this exhibition [to find] it relatively simple to delineate who belonged, who didn't and who was on the borderline and why." The crux of the new revolutionary, conceptual, orderly, constructed and balanced paintings that so readily revealed their secrets to the man with the checkbook was that "there is no longer that total sense of identification [of the artist] with the work; rather there is a sense of discretion, of removal which says, 'I am no longer the painting and it me. It is there and it is what I say, but it is not all of me for I have something left outside of it with which I control it and the rest of my life.' "

This first bourgeois manifesto in the history of art, with its call for mental and social security in painting, could not, of course, be laid at the door of any artist. Yet some of the artists in the show appeared to have had a hand in composing it and one is compelled to admit that the majority of artists today are living up to its program. The paintings of Miriam Schapiro featured a central panel within a field of gray, like the band in a Newman, but wide enough to contain a series of symbolic objects set in compartments in the manner of early Gottliebs, but one above the other and realistically painted. Since Miss

Schapiro's favorite symbols are the egg and the arch, and since only three or four years earlier she was an Abstract Expressionist of the wilder sort, her new borrowings and mythmaking kept casting into my mind thoughts of the goose that laid the golden egg. Another converted Abstract Expressionist overtaken by "discretion" was Kenneth Noland, who shared with Raymond Parker a huge square room with magnificent unbroken walls hung with gigantic paintings. From a decorator's point of view the effect was stunning. As paintings, however, the only satisfactory works in the room were Parker's "Painting" dated 1958 and his "Painting" dated 1963. Noland's work was neither more nor less feeble and inhibited than it was before his abstractions became "new." He composes targets with a systematic blotting of the paint upon raw canvas, leaving a ghostly edge, as of run-off turpentine. His more recent paintings abandon the target for arrangements of mathematical shapes inside one another. "Lebron," of 1961-62, a gray circle within a blue oblong, within a yellow oval within a white circle within the gray square of the canvas, suggests by its attractive forms and savory pastel shades an enlarged season pass to some expensive club. (Perhaps that's what it is.) In "Spread," of 1958, the outer circle of the target flies outward and—spreads, by blotting. This painting invited comparison with the more dynamic Expressionist poster in the New School for Social Research exhibition of German political art which used the same motif (see chapter 19).

Paint blotting or penumbral contours were characteristic of another exhibitor, the late Morris Louis, whose parallel stripes are vertical and diagonal rather than circular, as in Noland's targets, and whose "Green by Gold" was the only entry of his that approached a composition issuing from the experience of painting, as opposed to the execution of a design concept. Another convert to stripes with absorbed edges, Frank Stella, produces geometrical compositions resembling those of Anuszkiewicz and also resembling, unfortunately, a ceiling ventilator installed almost directly above his canvases. With Noland, Louis and Stella what is new in the new abstraction reduces itself to the consistency of the paint, since in

other respects their work adds nothing to that of abstractionists who have been with us for twenty-five years, such as Charmion Van Wiegand, Burgoyne Diller, George L. K. Morris and Richard Pousette-Dart, or newer "purists," like Ludwig Sander and Leon Polk Smith.

Ellsworth Kelly's entries were good old "hard-edge" painting, out of Albers, very competently achieving electrical retinal results with blues, greens and reds or with blue alone. In the bold dimensions of his forms Kelly is more interesting than Anuszkiewicz, who tends toward similar color effects. "Blue Tablet," 1962, cleverly produced an illusionist Newman by recessing half the canvas, thus creating a band of shadow that varied with the position of the spectator. George Ortman inlays his surfaces with arrows, crosses, circles, hearts, enclosed within diamond and square shapes, often backed by stripes. All have a more or less specifically totemic intention; while the holes in "Circle," of 1958, evoke a ball-rolling game at a fair, "New York City Totem," of 1962, is a diagram of sex that is more typical of his recent work. Ortman's blues, whites, purples, and yellows are strong, simple and pleasing, and his puzzles invite speculation.

Besides Raymond Parker, the only painter in the show whose paint handling contained emotional quality was Al Held. (Speaking of "belonging," Held, Parker, Ortman and Kelly were the best painters in the show and did not belong in it.) Held is a full-fledged Tenth Street Expressionist (his work has interesting affiliations with that of Nicholas Kruschenick), who paints huge, heavily loaded, knobby-surfaced canvases in which the size is not merely an overexposing showcase for an unimpressive image, as with Noland, but the means of conveying an expansive and enveloping—including self-enveloping—emotion. To compare Held's "The Big A" with Stella's "Pagosa Springs," a cutout of an "H" done in white and bronze parallel lines, like a radiator cover, is to clarify the difference between creative painting and what the Introduction called "a sense of discretion and removal."

In the last and most discreet artist, Paul Brach, the spirit of Reinhardt which reigned over this "new" abstraction exhi-

bition was brought fully into play. Brach paints squares, rectangles, circles that disappear into a background of the same hue. His three largest canvases were all square, but he lacks the extremism of character or the intellectual conviction to make them all exactly alike. Brach, also an ex-Abstract Expressionist— with the exception of Stella none of the artists at the Jewish Museum was very young—became in the past few years what the catalogue panegyrist called an artist of "invisibility," "voids," "subtraction." In sum, he had adopted the idea of the negative idea. But it was into a field of *blue* that his diagrams disappeared, not into the black extinction of Reinhardt. The incantation which the latter has pronounced against Abstract Expressionism has had the effect not of precipitating a holocaust of painting but of turning some painters back toward craft practice with the intention of wooing the vanguardist tastes of the emerging American art audience.

PART TWO
THE ART OBJECT

THE GAME OF ILLUSION
POP AND GAG

In earlier times the hero was "represented" by a statue of marble or granite. In Moscow today the tomb of Lenin contains the actual body of the leader as a statue. The tomb is the world's greatest collage; it incorporates a non-art object, the body, into a traditional esthetic structure. The effect is to convert the corpse into something which affects the imagination in the manner of a work of art but with the weight of actual fact.

The transformation of things by displacing them into art and of art by embedding it in a setting of actuality is the specifically twentieth-century form of illusionism. "The noises of waves, revolvers, typewriters, sirens, or airplanes," explained Erik Satie, a contemporary of the Cubists, in commenting on his ballet *Parade*, significantly subtitled *Ballet Réaliste*, "are in music of the same character as the bits of newspapers, painted wood grain, and other everyday objects that the Cubists frequently employ to localize objects and masses in Nature." In short, the man-made is introduced into the order of trees and waves. Another artist of the First World War era, Jean Arp, contended that his sculptures ought to be come upon as one comes upon a stone polished by a stream; that is to say, that his creations were on a par with those of geology.

No doubt this mixing of art and nature derives to a large extent from urbanization. The city dweller's "nature" is a human fabrication—he is surrounded by fields of concrete, forests of posts and wires, etc.; while nature itself, in the form of parks, a snowfall, cats and dogs, is a detail in the stone and steel of his habitat. Given the enormous dissemination of simulated nature through window displays, motion-picture and television screens, public and private photography, magazine advertisements, art reproductions, car and bus posters, five-and-ten art, it is plain that in no other period has the visible world been to such an extent both duplicated and anticipated by artifice. Surrounded by artistic copies of presidents, scenes, famous events, we become in the end largely insensitive to the distinction between the natural and the made up. The ghostliness of an environment loaded with doubles thus aug-

ments the fascination which the game of substituting the image of the thing for the thing itself and vice versa has held for painting since artists, somewhere around the middle of the nineteenth century, lost their patience with mere picturing. The most pervasive term in modern art is "New Realities." It has been used as the title of vanguard art magazines, of art movements (both abstract and ultra-representational), and of group exhibitions. Painters and sculptors in every mode, from Albers to Shahn, have applied to themselves the name "Realist" (being "New" usually goes without saying). Since it signifies something different for everyone who uses it, the label is meaningless. Its popularity does testify, however, to the belief, all but universal among twentieth-century artists, that a work of art ought to be a thing added to the world of things rather than a reflection of things that already exist. In short, while the work of art today is not illusory in the sense of being a representation, it is of a nature to give rise to new forms of mystification through drawing the spectator into an invented realm not unlike that of his everyday life.

Imagine that a cut of pie manufactured by Ma So-and-So, Inc., which looks and tastes like plaster, is reproduced in plaster and set in a display case, and that next to it is a poster on which the pie is painted with such luscious realism of color and tone that you can taste the blueberries. To extend this game of the real pie that is ersatz and a painted pie that is full of the flavors of memory, an artist creates out of plastic or fabric a segment of pie that looks like fabric, not pie, that is utterly non-suggestive of flavor, and that is six feet long. It is neither a real pie that lacks pie qualities nor a fake pie that seems real. This "sculpture" is an illusory object like the poster, but since it creates no illusion, it is logically, just what it is, that is, a reality. Yet a piece of plastic or fabric pie is not real, either. It is the bastard child of illusion, and its only excuse for existence is to enter into the processes of the esthetic imagination as they have developed during the past century, so one would not be inconsistent in considering this inedible nonlikeness of pie pure art. The only hindrance is that the pie does not look like art; it is purposely not like

art any more than it is like pie. But its looks are beside the point. It exists as a demonstration model in an unspoken lecture on the history of illusionism as it occurs in both painting and the streets of big cities. Since the purpose of the pie is to dispel illusion, it might more properly be called a criticism object than an art object. To emphasize his point, in case anyone missed it, the artist (critic) suspends from the ceiling of his gallery a pair of denim pants about size 64 (presumably one who eats six-foot pies will need the largest pants he can get).

This is art comically talking about contemporary art in terms of things—a kind of farce ballet, with credits due to *Ballet Mécanique* and *The Gold Rush*. The performance should be appreciated by anyone who has reflected on the Pygmalion fable or experienced the shock of running into Mr. Schweppes, parted whiskers and all, not in an advertisement but face to face on Fifth Avenue. In a civilization in which public events and personages exist for us primarily through the communications media, in which events often are made to occur exclusively for those media, discourse on illusionism is entirely relevant.

The pie and the pants I have described are, with perhaps some difference of detail, the creations of Claes Oldenburg, who at the outset was the most skillful gamester of illusion of the New Realism, as this type of art is named by the Europeans, with paranoiac persistence, or Pop Art, as it is called in the United States and in England. Yesterday's generation of illusionists was headed by Robert Rauschenberg and Jasper Johns.

On Halloween in 1962, Sidney Janis, whose gallery represented de Kooning, Rothko, Guston, and other top Abstract Expressionists, opened a two-locations exhibition of "factual" (i.e., illusionistic) painting and sculpture. Under these auspices, and after fifteen years of the austerity of abstract art, the new New Realism hit the New York art world with the force of an earthquake. Within a week, tremors had spread to art centers throughout the country.

A good part of the impact was attributable to the fact

that illusionistic art is easy to talk about, in contrast to abstrac-
tion, whose rhetoric had been reused until it was all but ex-
hausted. This was a powerful advantage for the new work, since
much of contemporary painting and sculpture is art only
through having sidled, leaped, or been smuggled into the uni-
verse of art words.

Coupled with the sudden availability of language was the
sense that art history was being made, in that it was from the
leading emporium of American abstract art that these appetite-
wrecking collations and misplaced home furnishings, advertise-
ments, and comic strips were peeking. Exhibitions with much
the same content had been given one or two years earlier by
the galleries of individual Pops and the style had been covered
by the Museum of Modern Art in its massive "Assemblage"
exhibition. The visual puns of Rauschenberg and Johns, Larry
Rivers' adaptations of playing cards and cigarette packages,
and, long before these, the refined associationism of Joseph
Cornell's "boxes" had connected American illusionist van-
guardism with the "ready-mades" of Duchamp, Schwitters,
Man Ray, and other artists of the First World War period.
But with the Janis Gallery converted to the Pops, art politics
sensed the buildup of a crisis. Was this the long-heralded
dethronement of Abstract Expressionism? Conversation turned
to speculation about treachery, secret motives, counter-
strategies. What was generally disregarded was that this gallery
had prospered by following the decisions of art history without
handicapping itself by preferences of taste or ideology. With
the New Realism, the Sidney Janis Gallery ventured for the
first time to create a bit of belated art history on its own
account—an undertaking not unusual in the present art
situation.

The New Realists exhibition proves on analysis to be
itself an "assemblage" uniting half a dozen tendencies of the
art of the past fifty years. Most of the European exhibits,
amounting to more than half the total, and a few of the
American had no connection with the theme set for the show
by the new United States anti-appeal art packages. Some, like
Enrico Baj's "Style Furniture," Mario Schifano's "Propaganda,"

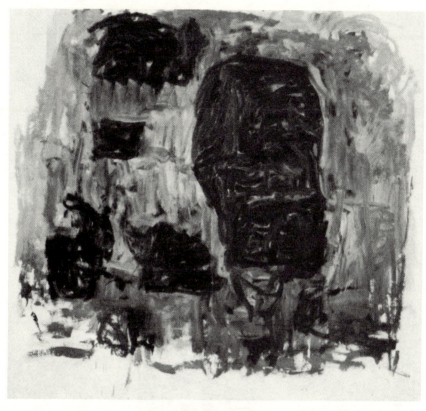

Philip Guston, *Painter IV*. 1963, oil on canvas, 69 x 78. Marlborough-Gerson Gallery

"*. . . it continues to sustain its dilemmas . . .*" (page 46)

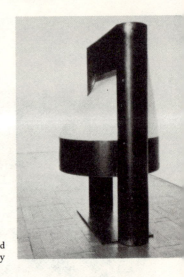

Edward Higgins, untitled. 1963, steel and
epoxy, 42 x 30 x 24. Leo Castelli Gallery

". . . hallucinatory overtones . .
(page ?

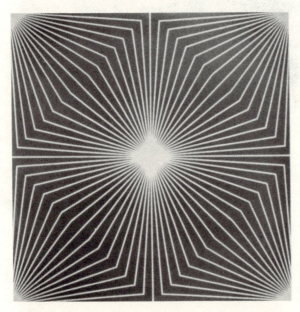

Richard Anuszkiewics, *Inner*
Outer Worlds. 1963, liquitex on
sonite, 48 x 48. Coll. Donnelly
man. Contemporaries Gallery

". . . the proper tiled laboratory mood . . ." (page 51)

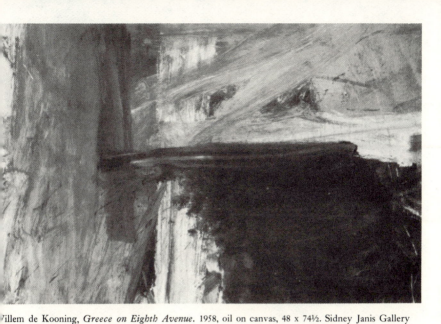

Willem de Kooning, *Greece on Eighth Avenue*. 1958, oil on canvas, 48 x 74½. Sidney Janis Gallery

". . . *invested . . . with too much freedom, too much angst.*" (page 49)

Ad Reinhardt, *Abstract Painting*.
1960-1, oil on canvas, 60 x 66. Coll.
Museum of Modern Art

". . . *black, square trapdoor . . . a block-shaped cross
marking the tomb of modern art.*" (page 53)

Roy Lichtenstein, *Ice Cream Soda.* 1962, oil on
canvas, 64 x 32. Coll. Myron Orlofsky. Leo
Castelli Gallery

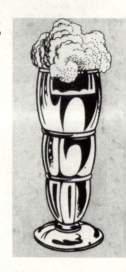

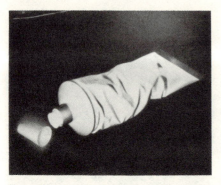

Claes Oldenburg, *Tube.* 1964, wood, lacquer,
metal, rubber, vinyl, kapok, cloth, 66 x 25½ x 17

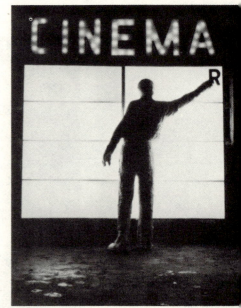

George Segal, *Cinema.* 1963, 8' x 8'. Art News

". . . *advertising art advertising itself as art that hates advertising.*" (page 74

Jackson Pollock, *Cutout*, 1949, oil on canvas, 24 x 31. Coll. Martha Jackson

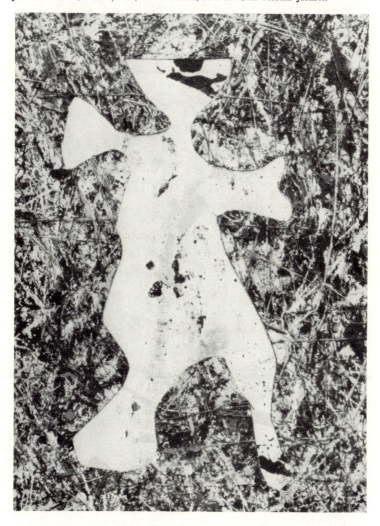

"... the empty canvas as a metaphor for the landscape" (page 83)

Larry Rivers, *Dutch Masters*, 1963, oil on canvas. Tibor de Nagy Gallery

"... *a fusion of the reality and the popular image of it.*" (page 85)

Marcel Duchamp, *Disturbed Balance.* 1918, glass. Coll. K. S. Dreier

"Impermanence of the art object . . . the artist's weapon against art" (page 95)

Robert Rauschenberg, *Coexistence.* 1961, combine on canvas, 60 x 42. Leo Castelli Gallery

". . . chance effects, 'mistakes,' 'accidents' . . . enter into a planned disposition" (page 179)

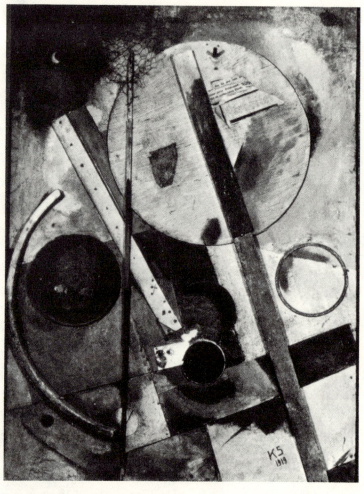

Kurt Schwitters, *Das Arbeiterbild*. 1919, collage, montage, mixed technique, 49 x 36

"... *art subject to time on equal terms with nature* ..." (page 92)

and Tano Festa's "New Shutter" (these artists are all Italian), merely employed everyday images and surfaces to create works of art in the conventions of Cubism, Expressionism and Neo-Plasticism. Yves Klein's sponge sculpture and reliefs, Peter Agostini's plaster clothesline and Robert Moskowitz's "Un-titled," a handsome gray-on-gray using as its upper half a glued-down window shade with wrinkles, were in the same category of work in accepted art forms created out of odd stuff. In contrast to these things-as-art, other works in the exhibition did not belong because they were simple *things*, without overtones of dream or the power of self-comment. These included accumulations of swords and faucets by Arman and Jean Tinguely's skeletal radio receiver, both from France. One of Tinguely's two "Works in Progress," a refrigerator that razzed the spectator who opened it, did belong; so, too, did the ominous cord-and-wrapping-paper bundles of another Frenchman, Christo.

In the past, the Europeans have had a much more sophisticated visual vocabulary of illusion than the Americans, while we have plunged into the dream-fact and, as they say, made it work—from millions of chock-full-o'-nuts sandwiches to a lighted waterfall on top of a Broadway building.

Among the Americans in the show, the most imaginative and critically conscious were Oldenburg, Jim Dine, and George Segal. All three use paint and modelling materials to cause the idea of art to abut upon commonplace objects without lending glamour to them. Oldenburg's plastic-steeped ladies' underwear brought to Fifty-seventh Street shoppers an atmosphere not very different from that induced by windows on Fourteenth Street. The essential distinction between the gallery objects and the store objects considered as objects was the art reference of the Oldenburgs, provided by the identification of their maker as an artist and the place of exhibition as an art gallery. This amounted to getting rid of art qualities on a scale that goes far beyond the famous "White on White."

Dine incorporated a lawnmower into art by leaning it against a canvas marked with some Impressionist strokes of green paint, which had also splashed down on the mower.

Similarly, carpenters' tools, soap dishes, and a lead pipe become art by hanging or jutting from painted surfaces. The implication was: art is paint and canvas and anything connected (literally) with it—a formula that satirizes the abstract painting of the past ten years.

Segal's plaster family sat around a wooden dining-room table, one member holding in his plaster hand a beat-up aluminum coffeepot. The imprecisely realistic creatures seemed to suffer physically from the fatiguing weight of actual wood and metal, and in this group and in his strangely anguished "Bus Driver," flanked by a genuine coin receptacle, the game of illusion reached a pitch of pathos that belongs equally to sculpture and the theatre. Segal was the only exhibitor who used the new illusory combinations to create a new feeling rather than as a commentary on art.

In the two years following the Janis show, Oldenburg and Dine had run out of ideas and Segal had ceased to be touching. The art of these men depends on surprise, and no effect is more difficult to obtain in a situation swamped by promoters.

Other Pop artists varied from tiresome decorator's apprentices matching gags to genuine artists in search of a new way. Old-fashioned street and shop signs and the patterns stenciled on packing cases aroused in Robert Indiana a nostalgia for Americana. Tom Wesselmann reiterated the common point about art and fake by inserting a reproduction of a "fine-art" portrait behind a cutout of the smiling lady who offers standard brands, hamburgers and hot dogs. Like James Rosenquist's paintings composed like collages, this was advertising art advertising itself as art that hates advertising. Wayne Thiebaud, a serious painter, depicted rows of sandwiches, salads and ice-cream sundaes in perspective instead of the more customary rows of trees and shrubs. Art lovers who discussed Thiebaud in terms of "painterly" qualities seem to me to have missed his point, which was to be painterly but with "no artificial color added." Something similar but with motives that aroused suspicion was true of Roy Lichtenstein, an Abstract Expressionist suddenly retooled to blow up comic strips. Andy Warhol offered columns of Campbell's Soup labels in narcotic

reiteration, like a joke without humor told over and over again, until it carried a hint of menace (later, he reiterated electric chairs).

The new American illusionist contrivances have a deeper identification with commercial art than the plagiarism or adaptation of its images. They share the impersonality of advertising-agency art-department productions. They are entirely cerebral and mechanical; the hand of the artist has no part in the evolution of the work but is the mere executor of the idea-man's command, though in this case the artist himself is usually the idea-man (sometimes the idea for a work comes from friends or sponsors). Nor is the self of the artist engaged by the process of creation. As a phase in the history of modern illusionism, the American contributions to this exhibition, with the exception of Segal's, represented a hyper-objectivism that kept the game of fictions in the air without a landing spot in reality. If, as some have maintained, there is terror in this art, it comes from its irremediable deadpan—a grin in porcelain.

The attempt to purge Abstract Expressionism by polemics against it in the art pages of the press produced nothing more than ideological nagging. The purging of art by works of art based on a different premise is, however, always vitalizing. Those artists, dealers, and curators who functioned on the assumption that the look of Action Painting was sufficient to authenticate a canvas were put on notice by the new illusionist objects that any image, including Coca-Cola lettering or the numbers on a pinball machine, could be equally viable. In sum, there is no greater esthetic virtue in copying a de Kooning than in copying the design on a beer can. If you do either, you are talking to the audience about itself, not engaging in creation. In dramatizing this principle, Pop Art has been a contribution to art criticism.

STYLE AND THE AMERICAN SCENE

By some as yet undefined principle of economy of attention, the rise of postwar American abstract art brought a demotion of the American scene in painting. Suddenly, person, place, object, event disappeared into the tinted oblong, the vertical stripe, the dull black rectangle. A joke went the rounds to the effect that Newman had closed the door, Rothko had pulled down the shades, and Reinhardt had turned out the lights.

American-scene painting lost the limelight, but it was by no means snuffed out. Stuart Davis, Ben Shahn, Edward Hopper, Jack Levine, Philip Evergood, the Soyers remained as strong in their varied neighborhoods of taste as Pollock and de Kooning in theirs. Recently, with abstract art subjected to increasing pressure, American representational painting of earlier periods has been moving up along a broad front. In January 1963, I.B.M. staged a historical survey exhibition of its permanent collection, augmented by borrowings, under the aggressive title of "Realism: An American Heritage." The day this exhibit closed, a show of one hundred and twelve drawings, plus four paintings related to them, done between 1844 and 1847 by George Caleb Bingham, the Missouri painter of flatboatmen, fur traders, and county politicians, opened at Knoedler under the auspices of Harry Truman, the Governor of Missouri, and Thomas Hart Benton. Close behind came a retrospective at the Graham Gallery of Thomas Anshutz, a pupil of Eakins and the teacher, at the Pennsylvania Academy of Fine Arts, of leading early-twentieth-century repertorial painters.

Paintings of the American scene have a natural appeal to the public and its political leaders, much of which is owing, no doubt, to sentiments aroused by their subjects, from Indians below a waterfall or Pilgrims in the snow to boys playing handball in a slum schoolyard. Such responses are, we are told, irrelevant to paintings as works of art; the only legitimate esthetic experience is the one induced by painting elements —color, spatial relations, significant form—and the manner in which these are handled. Yet in the case of paintings of the

American scene, the relation of the work to the scene itself is crucial. If realism were indeed an "American heritage," this relation would have found expression in a national style. I.B.M.'s identification of American art with realism was, however, a mere discharge of patriotic gunpowder directed against abstract art, presumably on the ground that it is un- (or not-quite) American. The fact is American painting is not realistic, nor is realism, either esthetic or philosophical, a characteristic of American thought. The I.B.M. show comprised American imitations of our participations in European modes, from eighteenth-century British portraiture to present-day French Surrealism and German Expressionism. It demonstrated anew what is made clear by the American Wing in any museum: that the outstanding feature of American "realistic" art is that it is so unmistakably artistic—and so unmistakably unreal, or, as the historians call it, "romantic." It is the assurance of its being *art* that endears representational painting to the public and to conservative critics as much as any feeling for its subjects. That, in the course of turning into art, the American scene has been translated into French, German, or British scenery is of secondary importance in this definition of realism. Here, artists and audience of "realistic" art are in league against reality.

The obstacle to realism in American painting is that there have been too many kinds, each arising from an individually acquired way of seeing. Reality, or the sense of it, depends on a unified style shared by artists and the community; a continuing tradition makes *any* style realistic, for it effects a single way of feeling and looking that gives human shape to the environment. In this respect, painters in Colonial Boston and Philadelphia were closer to the conditions underlying the realism of Goya or of Rembrandt—or of ancient Egypt, for that matter—than later American artists, and this no doubt accounts for the forceful presences in portraits by Feke, Earl, and Copley. To be convinced that an object or a scene is real, one needs to be convinced that it will hold its form no matter how many pairs of eyes impinge upon it or under how many different moods it is encountered. Wallace Steven's poem

"Thirteen Ways of Looking at a Blackbird" is a way of declaring that no blackbird exists and that instead there are only varieties of imaginary perspective that may bring backbirds into being. In American painting the degree of realism in any work is a matter for individual judgment; one man's reality is is another man's fantasy and a third man's corn. Bingham, Missouri's leading realist of the last century, is likely to seem sentimental and folksy to admirers of Benton, its outstanding realist of this one, while Benton may be oversophisticated and "foreign" to admirers of Bingham. The reality of both fails because neither has anything in common esthetically with the other; they derived their styles from sources centuries apart and rooted in different cultures. This lack of association between artists of the same region is often reproduced in different phases of a single artist's career and tends to put him out of touch with his own reality.

In the absence of an accepted style, to say that an artist is "realistic" means only that one trusts the clarity of his mind and his glance and the probity of his character. The less his *art* shows the better. The public accepts superior realism of the snapshot (not the arty photograph) over the representational painting not because the photograph is more accurate —any portrait painter can explain wherein the photograph falls short—but because all photographs have major characteristics in common and this makes each seem more faithful to the appearance of things in general.

One stream in American painting derives from the attempt to solve the problem of style through an undeviating grasp of "the fact." Wrote Anshutz after becoming a student at the National Academy in New York: "What I mean by truth in a painting is as follows: Get up an outfit for outdoor work, go out into some woebegotten, turkey chawed, bottle nosed, henpecked country and set myself down, get out my materials and make as accurate a painting of what I see in front of me as I can. If I draw it well and color it as I see it and if I see it well (which is the hardest part) my picture is true . . . so my style now is painting and drawing what I see." It is interesting that Anshutz, an academician all his life, adopts a

folkloristic lingo to state his credo and maintains an attitude toward style hardly different from the attitude of folk artists like Hicks and Pickett, self-taught artists like Harding and Bingham, or artists with purposes beyond art, like Audubon and Catlin, men who rank high in American art because they can be believed. As Anshutz expressed it twenty years later, "Any style is correct . . . art whether inborn or acquired is based on knowledge and knowledge on facts."

The notion that any style will serve reveals a typical misunderstanding among painters of the American scene as to both art and reality. Though he realized that "seeing well" was "the hardest part," Anshutz underestimated the power of style in transforming what the artist sees as well as what he paints. Even Bingham, as native a craftsman as America has produced, and whose early skill was gained almost entirely through hard scrutiny, absorbed the current German Romantic manner, and his visual veracity succumbed to it after his studies at Düsseldorf. In any case, American reality tends to disappear somewhere en route between the scene and the salon. Because they are more likely to escape the intervention of style, on-the-spot drawings and sketches, as in some of the lithograph series that were popular in the nineteenth century, have been frequently more authentic representations of the American scene than full-dress oil paintings. The longer the objectivist painter worked on his picture the more his esthetic ideal "bled" through the retinal fact; in his way of finishing the picture he at once revealed his ideal and yielded to it. Anshutz's water colors and some of his small oil studies suggest what he might have been able to preserve of his visual perceptions had he been guided by another discipline—for example, Impressionism—rather than by the realism of the Pennsylvania Academy.

If the American landscape would not yield an American realist style through concentration on the facts, it did prove capable of supplying settings in the style of any paintings the artist might admire, as it has supplied tourists with their choice in Alps, fiords, and Saharas. Speaking of a group of American artists who settled in East Hampton, Long Island, in the eighteen-seventies—Saint-Gaudens, J. Alden Weir, E. A.

Abbey, William M. Chase—Van Wyck Brooks noted that they had chosen this spot for its English lanes, Dutch wind-mills, and meadows of Brittany, and he concluded that "they could see America only when they saw it as European." It had, in short, been impossible to disentangle New World fact from European form. From wilderness to tourist paradise, the American scene has presented this character of an artistic façade or backdrop. In the sixteenth century, Jacques Le Moyne, called the first painter in America, sketched the Indians of the Florida coast as if they were French ladies and gentlemen who had left their clothes in the woods. In the Social Realist nineteen-thirties, girls on Union Square were painted as ballet dancers of Degas in costumes by Klein's, and in the latest revival of figure painting a youth on a porch in California has stepped through a window of Bonnard. Each of Brooks' artists was searching the American scene for his own conception of art, not unlike the man with the camera who snaps the shutter when he finds what "looks like a picture." Aiming at a museum piece, he used a segment of the American countryside as a model for producing a European painting. The real scene was employed in the same way as one of those sets some "realistic" artists—Benton, Ivan Albright—build to work from on their canvases.

With its rivers and gorges arousing the greatest enthusiasm when they seem to have been shifted in from somewhere else, America has been a lumber room of esthetic props for naturalists, romantics, wonder seekers, folk philosophers from every portion of the globe. Fragments of the Continent have been assembled to produce an international congress of land-scapes, corresponding to the nostalgia of its mingled folk for places seen and unseen. The American scene is simply the sum of all these dreams.

The United States is the first culture in which the problem of imposing style upon the environment has been confronted by strangers on the move. The vast bulk of paintings of the American scene has been done by explorers, travellers from

abroad, members of scientific and military expeditions, and immigrants, as well as by itinerant limners and sign painters, journeyman portraitists and teachers. The mobility of the American artist—and of his audience—radically differentiates his "realism" from that of the European or the Oriental. For the artist of other cultures the region where he works is a source not only of motives but of stylistic influence—Poussin in Rome, Miró in Paris. The subjects of his work are familiar to his public, which can weigh the feel of the personage or site in the picture against its own sense of how things are, as well as how they look. In contrast, the American artist carries a style in his head as a technique or manner of painting which he applies to anything that holds out esthetic promise or is a "good subject" to interest an audience. For him the relation of form to object is as fortuitous as the relation of a tractor to a site marked off for an excavation; "any style is correct" as long as it tells the tale. Painting America is like painting the moon; the artist is separated from the prospect by an inner distance of strangeness, and this estrangement causes the imaginary to interpose itself no matter how determined he may be to "stick to the facts." Since all places are equally out of reach, the travelling American realist continues his travels until, as with Church and La Farge, the American scene covers the entire globe.

For people on the move, a terrain is either a reminiscent setting (actual or pictured) or mere ground to cover. It may also be a place for the individual to locate himself; this entails overcoming his separation from his surroundings whether this be an effect of misplaced recognition (East Hampton as Holland) or of the deadness of unlived-in space (hundreds of miles of prairies). The problem of self-location is the link between contemporary American abstract art and American-scene painting of the past. We have seen that the American reality remained out of reach in the absence of an indigenous style. To achieve such a style American art had to disengage itself from the objective fact on the one hand and from the European

art image on the other. Both these conditions have been met by American painting of the past twenty years.

Some of the new abstract art is unrelated to the American environment except in the qualities of light or color, in deliberate ruggedness or lack of finish, in extremism of feeling and statement. In most of the abstract art, however, and particularly in its Action Painting aspect, the scene has not been extinguished, though details have been obliterated or remain only as subjective clues. Jackson Pollock took the empty canvas as a metaphor for the landscape which he could appropriate to art by his untrammelled presence as an artist. Before he dived into this expanse with his drip paintings, he had practiced melting into East Hampton cornfields and kitchen gardens with such canvases as "Eyes in the Heat" and "Constellation," in which those so inclined may identify flora and fowl. Among Pollock's later paint-tracking extravaganzas, "Blue Poles" evokes the ubiquitous American weed patch bordered by a rusted-out barbed-wire fence. Pollock's procedure is not a translation of nature into abstraction, as is supposed by those who cannot rid themselves of the "objective" fixation; it is, rather, the artist bringing to the canvas an inner landscape that is part of himself and that is awakened in the activity of painting. Since style determines visual reality, he has been able to reach the scene through favoring the canvas over the cornfield.

Pollock painted as if he had penetrated the landscape and were working inside it; then he laid the canvas on the floor and walked into it, so that it became literally his landscape. With Willem de Kooning, Hans Hofmann, Franz Kline, Philip Guston, Esteban Vicente, Elaine de Kooning, Grace Hartigan, Jack Tworkov and Joan Mitchell, landscapes existing within the artist's mind and sensibility (including embedded plants, buildings, creatures) have been, so to speak, disinterred by the act of painting, which continues independently of the scene. These painters do not study a particular view, but they have done much looking as artists and are conscious of the landscape as coming and going in the process of painting (place names are often used as titles of their works). What they have

in common is that the separation between the artist and his visual environment has been overcome not by cancelling the setting (as is mistakenly supposed by those who lump together the different kinds of abstract art) but by frankly giving precedence to art over subject matter.

The new relationship is summed up in a recent drawing by Steinberg: an artist paints himself into the countryside by extending the line of the horizon into a spiral that closes in on him. Since for this artist, nature was his own creation to begin with, he has wound himself into a fiction and Steinberg's little man is up in the air. On the other hand, the visible world *is*, culturally and psychologically, a creation of art, and being an artist means that one is privileged to change it and thus genuinely to appropriate it. The Beat expression "making the scene" describes exactly the present-day artist's effort to locate himself in a landscape he has participated in creating.

Painting seventy-five years later in the same countryside as Van Wyck Brooks' "Europeans," Pollock and de Kooning, like their predecessors, absorb the scene into their previously acquired painting processes and into their values based on attitudes toward art. The difference is that though the new-comers are fully conscious of the Dutch or British look of the East Hampton flatlands, they have no use for it as a means of achieving Americanized versions of foreign genre pictures. For the contemporaries, as for those who came before, art precedes appearance. But having gone beyond imitating European art, they seek no stylized subjects in the American scene. Our countryside returns to its pristine state and awaits discovery by an art directly responsive to it. Long Island or Woodstock underbrush enters an abstraction by Pollock or Guston in a state too primitive for definition except as substance in general. Similarly, the relation between the gardens and sunlit walls of Provincetown and the paintings of Hans Hofmann must be established entirely by tactile imagination; the last thing one may expect to find is resemblance to details. Here again nature begins in the artist. Hofmann has originated "matter" that neither he nor anyone else had ever seen before. Saturated with nature the plateaus and hills of paint in his

canvases change like the scenes outside the window, parts
brightening as others grow sombre.

The irony is that as the American scene faded out of it
in the postwar years, American painting came for the first
time to be recognized throughout the world as distinctively
American. Since that beginning the scene has been returning
to painting in more explicit forms. Now, however, instead
of being seen in the mirror of European art, it appears to
younger American "realists" in the mirror of Abstract Expres-
sionism or Action Painting. That for the first time a stylistic
continuity has come into being in American art is of the first
cultural importance and far transcends the issue of abstract
versus representational.

Some of the new painters of the American scene move
back and forth between expressive subjectivity and recog-
nizable motifs—for instance, Elaine de Kooning sees no incon-
sistency in doing abstractions, near-landscapes, portraits and
sports pictures. In 1953, Larry Rivers painted his "George
Washington Crossing the Delaware," a large canvas spotted
like a photographer's window with shots of the Father of his
Country. The painting, which mingled French and Tenth
Street influences, recalled, of course, the celebrated "Cross-
ing" by the visiting German of a century ago, Emanuel
Leutze, which by this time underlies the American scene like
an image at the bottom of a pool. Rivers subsequently devel-
oped several series of paintings based on American surfaces,
from news photographs of Civil War veterans to Buicks,
restaurant menus, and cigarette packages. Rivers paints por-
traits of paintings; for him the head of Daniel Webster on a
cigar-box label is equivalent to the head of the statesman on
his own shoulders. The result is a fusion of the reality and
the popular image of it.

Since Rivers' "Washington," conceptually though not
stylistically related to Stuart Davis's earlier utilization of road
signs and lettering, a broadening flow of paintings derived
from art-in-the-scene has coalesced into the newest movement

in American art. The suggestion in Rivers was picked up in Jasper Johns' targets and American flags and carried into a variety of forms by a school of insignia painters.

The proposition that man-made images *are* the American reality underlies the naturalism of the painters of comic-strip blowups, store-window items, and billboard parodies, who often incorporate the objects themselves into their works (see chapter 5). Like the nineteenth-century genre painters, the new art of daily life accepts the prevailing esthetic forms as the forms of fact. Reacting against the radical effort of Action Painting to break through the scene to the subjective reality, the art of the façade declares any other American reality to be either nonexistent or inaccessible. In any case, the issue has been stated for the critical consciousness that art in America still stands as a barrier (Pop Art reminds us that a billboard is art) between the spectator and reality; between the husband and the wife is the photographer's model in the model kitchen, between the citizen and his neighbors is the Our Town of the colored poster. To overcome this interposition, continuing esthetic awareness is necessary; this has begun to be present by means of the continuity of postwar American art. If Realism is an American heritage, it is a heritage of the future—one, incidentally, that will not be easy to collect.

Saul Steinberg

THE ART OBJECT
AND THE ESTHETICS
OF IMPERMANENCE

In defining a poem in terms of its psychological effect on the reader Poe introduced time into criticism. "All excitements," he argued in "The Poetic Principle," "are, through a psychal necessity, transient" and half an hour "at the very utmost" is the limit of "that degree of excitement which would entitle a poem to be so called at all." There are, of course, poems that take longer to read. But though it is physically present on the page, for Poe "a long poem does not exist."

A comparable time limit on paintings was proposed recently by Marcel Duchamp, except that instead of considering the audience's capacity for "excitement" Duchamp reflected on how long the stimulating power of the work itself can last. Discussing "the short life of a work of art," he declared that a painting possesses an esthetic "smell or emanation" which persists for twenty to thirty years, after which it dissolves and the work dies. As illustration, Duchamp mentioned his own celebrated "Nude Descending a Staircase"; despite all the fuss about it, he said, the "Nude" is dead, "completely dead."

As against the common-sense notion of the poem or painting as an object to which the beholder reacts, Poe and Duchamp pose the idea of the work as a temporary center of energy which gives rise to psychic events. To attribute independent power to things is a species of fetishism; but the fetishes of these artists are of a modern variety because their potency is measured by the clock. In the introspection of Poe and the history consciousness of Duchamp, an interval of portentous time replaces the transcendental "thing" of the older esthetics and the older magic. The work of art is like an irradiated substance; when its charge dies down it begins to *last*.

The concept of painting as involved in time is of fairly recent origin. The French Catholic philosopher, Etienne Gilson, analyzing the nature of painting in his *Painting and Reality*, refers to "the *received* [i.e., accepted] distinction between arts of time (poetry, music) and arts of space (sculpture, painting and, generally speaking, the 'arts of design')."

Gilson endeavors to uphold this distinction by arguing that though the esthetic experience of a painting continues for so many minutes then ceases, the painting itself has a physical existence in space and that it is this spatial existence that determines the nature of painting as an art. The spatial concept has, however, Gilson admits, been meeting resistance among modern estheticians and artists, probably from artists most of all. Gilson finds himself in direct conflict with Paul Klee's assertion in his "Creative Credo" that Lessing's famous separation in the *Laokoön*, between arts of space and arts of time is out of date in twentieth-century space-time thinking. It takes time, Klee explained, for a dot to turn into a line, for a line to form a surface, and so forth; in sum, for the picture as a whole to come into being out its parts. It takes time also for the spectator to appreciate it—"leisure-time," said Klee, plus, he added (quoting the nineteenth-century phenomenologist, Feuerbach), a chair to keep the fatigue of the legs from distracting the mind. All this phenomenology of action and response is applicable, Gilson concedes, but only to "the genesis of the work of art and of its apprehension by a beholder." A painting is of time when it is considered as an encounter between the artist and his audience. It belongs to space when it is conceived as a thing, that is to say, as Gilson puts it, "from the point of view of the work of art itself."

The notion of the art object as worthy of being considered from its own point of view apart from the artist's act of creation and the excitement of the spectator is of capital importance in regard to twentieth-century art. A painting is set aside as a thing independent of the human circumstances surrounding it not merely for the sake of philosophical completeness but for ideological purposes. This is made amply clear by Gilson in *Painting and Reality*. Art which is, in his words, "in keeping with the physical mode of existence that belongs to painting," that is, with the mode of spatiality, will conform to and uphold values of stability and permanence; which means that it will oppose the evanescent-energy concepts of Poe, Duchamp, Klee and other contemporaries. From

the essential "thingness" of painting Gilson derives an esthetics of quiescence, contemplation, pattern, as against the "action" tradition of such paintings as Gericault's "Epsom Derby" or Jacques-Louis David's "Bonaparte Crossing the St. Bernard." Paintings like the David and the Poussin "Rape of the Sabine Women" are to be restudied in such a way as to transform their "motion in time" into "visual pattern in space." Gilson carries his concept to the literal conclusion that the still life is the supreme subject of painting since "in a still life nothing acts, nothing gesticulates, nothing does anything else than to be"—a formula of negatives curiously homologous with the anti-Expressionist pronouncements of Ad Reinhardt. In sum, the concept of the art object becomes the basis for imposing on paintings a mental "set" or gridiron of values—in this instance, the values of a religious quietism over and apart from the actual experience of both painters and spectators.

Gilson's metaphysics of the art object provides (in reverse) a clue as to why so many modern paintings and sculptures are deliberately produced out of materials that change or fall apart. The short-lived work of art, as dramatized, for example, by the self-annihilating "sculpture" exhibited by Tinguely a few years ago in the garden of the Museum of Modern Art, displays art as an *event*. To underscore the phenomenon of creation and its effects on the beholder as the exclusive content of a painting, some twentieth-century artists have been willing to condemn the work itself to extinction. Duchamp, though he doubts that esthetic shock is any longer possible, seems himself shocked by the degree to which contemporary artists connive at the self-destruction of their products. "It's the most revolutionary attitude possible," he has asserted, "because they know they're killing themselves. It is a form of suicide, as artists go; they kill themselves by using perishable materials." Apparently, Duchamp can endure the thought that his "Nude" is dead but is awed that a work shall vanish and take its creator with it.

The painting with a "short life" is an antidote to the painting as an object that obstructs the psychic transaction between the artist and the spectator. One who today reacts

with excitement to Duchamp's "Nude" is, in the opinion of her creator, stimulated by "the thing he has learned" rather than by the painting itself. From the artist's point of view, better a dead work than one enveloped forever in abstractions. In the end, Duchamp acknowledges that his notion of the fading aroma or "soul" of a painting may be a fantasy. But it has vital, practical function: "it helps me make a distinction between esthetics and art history."

The esthetics of impermanence stresses the work of art as an interval in the life of both artist and spectator. Compositions into which found objects are glued or affixed or from which they protrude or are suspended make art subject to time on equal terms with nature and commodities for daily use. A German critic's description of a work by Kurt Schwitters shows the direct connection between the embodying of time in a contemporary work and bringing the spectator into contact with the artist: "The MERZbau is a three-dimensional assemblage to which new elements were *merzed on* for sixteen consecutive years until, eventually, it grew upwards through two stories and downward into a cellar in Schwitters' house in the Waldhausenstrasse in Hanover. The important thing is for the spectator to stand '*in*' a piece of sculpture." (His italics) The yellowing and crumbling newspapers in a collage of Picasso or Schwitters incorporate a rhythm of aging equivalent to the metamorphosis of characters in Proust's *Remembrance of Things Past*, composed in the same period. Art that deteriorates more or less visibly is the reply of the twentieth-century mind to the fixated estheticism of Dorian Gray.

Action painting, which has usually refrained from attacking the physical integrity of the canvas (though there are notable examples of perishable Action Paintings by Pollock, de Kooning, Kline and others), has focussed on the inception of the work in opposition to, as Klee put it, the "end product." Its vocabulary tends to describe its creations in terms of their coming into being: expressions that conceive of a painting as beginning to "happen" or as "working itself out" are typical.

Some Action Painters apparently concluded that the picture ought to be begun and finished in Poe's "half an hour" as a guarantee of authentic excitement. In Action Painting the artist is the first spectator and the audience is invited to repeat with him the experience of seeing the work take shape. Mathieu, for example, actually made painting a picture into a public performance; and analogies have often been drawn between Action Painting and the paintings executed as a spectacle by Zen monks. From Action Paintings to "happenings," which carry painting and sculpture over into theatre, took only a single logical step—a final step, by the way, which in art one should always hesitate to take. In the "happening" the art object, Gilson's "physical existence," is abandoned altogether and composition turns literally into an event.

As an art form the "happening" is superfluous, as are such other coarser manifestations of transience as audience-participation collage and decollage (reassembling torn fragments of posters), art controlled by timers or by photoelectric cells, "making art by eating" (done both in New York and Paris; art-eating has the advantage of combining the art exhibition and the artists' party, the two chief tourist attractions of the art world). Today all works of art have become happenings. A Giotto and a Kaprow are events of differing duration in the psyche of individuals and in the history of art. Ontologically, a painting may be an immobile object to be contemplated; in this respect, however, there is nothing to differentiate it from any other object, and, as we have seen, it can be made to move and act by "ontologists" of a different persuasion. More relevant to the philosophical definition of art than its inherent spatiality is its function in a given human environment. In terms of what it does, the chief attribute of a work of art in our century is not stillness but circulation. Whether through being moved before multitudes in exhibitions and reproductions or through being made available to multitudes in *their* movements, as in the great museums, it is circulation that determines the nature and significance of paintings in the contemporary world.

Circulating as an event in art history, the painting sheds

its materiality; it assumes a spectral other self that is omnipresent in art books, illustrated articles, exhibition catalogues, TV and films and the discourses of art critics and historians. Composed in the first instance of the painter's motions in time, the picture also exists temporally in the frequency-rate of its public appearance. To introduce it into and identify it as part of the cultural system, it must carry an art-historical tag that relates it to paintings of other times. Thus the painting becomes inseparable from language (one of Gilson's temporal media); in actual substance it is a centaurlike being—part words, part art supplies (see chapter 17).

It is inspiring to imagine with Professor Gilson a painting engaged in "the simplest and most primitive of all acts, namely, to be." To witness an enactment of isolated being, however, one would have to seek out a painting hidden from curators and reviewers. Perhaps a little more than other contemporary museums, the Guggenheim has dedicated itself to hooking up its exhibits historically. Its "Six Painters and the Object" show linked comic strip and billboard art to Seurat and Léger. Its "Cézanne and Structure in Modern Painting" exhibition rounded up such widely separated contemporaries as Jenkins and Marca-Relli, Ferren and Albers, as "heirs of Cézanne" with whom "structure is the guiding principle." Van Gogh has been similarly "explored" in relation to twentieth-century Expressionism, i.e., has been stuffed under a stylistic label with artists far removed from him in motive, intellectual character and conception of the object. It is probably futile to object that these tags interfere with the apprehension of the works shown; and no doubt there are theoretical grounds for connecting Cézanne with "structure" and even the rationale of structure. Yet one would like to see Cézanne associated for a change (and to help free the physical presence of a Cézanne from its ideological casing) with Expressionism and even (via de Kooning and Hans Hofmann) with Action Painting, and to see Van Gogh brought forward among painters of "structure," by way, for example, of his color theories.

After all, historical continuity depends on the facets chosen for emphasis, and nothing could be more misleading than the bifurcation of the history of modern art into Formalist and Expressionist limbs. It ought no longer be necessary to point out that every valid artist is both—that Kline is a Formalist, Newman an Expressionist, as well as the vice versa. Mr. Daniel Robbins, who prepared the catalogue for "Cézanne and Structure," strove heroically to enunciate this synthetic character of modern creation: of Albers' "Homage to the Square" series he wrote that the "primary effect is emotional and closely tied to nature," and, noting qualities in Albers' painting that he found "baffling," "moving," equivocal," he concluded that "in terms of the conventional sense of structural esthetic, it produces a sense of frustration." Then why include Albers in the theme of "Cézanne and Structure," unless a "conventional" and "frustrating" label is better than no label at all?

Once set in motion, a work survives apart from its physical body. Indeed, the art object tends more and more to dissolve into its reproductions and to fixed opinions regarding its meaning. Exhibited for limited periods, frequently to illustrate a concept, the original painting retires leaving the image in the catalogue or historical or biographical monogram by which it is "placed" and comprehended. Duchamp is probably mistaken: perishable materials will not prevent artists from achieving immortality in the future chronicles of art. Today, painters are renowned in places where not a single painting of theirs has ever been displayed; why should they not be equally famous in areas of time never reached by their actual products?

Impermanence of the art object arose as the artist's weapon against art as an intellectual prop for changeless ideas. Today, however, impermanence has become a stylistic device, eagerly appreciated in terms of esthetic precedents. Refuse, old newspapers, rugs—ephemera symbolizing the moment of vision when anything that lies at hand is sufficient for esthetic excitement —are embalmed in bronze or plastics to insure the works composed of them against the ravages of time. Art cannot trans-

form the conditions of its own existence. The struggle to preserve the direct encounter between the artist and the spectator will, however, no doubt continue by one means or another. To *épater le bourgeois* may prove far easier than to exorcise the art historian. Perhaps one should look forward to masterpieces on such themes as "The Abduction from the Studio" and "The Rape of de Kooning's Women."

PART THREE

ARTISTS

ARSHILE GORKY
ART AND IDENTITY

Arshile Gorky, the Armenian refugee who became a leading American abstract artist, worked for ten years on the double portrait "The Artist and His Mother" without being able to finish it. Unfinished paintings are not infrequent in contemporary art. Indeed, the question of whether a painting *can* be finished has aroused much discussion among vanguard artists. The consensus of a panel some years ago was that what finishes a painting is the artist's final decision to let it alone; in short, that finishing is a matter of mood or of metaphysics. The notion of completing a work according to objective standards belongs to an approach now largely obsolete in art—the approach, that is, of the craftsman who begins the work with the end product in mind and proceeds step by step to realize his "idea." Such rationalized procedures survive in commercial art and among some geometrical abstractionists, but for the typical painter of the twentieth century "the work of art," as Paul Klee put it, "is primarily creation; it is never experienced as a mere product." The work is identical with the movement, psychological and manual, that creates it; when the movement stops, the work is done. If it is approached again, a new movement transforms it into a new whole, and so does each subsequent encounter. Thus the work is always finished, or never finished —depending on the artist's willingness to begin with it anew.

Gorky, however, in the years of "The Artist and His Mother" (1926-36), had not yet attained this concept of painting. Those were the years of his intense apprenticeship to other artists—Cézanne, Ingres, and above all Picasso—and the apprentice obeys the craftsman's rule. Consciously discounting originality, Gorky strove to achieve works that would approximate as closely as possible those of his current master. To this end he completed his compositions to the last detail, often returning to the same theme again and again to gain further sureness of handling. In this phase, his ink drawings alone ran into the hundreds, even the thousands, each meticulously worked out on expensive imported paper. In his oils of the late twenties and early thirties, coats of paint are brushed one on top of another between the outlines of the shapes with such

eagerness for exact effect that they come to form thick slabs of pigment. If anything, these paintings are overfinished. It is to this quality that they owe their individuality; in reproductions they seem mere imitations, but on a wall they are immediately recognizable as Gorkys.

The big retrospective exhibition at the Museum of Modern Art in 1962 was regrettably underweighted at the expense of Gorky's work around the early thirties. Only two oils were shown of the large number of Cubistic still-lifes he painted before 1935. In throwing all the stress on the last six years of Gorky's production, the retrospective built him up according to the popular measure of originality (a value he willingly surrendered to his ideal of becoming a master), but in doing so it dissipated the drama in the development of his style and its eventual transformation.

That Gorky failed to finish "The Artist and His Mother" had to do not with his usual manner of working but with the subject he had chosen—that is to say, himself and his ancestry. To Gorky at that time nothing was more fenced off than his own self. In his work he did his best to assume not only the style of painting of the master he was imitating but the style of his personality as well. In life he played the part of The Great Artist according to the bohemian stereotype. Stories of his costumes and his posings—his "camouflage," as Julien Levy, who was his friend and dealer, called it—abound among his contemporaries. Between Gorky and the photograph of himself as a boy of eight by the side of his mother, which he used as the basis of "The Artist," stood the barrier of his contrived identities. The unity of Gorky's paintings and a large measure of their importance lie in his struggle to overcome this barrier through the sensual and psychic experience that he accumulated in creating them, and it is its place in this effort that lends exceptional interest to the mother-and-son portrait.

In turning from his imitation of contemporary masterpieces to the study of the pair in the old photograph, Gorky embarked upon an aspect of modern art more fundamental than that of manner. In the art of our time, the identity of the artist is a paramount theme. The concept of art as creation

brings the artist literally into the picture. The process by which the work comes into being often constitutes the content of the work; the artist's activities furnish its "plot." Thus the playwright appears on the stage writing his play, the novelist appears as a character in the novel engaged in writing a novel, and the painter's activity and state of mind while painting are exposed in his brush strokes, his splashes, or the recurrence of characteristic shapes.

One of the lessons learned from the vanguard Europeans by American artists in the forties was that a work of art need consist of nothing more than an inscription of the artist's identity. In conceiving a distinctive way of signing one's name it matters little whether one stresses an exaggerated simplicity, a tangle, or an obsession, as long as the total effect is that of the unique signature. Robert Motherwell, one of the quickest to grasp this point of the Paris school, was able, within two or three years after he had begun to paint, to exhibit "Motherwells" that distinguished themselves from the masses of canvases by unknown artists. More than fifteen years later, his work still followed the same concept of presenting variations on his established signatures: solid black ovals between vertical bars, with titles referring to Spain (the elegiac Motherwell, who looks back to the Spanish Civil War and his Spanish-descended first wife), paste-ups of torn papers, often whiskey labels, with slashes of paint, bearing French or Italian titles (the romantic Motherwell), paint whorls and splashes (the free, casual Motherwell). In several of his late paintings, Motherwell makes his intentions charmingly explicit through compositions containing a horizontal bar of color on which is hand-lettered "MOTHERWELL." In one of these, called, "Sea, Sky and Sand," "MOTHERWELL" is in the sky bar; in a collage entitled "U.S. Art New York, N.Y.," "MOTHER-WELL" is signed for everybody (as if he were the underwriter for the whole "school").

Gorky's transactions with his personal and esthetic identity possessed none of this lightness. In painting "The Artist and His Mother" he had to bridge the distance between the child named Vosdanig Adoian, shown in the photograph with

his young mother in her flowered peasant apron, and the van-
guardist painter of the Paris School (though he had never been
to Paris) who called himself Gorky, after the Russian writer,
whose "Gorky" was also a pseudonym. The photograph is an
exceptionally clear one for the product of a neighborhood flash-
light studio—artificial backdrop, stiff, dressed-up poses, "look-
at-the-birdie" facial expressions—in the Near East fifty years
ago. In terms of likeness, characterization, and atmosphere,
Gorky's paintings were able to add nothing to it. On the con-
trary, as a representation of things seen the painted versions
are unquestionably inferior. None of the Gorky portraits is
a good likeness, and in this respect his self-portraits are least
good. Gorky could not grasp himself even as appearance. Yet
for all his play-acting he would not finally accept himself a
mere made-up visual formula. In working on "The Artist and
His Mother," he in effect spent years unfinishing the little
photograph, changing the distant likenesses in it back into paint-
ing concepts in order to be able to take hold of these people
as his own creation.

The product of this effort, the double portrait, stands
apart from Gorky's other paintings of the period. Although
echoing Ingres and Picasso, it is not, as Gorky's work generally
then was, the result of an active application of a derived idea
but is, rather, a labored utilization of such technical resources
as he could muster for this one purpose. Nowhere else, save
in his earliest landscapes, is Gorky's composition as naturalistic
as in this portrait. The arrangement of figures and objects con-
forms slavishly to that of the photograph, except for the shift-
ing of a painted column to prevent its rising out of the mother's
head and, in what is probably the final version, a slight turning
of the boy's right foot. No attempt is made to inflect the
details into such favorite Gorky motifs as the bird, the heart,
and the boot, though he had already successfully managed
metamorphoses of this kind (for example, in the "Portrait of
Ahko," done around 1930). Only the hair of the boy, the
contour of his left arm, and the upper edge of the mother's
apron are to any degree "abstracted," and even these might
be, like the hands and forearms of both figures, a preliminary

blocking off of the forms. In sum, unable to grasp the boy in the photograph as himself, Gorky was equally unable to control his painting as a product, with the result that his relation to it became a protracted struggle.

"The Artist and His Mother," though neither a faithful likeness of its subjects nor a typical example of the artist's work at that stage, is thus a self-portrait in the sense that it is an autobiographical record of an art-action that extended over a decade. One might compare it to an action shot of someone taken with a lens too slow to give a recognizable image. Gorky's striving to conceive himself as an individual here employed painting as its means and physically manifested itself in the drawing, the color, and—primarily—the surface of the unfinished work.

"The beholder," Klee continues in his remarks on the work of art as creation, "suffers from the disadvantage of being presented with an end product; as far as the creative process is concerned, he appears to be going at the work the wrong way round." The "right" way to approach "The Artist and His Mother" would be to regard it as an occurrence in time, to return to its beginning and imagine its slow emergence, as when one watches a letterer or sign painter at work on a shopwindow. In this painting the spectator would have to visualize the evolution of the work by means of clues left behind, as in a mystery story or a drama.

The richest clue is the polished surface of the double portrait. In his dream identification with the Old Masters, Gorky sought in this painting to sink the image of his own past into the eternal sheen of museum masterpieces. "By scrapings and reapplications of thin pigment," wrote William Seitz in his catalogue of the Museum of Modern Art's Gorky retrospective, "Gorky gave his surface the soft glow of old marble or porcelain," with the effect of "emphasizing the hieratic dignity and masklike intentness of the mother's face." This description communicates very sharply the transcendence of self into art which is the content of the work.

In the later years of Gorky's wrestle with "The Artist and His Mother," he was engaged in a close exchange of ideas

and methods with Willem de Kooning. Some of de Kooning's paintings of men, also non-resembling self-portraits, were worked over with sandpaper—Gorky used a razor blade—to a polish similar to that of "The Artist and His Mother," until in one instance the surface turned into a layer like oilcloth and separated from the fabric. In their common striving for the masterpiece, these artists refused, despite their enthusiasm for Cézanne, the Cubists, Picasso, Miró, and Mondrian, to cut their tie with the works of earlier centuries. Unfinished paintings (at that time de Kooning would regard none of his paintings as finished) yet a surface that recalled the Old Masters —the idea was contradictory, but profoundly fitting to the adventure of the two immigrant artists in New York's bohemia of the thirties. The change of art from picture-making to creation and self-creation, into a means, that is, for each individual to define himself through his use of the materials of art, had coincided with the emergence of the big city, crowds, mass migrations, displaced persons, and a widespread anonymity —in a word, of that "*vie moderne*" which Baudelaire recommended as the subject matter of art. In Balzac's "The Unknown Masterpiece," the subject of the painting as well as the idea of art itself vanished into a process whose result had to the artist the absolute character of a revelation. Balzac's tale, which uncannily anticipated the direction of art, had had a deep effect on Cézanne; both Cézanne and the tale had a deep effect on de Kooning.

Gorky and his friend were conscious of the tradition of Western painting as pivoting in modern times upon a revolutionary transformation of motive that brought art within reach of their own needs of self-definition, yet without lessening the distance and grandeur of Rubens or Michelangelo. Respecting great art in this way as a potentiality for the living artist implied that to dare to undertake masterpieces was also to confront the New. "Has there in six centuries been better art than Cubism?" asked Gorky in 1931, and answered his own question: "No. Centuries will go past—artists of gigantic stature will draw positive elements from Cubism." In the phrase "gigantic stature," Gorky projects into the future the

fantastic ambitiousness of his identification with the Renaissance.

As a self-portrait in process, "The Artist and His Mother" is the link between Gorky's early, imitative paintings and the free imaginings of the drawings and canvases of his last phase (1942-48). The connection is evoked explicity in the title of a 1944 painting, "How My Mother's Embroidered Apron Unfolds in My Life." A more important link—and this matter of the link is as vital to criticism in regard to Gorky as was the "missing link" in discussions of evolution—is the fact that in the double portrait Gorky reached for identity in the direction of his actual self and away from his Great Artist "role playing," and that his later creations took the same direction. For him, the effect of Surrealism, under whose influence he fell at the close of the thirties, was to ease his communication with his childhood and at the same time to loosen his concept of art and the artist so as to bring both closer to himself. The masterworks for which he now strove were no longer projected as productions logically justified by the existing Great Works; instead, they were conscious heightenings of the jottings of his eye and hand moving at random. The regard for fact shown in "The Artist and His Mother" came through in the hybrids born of observation, fantasy, and recollection with which he peopled the "interior landscapes" of his mature works.

The thematic objects and creatures in the paintings of Gorky's last years were usually born out of doodlings that took off from nature studies. But in his esthetic explorations of the unconscious, his early devotion to values learned in the museum continued to assert itself in his classical drawing and his tonal use of color, while his prolonged Cubist exercises caused his composition to be firmer in structure and more contemporary in concept than is common among Surrealists. It is the Cubist ground of Gorky's paintings that makes it inexact to refer to him as "an American Surrealist."

Stuart Davis, an early defender of Gorky, found that in his Surrealist turn he had "settled for a self on a lower level than the potential of his early noble pretensions." Yet "lower level" may be the level of reality, as playing games may be

both more "noble" and more creative than holding the posture of a statue. Whether one agrees with it or not, however, Davis's judgment, *in testifying to the power of an esthetic choice to affect the substance of the individual's identity*, confirms the significance of Gorky's experience.

"The Diary of a Seducer" (1945), Gorky's masterpiece, achieves in symbolic language the self-portrait that his skill could not elicit from the Armenian photograph. Its soft, organic shapes, linear fluency, and concave "sheltered" space mirror the emotional states and reflective interests dominating Gorky's personality. Above all, though, "The Diary" is a representation of Gorky in being a great painting rich in references to other masterworks. For art was part of Gorky's physiognomy; without it he was nobody. No wonder he could not see himself in a mere boy.

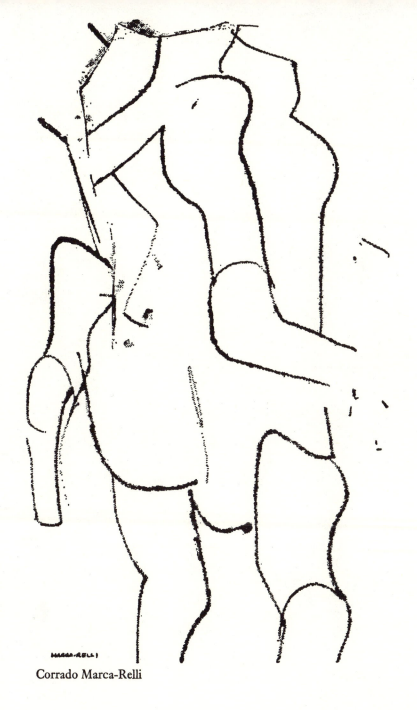

Corrado Marca-Relli

DE KOONING
1. "PAINTING IS A WAY"

Art in the service of politics declined after the war, but ideology has by no means relaxed its hold on American painting. Zen, psychoanalysis, action art, purism, anti-art—and their dogmas and programs—have replaced the Marxism and regionalism of the thirties. It is still the rare artist who trusts his work entirely to the intuitions that arise in the course of creating it. Foremost among such adventurers in chaos is Willem de Kooning.

De Kooning's independence from the doctrines influencing painting has been achieved through fighting it out with them. The academician or professional keeps his work free of ideas; if he favors a cause, he supports it "as a man." De Kooning's art has never been detached in this sense. On the contrary, it has been involved with every major intellectual current among American painters in the past thirty years. He is an ideologists' man, but anti-ideological. In de Kooning's view, the artist takes art as he finds it. It is not his private invention; other artists act upon him as he acts upon them. When his colleagues are given to causes and systems, this affects de Kooning and his painting. Only it happens that whatever the dominant idea, de Kooning is moved by it to difference or opposition. This response rarely takes the form of theoretical controversy. De Kooning's way has been to separate the notion from the painting and to reflect on each as a possibility.

Thus, in the thirties, de Kooning accepted Mexican-style mural painting, Surrealism, neo-Plasticism, Social Realism, but never on their own terms. Throughout that decade and into the mid-forties his work distinguished itself by a tentativeness that contrasted dramatically with the prevailing demonstrations of conviction; even Arshile Gorky, another outsider of the period, in his subservience to Cézanne, to Picasso, to Miró, had more in common with the general attraction to authority. Responding to "proletarian art," de Kooning was moved by its consciousness of the poor man, the artist's unemployed neighbor. But sharing the economic situation of the workers did not, he found, result in genuine identification with them, and he rejected the Hooverville starvelings of the politically

oriented artists as well as their heroically proportioned militants; he rejected also their poster-style drawing and color. So in the period of proletarian art de Kooning produced a series of paintings of brooding men that were near self-portraits executed as curious experiments with perspective.

In sum, de Kooning's relation to the paintings of others has been to dislocate from within the thought that originated them. Testing whether it will satisfy his needs, he converts each existing solution into a hive of problems. No one has been more effective than he in multiplying difficulties for painting—and for himself as a painter. These difficulties are real; after all, doctrines are so prominent in the art of our time because they provide first aid against bewilderment. In the midst of the destructive certainties that marked the depression and war periods, de Kooning offered the New York art world the example of an artist who dared, when necessary, to endure unalleviated confusion. At times he was utterly stymied, and there were prophets who predicted that this artist would never produce a canvas.

The ideologies of the thirties revolved upon theories of history; de Kooning's resistance to them shaped his attitude toward the art of the past. A work of art of any earlier period, by the time it reaches the twentieth century, and particularly the mid-twentieth century in America, has shed the intellectual and cultural husk of its origin and turned into an object brought into being by the skill of an individual artist—it is not salvation, not philosophy, "just art," as de Kooning likes to say. The contemporary artist receives it as art in the context of his own possibilities. This view brings back to life the works of all ages as possessing a common status. The paintings of an artisan in a workshop of Egypt or medieval Europe or of an Expressionist in a Manhattan loft stand in a potential relation to the art of the future. As for inherited ideas, those of yesterday's vanguard schools are no more compelling in regard to painting today than the philosophy of Michelangelo or the religion of Rembrandt. Mondrian is a great painter, but

what is so remarkable, de Kooning asked, about the neo-Plastic idea, especially after it has been stated? "We are all," de Kooning said in an artists' panel discussion half a dozen years ago, "basing our work on paintings in whose ideas we no longer believe." This formula goes to the heart of the postwar cultural situation and its creations. At the time he delivered this opinion, de Kooning's favorite characterization of current work, including his own, was "counterfeit," a term which expresses the contrast between the art of today and that of other epochs, including the "epoch" of prewar vanguardism, when the art object and its idea were one.

To detach paintings from fixed social, esthetic, or metaphysical objectives is basically to redefine the profession of painting. The function of art is no longer to satisfy wants, including intellectual wants, but to serve as a stimulus to further creation. The Sistine Chapel is valuable not for the feelings it aroused in the past but for the creative acts it will instigate in the future. Art comes into being through a chain of inspiration. Said Brancusi: "It is not difficult to make things; what is difficult is to put ourselves in the proper condition to make them." The work of art belongs to this moment of potency. Today, art and the artist are suspended upon one another, with no net of social values or religious beliefs underneath. "Painting," de Kooning wrote, "is a way of living. That is where its form lies." This sounds like the esthete's idea of a life that is "a work of art;" de Kooning's meaning, however, is almost the opposite. Art derives from life, but neither the artist nor the painting has a character that pre-exists their encounter. Here de Kooning turned inside out the Romantic image of art and the artist, as exemplified, for instance, by the paintings and by the personal life of his friend Gorky; he would neither imitate masterpieces nor emulate the traditional image of the Artist. Since, for de Kooning, art must discover its form in the actuality of the artist's life, it cannot impose itself upon its practitioner as other professions do upon theirs. Art becomes a Way by which to avoid a Way. De Kooning discards all social roles in order to start with himself as he is, and all definitions of art in order to start with art as it might appear

through him. By their mutual indetermination, art and the artist support each other's openness to the multiplicity of experience. Both resist stylization and absorption into a type. The esthetic aim to which de Kooning applied the label "no style" derives from and is the expression of this philosophy of art and of self.

In conceiving art as a way of life, de Kooning makes his engagement in his profession total, in the sense of the absorption of a priest or saint in his vocation. The idea is faulty. Painting lacks the structure of values by which ethical or religious systems sustain the individual. Nor can acts of creation shed an uninterrupted light. De Kooning is expressing, however, the actual condition of the contemporary artist: that for him art has assumed the character of a fetish by which his personality is ruled in the act of painting but which leaves him scattered when it departs. That de Kooning experiences this condition to a more extreme degree and with a fuller acceptance of its implications than any of his contemporaries has contributed to making him the foremost painter of the postwar world. In phases of de Kooning's work from the thirties to the present there appear a kind of heightened quiver and a muted luminosity, as of a metaphysical presence. Art as a separate being, an abstracted continuum of creations from the cave paintings to the present, occupies the artist and elevates his performance. For an interval, painting and the painter are one in action on the canvas. But only for an interval, and in the inevitable dispersion both art and the artist are nothing. Nor will the most tortured effort restore the union. For years it was customary for de Kooning to speak of the artist as "desperate."

Tentative as they are, de Kooning's early paintings have an exploratory seriousness not found in the work of students or followers. Each of the portraits, still-lifes or abstractions functions as a forceful hypothesis which, in being pursued, seems to lose steam and is dropped, either as unlikely to yield results or because the artist can carry it no farther.

No temptation is evident to complete a picture for its own sake; it is restricted to the frustrating search that went into it. As we have seen, de Kooning takes in the thought of the time by negating it. He also negates the negation. He retains the dream of simply "good painting" in the sense of a Rubens or a Delacroix. The quality of his sketches and drawings, no matter how fragmentary, is sustained by the austerities of an imaginary brotherhood of craftsmen—one that includes also the commercial artist, for, unlike most American painters, de Kooning, who was trained in the Academy of Rotterdam and worked for a firm of designers there throughout his teens, counts professionalism as a high virtue. In both his work and his personality a readiness for humor is grounded in a skepticism that extends to art itself, especially the art of this time, for all his absolute engrossment in it.

The historical determinism, both political and esthetic, that ruled prewar New York held that art developed according to laws of necessity which artists had to obey or be swept into oblivion. The question "What next?"—still the most urgent one in art—was answered by projecting existing advanced styles into the future. In reacting against ideology, de Kooning hit upon a principle of the first importance in the evolution of his work: that the artist did need to follow a logic of progress, for example, from Cubism to Mondrian, to . . .? He could move ahead by going backward from the present into the past and exploring the resources of art at any point in time that appealed to him. History, this thought suggested, is full of open prairies passed over by the covered wagons of vanguardist theory. By returning to the origins of works and schools, the artist could unlock the elements that went into forming them and put them to fresh uses.

In his prewar paintings of men, de Kooning went as far back as Ingres, taking with him the Cubist device of displaced anatomy, as in Braque, but rejecting the play of planes emanating from the Cubist system. De Kooning's "Glazier" and "Seated Figure (Classical Male)," both 1940, combine classical modelling with Cubist anatomical dislocation; in both the artist leaves as a clue to his thinking flat colored squares behind

drawings in depth. This amalgamation defied history's "laws of development" by setting against them the will of an artist with a consciousness of history. In these paintings de Kooning restates the choice facing the contemporary painter: either to uphold the deep-space concept of traditional painting or to turn to the layered space of post-Cézanne art—and refuses to choose. For him, the traditional has lost its power to command and the new, no longer new, has become a tiresome commonplace.

Through 1945, de Kooning juggles ambiguities of new and old, depth and flatness, as his relativistic intelligence tries out combinations drawn from different segments of art history. "Pink Angels" (1945) culminates a sequence of compositions of apparitions and lost limbs which, recalling Duchamp and collage and paralleling the ironed-out bodies of Matta and Gorky, seem to start independently at an intersection of Cubism and Dada. This canvas, thinly painted in tones of pink and yellow, is scrawled with contours that present another of de Kooning's inventions of those years which has survived in his work: the floating shape flicked by his inspired drawing from studies of the human figure, city streets and interiors, impressions of Old Masters, the spontaneous movements of the hand. These beautifully lucid shapes provide the excitement of the paintings done in his experimental wandering from mode to mode, and their accumulation and re-use, together with the psychic tension of his compositions, establish the continuity of his work. Never seeking to impose an identity upon himself or his painting, de Kooning had already in this early stage revealed a signature impossible to mistake.

In 1946, a portentous year for American art generally, de Kooning's foraging among the approaches of predecessors brought him to explore a point in art between Cubism and the late works of Cézanne—an interval when painting intersected with Symbolist poetry and the methodological experiments of Mallarmé with form, analogy and chance. Given the fact that Symbolism lay at the root of psychoanalysis, this was an intellectual focus rich in possibilities for postwar American paint-

ing, as well as one exactly suited to de Kooning's passion for an art of all-inclusive experience. At this juncture of form and self-examination he was able to forge a beginning of his own, loaded with both tradition and contemporaneity; all of his subsequent paintings, as well as a good deal of the art of others, arose out of this synthesis.

In the context of Symbolism, the detached limbs, torsos, table tops of de Kooning's earlier compositions assumed the function of visual metaphors, related to the creased tablecloth that with Cézanne could double for a mountain. A half century of abstract art had, however, made it possible for de Kooning to release his metaphors from specific objects and thus to enable them to strike a much broader resonance of associations. Also, the abstracted metaphorical shape, representing both thing and emblem without defining itself as either, could resolve the conflict between "deep" and "flat" space; an oval with a circle inside it scratched on a wall can be seen simultaneously as a pattern on a surface and as an eye possessing volume. The white-on-black "Light in August," done around 1947, is the first masterwork of de Kooning's Symbolist abstractions, and the fact that it bears a literary title, and particularly one taken from Faulkner, an heir of Symbolism, seems to me enlightening.

Dissociated from their sources in nature, organic shapes carry emotional charges of the same order as numbers, mathematical signs, letters of the alphabet; the memory of a friend may be aroused by a pair of gloves or a telephone number, an erotic sensation by a curved line or an initial. In de Kooning's paintings of the period of "Light in August," a head shape becomes an "o," a square becomes a window or a chest frame, the contour of the breast the loop in an abstraction or a passage in a landscape. De Kooning's extensive vocabulary of motifs and his multiplex use of them has been much noted. As a device of painting, ambiguity of form is, as we have seen, nothing new; it was rediscovered by the Surrealists in Leonardo, with equivalences in Baudelaire, Poe, and de Nerval. Fernand Léger, under whom de Kooning worked on a mural commission in

the thirties, had delivered a paper in connection with his film "Ballet Mécanique" in which he spoke of a fingernail made to resemble a planet through a closeup shot.

The meaning of visual metamorphosis, as of all metaphor, lies in the artist's use of it. Faithful to painting values, de Kooning employed his repertory of signs to introduce revolutionary innovations in form. The Surrealists had been content to deal with their dream creations as natural objects; Dali's pianos on crutches and Ernst's feathered bric-a-brac were in respect to painting things no different from ordinary pianos or birds and could be incorporated into conservative picture structures. De Kooning, on the other hand, ever conscious, as he has said, that "the idea of space is given to an artist to change it if he can," frees the shape that is a sign, from the stasis of both free-standing objects and symbolic systems into a new kind of psychodynamic composition. Produced by a gesture, as in writing, but differing from calligraphy in preserving the sense of volume characteristic of traditional Western art, each of his forms enters as a separate integer of suggestion into complex interaction, at once formal and subjective, with the others. While the figurations of the Surrealists and of Gorky remain immobile as representations against a landscape or neutral background, those of de Kooning, coming into being through rapid flaunts of the brush, sideswipe the mind in passing from one into another with a continuous effect described by the artist as "slipping glimpses." Thrown off balance, the consciousness is compelled to reaffirm its unity through an act of equilibrium. This is equally true of the artist and the spectator; in de Kooning's practice, inducing such mental affirmations brings the audience into the act of creation. Without abolishing its elements of disorder, each of de Kooning's paintings achieves unity anew as an organization of energies. It is this that lends to them the effect of classical composition.

Metaphorical abstraction makes it possible for the painter to act freely on the canvas while discovering, in a manner analogous to automatic writing, links of meaning in the images that come into view. It is characteristic of de Kooning's attitude

toward intellectual systems that free association entered his painting through years of painting practice and the example of other painters, rather than through an ideology of the unconscious such as inspired Gorky and Pollock. One effect is that de Kooning's spontaneous compositions rarely rely on automatism or doodling; though they may start with a scribble or a sign, his forms are animated by conscious intuitions, often related to paintings of the past. Without being premeditated, his movements occur under the constant scrutiny of his esthetic conscience. Produced under the pressure of a heightened attentiveness to values, which at times has caused them to take years to complete, de Kooning's improvisations provided the model for the concept of Action Painting.

His "Excavation," brought to resolution in 1950 after months of strenuous doing and undoing, displays a density of experience more often encountered in poetry than in modern painting. A nine-foot painting (a moderate size by today's standards), the work is, internally, limitless in scale. Its shapes, crowding invention upon invention (no living artist can match de Kooning in throwing up interesting forms), neither confine themselves to the picture surface or recede behind it but carry on a continual delving or "excavating," as of planes edging into one another. One thinks of Yeats'

> Those images that yet
> Fresh images beget,
> That dolphin-torn, that gong-tormented sea;

except that the yellowish monochrome of "Excavation," lit by flashes of bright red and blue, has rather an effect of jarred rock.

With his one-man show in 1948 and his exhibition of "Excavation" at the Venice Biennale in 1950—the following year it won first prize at the Chicago Art Institute and was purchased by that institution—de Kooning had established his leadership among American painters. Professional procedure now advised that he follow up his success with more paintings in the same mode. Although almost all of his colleagues were

to adopt such a course, for de Kooning contemporary painting incessantly demands new moves; perhaps something in de Kooning demands them still more. Even Picasso, repossessing one style after another out of the past, apparently seemed to him to be too patient. Once again de Kooning answered the question of what to do next by an act of opposition, this time by opposition to what he had just accomplished. For all the protracted agitation that produced it, "Excavation" was a classical painting, majestic and distant, like a formula wrung out of testing explosives. If, as de Kooning liked to say, the artist functions by "getting into the canvas" and working his way out again, this masterpiece had seen him not only depart but close the door behind him. In reaction against the calm of Cézanne and the Symbolists he now picked up the tradition of van Gogh and Soutine, in which the artist remains in the picture as its emotional subject.

In his famous "Women" series, de Kooning carried his painting as action to the verge of ritual magic, the modern magic of manipulating the materials of an art to bring forth real beings. Rimbaud had believed he could evoke "new flowers, new stars, new flesh" out of consonants and vowels. By an analogous magic, de Kooning willed the spontaneous appearance of a female figure through the unguided discharge of energy in paint. It was as if, returning past Cézanne in the direction of van Gogh, he had been carried back also from the Symbolism of Mallarmé to its primitive root in the laboratory of the "infernal bridegroom."

The "Women" have been much interpreted in terms of the artist's personality—for example, his presumed hatred of women, an interpretation that ignores the lyrical element in these paintings—and, in terms of myth, the summoning up of a monstrous Earth Mother, an interpretation that ignores de Kooning's dislike for idealizations. Considering their mode of creation, it seems to me incorrect to treat the "Women" as pictures expressing fixed feelings. Each represents, rather, changing experiences of the artist broken off at an unpredictable point, when the painting was turned to the wall. What makes monsters is the irreconcilability of the forces that produce

them, and this ordains that every monster shall also be a cripple. The monstrousness of de Kooning's famous "Woman I" is a product of an irresolvable contradiction in the processes that brought her into being. She is a prodigy born of a heroic mismating of immediacy and will. In her de Kooning endeavored to give himself to the flow of memories, associations, present emotions, and changing hypotheses, and at the same time to drive this formless and all-inclusive living toward a foreseen result, a female figure.

The failure of Rimbaud's magic caused him to bid farewell to poetry. De Kooning did not quit, but "Woman I," repainted daily for almost two years, reduced him to despair and may have left certain traumas. "Spiritual combat," said Rimbaud, "is as brutal as the battle of men." De Kooning was fully aware that in allowing himself thus to snarl his creative drive he was violating the craftman's code he had always respected. "If I had character," he kept saying, "I would paint abstractions" (that is, the kind of paintings for which he now had a market). The notion that one lacks character because he refuses to conform to the demands of others may seem paradoxical, but de Kooning was in deadly earnest. He knew that the project on which he had embarked in this "Woman" could, if pursued to the end, finish him as a painter. He spoke of wanting to spend his entire life on a single painting—"Woman" would then be indeed "painting as a way of living." To continue his career, de Kooning finally had to abandon work on this canvas; months later, he yielded to the urgings of friends and surrendered the "Woman" to the public.

After a buildup of energies against an immovable obstacle, it is usual for de Kooning to be thrown into a period of creativity. "Woman I" was followed by a series of other "Women," none of which was completed. On de Kooning's hurricanes of paint occasionally floated a smile cut out of a magazine advertisement. These painted lips, masks of feeling, represented also academic art tossed on the waves of art as life. The theme of "Woman" was not abandoned but gradually ebbed into abstraction. In 1955, de Kooning attempted an experiment with his older metaphorical technique, a drawing,

crowding the edges of the paper, of a monumental woman, whose nose was the Washingon Monument and whose ribs were the Jefferson Memorial. This effort, however, was not pursued, and by the next year the female had been absorbed into the landscape.

It was time for the artist to locate himself anew. He now chose a spot between the absolutes of American contemporaries who were reducing painting to large, flat color areas and the quintessential craftsmanship of the cutouts of Matisse's last years. De Kooning challenged these simplicities with the rapidity of his gestures. In the paintings of the late fifties the range of symbolic reference was retained in the titles, consisting of place names (real and imagined), happenings, names of friends, dates. In the latest sketches, suggestions of the female figure recur once more, but through unforced associations of forms.

Painting the "Woman" was a mistake. It could not be done. Esthetically, the canvas is an inadequate expression of the artist's experience and intention. Something similar has often been said of *Hamlet*. For authority for such a creation, which defies its medium, de Kooning could also turn to Balzac's "The Unknown Masterpiece," which then occupied his thoughts, or to Melville's *Pierre* or *Moby Dick*, of which their author said that he wished to create a work that would *fail*. Undertaking such a work is, of course, unprofessional. But going against the profession is in modern art part of the practice of it. Given the situation of art one may ask whether there is for the artist any other way.

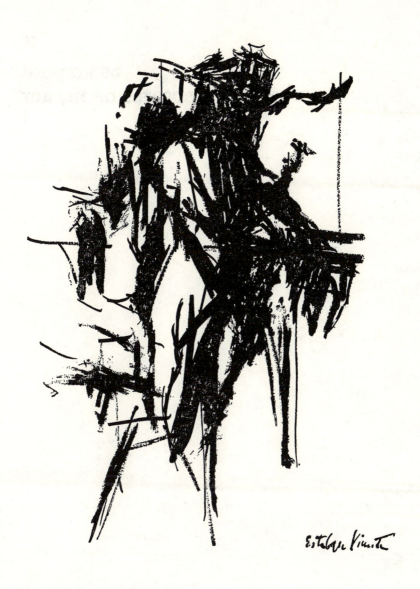

Esteban Vicente

DE KOONING
2. ON THE BORDERS OF THE ACT

Like Western civilization, like humanity itself, de Kooning is constantly declared by critics to be in a state of decline, if not finished for good. Behind the current de Kooning there is always a better one who has faded into the past. In the 1940's the accepted verdict was that though he had shown great promise before the war and was an important "artist's artist," he was too perfectionist (or neurotic) ever to produce a significant body of work. When, within a few years, de Kooning's wavering effort had made him the dominant influence in the new American abstract art, he had, alas, already "betrayed" abstraction by devoting the next half a decade to his *Woman* series. At first all but unsaleable, the *Women* were at length established, only to call attention to the fact that de Kooning had petered out by returning to abstraction in a mode different from that of his "classical" period. The new, enormously simplified "rural landscapes" emerging after 1957 were considered disappointingly empty by admirers of both the *Women* and of earlier crowded abstractions based on the city. More recently, women have been manifesting themselves in the landscapes, but instead of the imposing idols of ten years ago they are, alas again, light little girlies with rouged lips. In any case, they arrived too late to count. De Kooning, we are told once more, belongs to the past: a New York critic-curator, riding what he hoped was the latest bandwagon, announced that the Abstract Expressionism of de Kooning had "lasted until 1959 or 1960." Buried as usual, de Kooning is today busy contriving new evidences of how bad he is compared with yesterday.

A maker of art objects is represented by his product, which can be placed with more or less stability in the art of his time. With de Kooning, in contrast, art is a performance, which like an event in history is enlarged in retrospect. Nor has the attitude of the art public toward his work been a matter of indifference to de Kooning; many of his dramatic changes of manner have been deliberate nose-thumbings at the knowing. In staging himself before his contemporaries he has exploited the showman's resource of surprise. Going along

with or challenging prevailing values in art, he has, however, avoided the easier devices of attention-getting, for example, that of repeating the same image or employing spectacular materials or techniques. He has not, like most of his contemporaries, sought to create a personal emblem by which his canvases could be spotted at a glance. Nor has he consented to "type" himself, as his friend Gorky did in assuming the traditional guise and attitudes of the international bohemian.

De Kooning has preferred to court the undefined, to keep his art and his identity in flux—perhaps the eagerness to dispose of him would be lessened were he more ready to confine himself to a category. Rejecting any external definition of himself or preconception as to the direction of his work, his sole concern has been to maintain touch with himself as he is—an enterprise which in this epoch so disturbed by fear of anonymity has demanded the deepest insight as well as genuine moral independence.

Painting for de Kooning is not only a performance before an audience; it is a real action, comparable to crossing an ocean or fighting a battle. The art of painting is executed in silence, allowing a minimum of exchange with other minds; at times it even divides the artist's own mind, making what he is doing incomprehensible to him. Like prayer this movement of the spirit and intellect evokes extreme states; a succession of psychic tensions passes over into the self affecting the artist's personality and behavior. He is in a condition of constant heightening, depletion, transformation.

The logic of de Kooning's work lies not in its rational consistency but in the artist's unending struggle with painting and its possibilities. Each confrontation of the drawing board or canvas is a singular situation calling for a new act—and the act and the artist are one. The web of energies he has woven between his painting and his living precludes the formation of any terminal idea. No one could be more remote either from the "pure" artist, who paints what he conceives to be the essence of painting, or from the correct artist, who produces what is demanded by the history of art or by society. We have described how throughout his career de Kooning has

resisted every species of ideology, esthetic, social, philosophical. Picking up Kierkegaard's *Purity Of Heart Is To Will One Thing*, he remarked of the title that "The idea makes me sick." His own unexpressed standard is the standard of the mountain climber or the boxer, that is, his trained sense of immediate rightness. In the situation that keeps arising on the canvas, the artist-actor must be governed not by rule, nor even by esthetic principle, but by tact. What satisfies this sense in one set of circumstances will fail to do so in another—few of de Kooning's paintings have escaped disappointing him (him, too!) when he looked at them later.

Except in the artifices of the theatre or the historian, an act has no beginning and no end. Contemporary painters are much concerned about how to start a work and how to tell when it is finished. De Kooning breaks in anywhere, and gets out when he has to. He may commence a painting with a stroke of color, by writing the letter "o" on the canvas, by sketching a nude. Most of the compositions for which he is famous are powerful middles, without beginnings or ends. A concept can be pushed to a logical conclusion; an act can only be abandoned. To be forced to abandon a painting used to plunge de Kooning into despair—often he would destroy this trace of his inability to reach a resolution. The build-up of energy would send him rushing agitatedly through the streets. In recent years he makes his exit from a painting more calmly. "I just stop," he explained in an interview.

In de Kooning's *oeuvre* there are long paintings and short paintings, in terms not of size but of the time they took to paint. His key works have tended to be the long ones: "Excavation," "finished" in the spring of 1950, "Woman I," begun almost immediately thereafter, on which de Kooning worked almost two years. These protracted acts, like the scores of hurried ones executed on small cardboards in 1957, took place at critical stages of de Kooning's development and produced dramatic alterations both in the artist and in American art. It is remarkable that in de Kooning tenacity is matched by a mastery of the rapidly executed, almost instantaneous, gesture; in many of the landscape-figure-abstractions of the last few

years he has achieved through speed a lightning clarity and briskness unattainable in his more pressured compositions. One of de Kooning's outstanding qualities (compared, for instance, to Pollock or Kline) is the variety of tempo he has been able to introduce into his action without destroying its continuity. The least bit of a de Kooning partakes of his complex sensibility—in his case the high market value placed on a sketch or even a scribble is justified by intrinsic qualities.

In action the mind seizes upon whatever lies ready at hand both within itself and in the visible world. As against what might be called the slimming tendency in contemporary art— the effort to produce masterpieces by the minimum means (a square on a square, one-color paintings)—a de Kooning canvas is as unrestricted as Union Square. His compositions devour everyday sights, odd thoughts, moods, theories old and new, paintings and sculptures of the past. He has the hungry multifariousness of the Renaissance humanists, the "vulgarity" of Rabelais and Cervantes. His abstractions and female figures are no less accumulations than if they had been put together out of newsprint, rags and rubbish (some de Koonings do incorporate strips of tabloids, cut-outs of magazine advertisements, sections of discarded canvases). Ready-made materials are, however, too clumsy a medium to carry the "slipping glimpses" of de Kooning's insight. The constant interchange of image and symbol, direct impression and analytical generalization, can be seized only through the action of the brush. "Woman I" was a girl in a yellow dress whom de Kooning spotted on Fourteenth Street, then forgot, but who returned to life in the course of the painting, until she vanished forever in the cement-mixer of the de Kooning painting process. "Woman I" contains also mothers passed on East Side park benches, a madonna studied in a reproduction, E— or M— made love to, plus, de Kooning tells us, the "grin of Mesopotamian idols." Such a creation could not be the result of a mere combination of displaced elements, as in collage or Pop Art. Transformation had to be total, that is, to take place simultaneously in the psyche of the artist and on the canvas. Artists who boast of getting beyond de Kooning technically ought to ask them-

selves if they comprehend the difference in the objectives of his techniques and theirs.

Through the action of de Kooning's brush, things, persons, scenes, feelings are recorded in shifting forms that re-record themselves in the eye of the spectator as on a strip of film; one looking at a de Kooning never sees the same image twice (recent paintings—e.g., Andy Warhol's—composed of pictures repeated in series parody this de Kooning effect). The gestures that brought the painting into being subsist in it not only through vestiges of energy—swipes of paint, splashes, smears—but through the constant forcing together of the visual ingredients of the painting.

For de Kooning problems of painting (how to draw the Woman's knees, how to keep the pigment from drying too fast) do not exist in isolation; they arise inside the moving mixture of the painter's experience. Hence there is no final goal which a painting may reach ("I never was interested in how to make a good painting"), as there is no ultimate fact of which it can be the equivalent. One event makes another possible, whether or not it itself is perfectly executed. Designing a studio-dwelling for himself de Kooning completes a set of plans that fulfills all of his desires. The plans are ingenious and handsome, but no sooner are they finished than he starts a new set. The act of formulating the first conception has given rise to new possibilities, new problems. Any solution is but a point to be passed through on the way to another approximation. Perhaps the next gesture will bring the artist closer to his true self, that is, to something in him he did not know was there. But "closer" has only a symbolic meaning; for whether closer or less close to some presumed self of the artist, the work has been lived and is therefore the actual substance of his existence. "In the end," says de Kooning of his *Woman*, "I failed. But it didn't bother me . . . I felt it was really an accomplishment." Failure or success, he can claim with Jaques of *As You Like It*, "I have gained my experience."

De Kooning's performance is also an "act" in the arena of art history, a display of skill and imagination put on before an imaginary gallery of the great masters. In painting the *Woman*,

he has said, he wanted to see how long he could "stay on the stage" under the scrutiny of that immortal company. What saves him from presumptuousness is that he does not expect Michelangelo or Rubens to keep their seats until the curtain.

The intimate presence in his mind of the geniuses of Western painting is the secret of what is often referred to as de Kooning's ambitiousness. His consciousness of the art of the past as the context of his action belies the popular concept of Action Painting as self-effusion. An art in which the individual statement is keyed to complex judgments regarding the nature and direction of painting can have little in common with the painting-impulses of children and chimpanzees. As a decorator's apprentice and Academy student in Rotterdam, de Kooning grew up with art as his trade and the masters of other centuries as his teachers and artisan-competitors. It was in New York's Greenwich Village that painting was transformed for him from a way of earning a living into what he has termed "a way of living." But de Kooning has never altogether shed his craftsman's attitude toward art and his feeling of matching skills with illustrious predecessors. His practice of painting as a traditional trade, on the one hand, and as a laboratory for investigating the here and now, on the other, has given his work an authority unsurpassed in his generation. It has also involved him in intense contradictions, often immensely fruitful but leading also to unbearable confusions.

Among the intellectual advantages of his craft orientation has been his continuing skepticism toward vanguardist dogmas. Accepting the fact that our time has put every value of art in doubt, de Kooning, empowered by his sense of the traditional, has felt free to doubt also the doubt. It may be absurd for artists to continue painting the human figure—it is even more absurd to make a rule against painting it. Has "modernism" obliged the painter to take a position against women in paintings? Against the sky being blue, snow white? "Forms," replies de Kooning, "ought to have the emotion of a concrete experience. For instance, I am very happy that grass is green." A line across a sheet of paper, if one puts a tiny mark in front of it, becomes the horizon approached by a ship. What is gained, de Kooning

asks himself, by omitting that mark in order to make art "non-objective?"

Not some concept of what art ought to be but the range of the artist's experience, including of course his experience of art, is the source of value in contemporary painting. De Kooning is aware to an unexcelled degree how superficial it is to separate the natural world from the world of human artifice. Most art movements come into being through finding a new way of exaggerating this separation; they pit the natural against the man-made (e.g., primitivism, Romanticism) or vice versa (Pop Art, neo-abstraction) at the expense of the inherent synthesis of actual experience. By the measure of such movements de Kooning is not a "modernist." In his 35 years of creating art in New York, modernism after modernism has washed over his head, always affecting him yet without throwing him off his course.

At present, as noted above, de Kooning is again painting women, this time not timeless icons but today's cuties. His largest and most characeristic current creation, is, however, the dwelling-studio in The Springs, Long Island, that has finally materialized out of those plans drawn by him over the years. Here grand ambition and galloping contradiction (the house as a self-extending "action" which the artist must execute through strangers) have once more brought into being the unfinished masterpiece. The vast, many-planed building of concrete, steel, wood and glass concentrates the dramatic strains of de Kooning's art in flaunts of roof line and arbitrary platforms, staircases, balconies, recesses, whose only precedents are de Kooning's swooping paint strokes. It is a setting like the stage of an opera house in which the sole presentation is the act of constructing the studio—whoever sits or stands in it seems about to burst into a declamation for or against the enterprise. It requires no great insight to predict that when the work on this creation stops—as usual the only meaning of "finish" with a de Kooning—persons from every sector of the art world will visit it and discuss the latest decline it represents in de Kooning.

HANS HOFMANN
1. THE LIFE CLASS

Hofmann's school—I mean, school for teaching, not "school of painting"—when I first heard of it in the 1930s seemed to have the character of a Cause. Those who joined it soon took on the air of recruits to the Communist Party or of persons embarked on psychoanalysis. Secrets were being acquired, or rather the inexpressible. One gathered that Hofmann taught "abstract art" but that abstraction was not the point—you studied the Object in Space (though perspective was barred); also "pure" color (as opposed to tones). What you learned applied to all art, not to any art movement this or that side of Mondrian. It was instruction in the artist's true way of seeing.

In that decade of ideologies—New Deal, Marxist, Fascist—it was plain that the Hofmann teachings, too, offered a KEY.

To make that much of art was the opposite of an attraction. In the midst of Depression, threats of revolution and the visibly oncoming War, painting might at best claim a place among the professions, though it was hard to see how it could be as humanly useful as, say, pharmacy. It was indeed something of a triumph for the artist that, along with folk-lore, the theater, writing and the dance, painting was included in the Professional and Service Division of the Works Progress Administration. This placed the painter one salary rung above electricians and bricklayers, though the building workers with their strong unions received a higher hourly wage. As a vocation, painting thus had advantages (besides nude models) and disadvantages (besides the sense of not being needed). But as a philosophy of life, a Way, wielding a brush or palette knife seemed scarcely adequate. There were so many more important things that needed to be thought about and put into order. The intellectual vanguard itself had declared art to be contingent on other values, those of stability, or of power, or of social equity, to name but a few. T. S. Eliot, re-evaluating the ecclesiastical hippopotamus, had pronounced his credo of Royalism, Catholicism and Classicism, a series in which newly created art was a mere bauble adorning the Rock of traditional authority. Ezra Pound was tracing the horoscope of Imagism on the

calendar of Mussolini's March on Rome. Artists of New York and Provincetown (where the Hofmann School located itself in 1934) were questioning their calling on the picket line, at Artists' Congresses and on the battlefields of Civil War Spain.

For Hofmann there was no Question, though there were undoubtedly questions. Art was the supreme activity: whatever else might be required for man's needs, art was required the most. A painter's work could fill his life completely; with or without the lofting power of religion or revolution, he would always find art a little beyond his extremest efforts. In art a person could grow as high and as wide as the world, whose other affairs did not need to concern him directly.

In short, the thoughts of the master of the Hofmann School, already in his fifties when he migrated to America, belonged to a time other than the politically agitated thirties. When Hofmann spoke to his American students about the "cray-ah-teef" as if nothing else mattered, it was the great decade before the first World War when he had worked as an artist in Paris that he was invoking—those ten overwhelming years in which Fauvism, Cubism, Expressionism, De Stijl, Futurism, had burst into view with barely enough time between them to ensure their identification and the alphabet of twentieth-century art had been promulgated. In that turmoil of possibilities, not yet muffled by the Polyphemus of political economy, who had doubted that to *create* was all-important, or that the intellectual imagination was destined to unfold out of itself countless universes? "I opened my school in Munich in the spring of 1915 . . . to clarify the then entire new pictorial approach." Twenty years later in America, the School embodied the old arrogance of an art involved exclusively with its own discoveries.

Not that Hofmann was indifferent to world events. What induced him permanently to transfer his school to the United States, after a few terms of teaching at the University of California in Berkeley and at the Art Students League, was Hitler's coming to power and the subsequent outrages against friends and neighbors about which Miz, his wife, wrote him in detail from abroad before she came to join him in America. But

though Hofmann could not fail to react to Nazism as to a natural enemy, there could exist in his mind no competition between the value of action and the value of creation. Totalitarian violence might make painting impossible; it could neither reduce its transcendent status nor alter the "laws" by which it was brought into being. That Hans Hofmann had been compelled to exile himself from his native land could no more affect the "mystery of plastic creation . . . based on the dualism of the two-dimensional and the three-dimensional" than the flight of Einstein could change the relation of mass to energy, or that of Freud the intrigues of the Oedipus Complex. To Hofmann the creation of art was inherent in the idea of Man; as such, it was both objectively justified and self-evidently necessary. As the title supplied by Bartlett Hayes for his major theoretical statement was to put it, art was a "Search for the Real."

Perhaps Hofmann's segregation of art from social conflict had something in it of the traditional political abstention of the German intellectual deplored by Thomas Mann. For Hofmann, painting was a "realm" into which entered none of the negatives of contemporary life. Among the leading figures in postwar American art, he alone, apparently unmoved by motives of discord, purgation, despair, irony or esthetic subversion, has consistently maintained the idea of the beautiful *picture* based on nature and has proved by his work that such pictures can be painted in an utterly contemporary idiom.

In the thirties, then, Hofmann's School of the "new pictorial approach" was an anachronism. To blunt minds it represented the discredited cult of art for art's sake,* to others mere old-hat vanguardism. There, a certain moment in the history

*Thirties people, as a type, and their heirs—*e.g.*, Joseph Solman, painter, Hilton Kramer, critic—abominate Hofmann as the fountainhead of this perversion in American art. The "Marxists" among them ought, however, to have recognized that in seeing the object as enmeshed in laws which reduced its importance yet preserved its integrity, Hofmann was in the philosophical tradition which they claimed as their own and was offering a "dialectical" approach to painting which no American artist on the Left had been able to conceive.

of painting was being revered as the source of timeless values twenty-five years after that moment had reached its zenith and receded into the past. In the Hofmann School the esthetic revolution was still raging. There Cézanne, Matisse, the Cubists, were still defending "the integrity of the picture plane" and one set out with excitement to capture nature's depth and volume by exclusively "painterly" means. This resurrection of the old struggles of art was met with hoots of rage and derision at the public lectures with which Hofmann supplemented his classes in New York.

The transfixing of history in the Hofmann School was strengthened by an appropriate vocabulary: words like "spiritual," "soul," the "shell of life," "inspiration," "genius," were recited without a trace of embarrassment as terms of explication. A sample statement: "The artist approaches his problem from a metaphysical standpoint. His intuitive faculty of seeing the inherent quality of things dominates his creative instinct." I have sometimes wondered how long the School could have maintained its detachment within the controversies concerning social problems, the use of industrial techniques and materials in art, the influence of psychiatry, had it not been walled in by Hofmann's terminology, by his extremely limited English and, later, by his becoming hard of hearing.

Sequestered from time, the School was teaching modern art as a tradition; not any one aspect of it, or school, or individual master, but the quintessence present in all, their assumptions concerning space, their investigations of the relation of nature and art, their experiments with the suggestive powers of paint, their ideal of the artist as remolder of visual perception and of his own personality. Hofmann's educational aim was to avoid pinning down the student in any style or movement but to maximize for him the valid possibilities of today's painting. Absorbing the School's systematization of the "entire new pictorial approach," the student could start anywhere and move in whatever time-direction he was prompted to by his temperament or his mood, always assured that he remained inside the canon of art. The effect of the School in the prewar years was to set the Hofmann student on an historical shuttle

between those points in modern art which Hofmann had encompassed in his own Paris practice. Responding to the Cubist emphasis he might pass from Picasso and Braque forward to Mondrian or back to Cézanne; under the Fauvist stimulus he might be carried from Matisse forward to Expressionism and Kandinsky or back to van Gogh. (Dada and Surrealism never figured in Hofmann's curriculum: he had quit Paris before they appeared and their values could not be reconciled with his conceptions of painterliness and plasticity.)

That Hofmann's esthetics of the object in space and his continued use of the model dissolved for the students the false antithesis between abstract and representational values in art* made their range still greater; it became natural for them, as their knowledge increased, to move to and fro between styles based on sense impression and those resulting from conceptual projections. Thus in a painter like Jan Müller analytical figuration evolves into abstraction which in turn passes over into symbolic figuration. Some of Hofmann's older students, like John Little and Alfred Jensen have worked expertly in practically every contemporary manner. Others like Giorgio Cavallon pushed on fairly soon to abstraction based on division of the surface and contrasts of hue, as did Louise Nevelson in her sculpture; while Carl Holty by a highly circuitous route arrived at a point related to Cavallon's present phase. Others, each in his personal way, entered upon a typical sequence: Cézanne-like figures followed by Cubist still-lifes, then by neo-plastic pure abstraction. Wilfred Zogbaum, Hofmann's first student in Provincetown, returned to painting after the war and conceived abstract landscapes that drew on the local color of East Hampton's shores and skies; subsequently, he gave himself completely to metal sculpture in which he combines the incorporation of stones and hardware with interesting reminiscences

*I know, however, several Hofmann students who have never gotten over discovering twenty-five years ago that a painting "from nature" did not have to look like a lake with trees, a plate of lemons or Aunt Beckie in her bath. To them "abstract" art is still an *issue* on which to be pro or con (as it is also to many art historians and critics), which means that they never grasped Hofmann's message, summarized in one of his recent remarks: "I bring the landscape home in me."

of Léger's contour. The School also produced a peculiar version of Cubist drawing not at all like that derived from Cubism alone: his attention focussed on the model, the student was urged to comprehend that it was not the model as an isolated figure that was of primary interest but the energies whose meeting and clashing gave form to the space she occupied. Under the influence of Hofmann's dynamic such students as Mercedes Matter and Perle Fine brought forth studies in which planes and shapes were indicated as intersections of force by criss-crosses wheeling in constellations. Some of Hofmann's own paintings of the forties bear a structural resemblance to this type of draughtsmanship.

For most students of the School, to be given the maximum number of possibilities proved to be given too many. The problem of the Hofmann student was the same as that of Hofmann himself as a painter: how to choose a direction among the profusion of legitimate tendencies and masters of this era. For Hofmann, one suspects, no choice could in those years be ultimately satisfactory, insofar as it was bound to exclude the others. What but the reluctance to renounce *anything* creative could have made him give up painting for so long an interval in order to become as teacher the voice of the whole development? Engulfed by Hofmann's synthesis, the student, too, had to break loose of it, in order, by setting out on his own, to cease being a mere student.

To whom would a school of art outside of time appeal in the event-conscious America of before World War II? Primarily, as we noted at the start, to bearers of banners—in this instance, the banner of MODERN ART—these included avant-guardniks of taste, as well as timid spirits ready to obey the orders pronounced by the logic of art history. In addition, there were, especially in the Provincetown summer sessions, numerous spinsters whose motives for attending were summed up by Hofmann's jocular comment that "they came to get an experience not otherwise available to them." Of the artists who were to originate the new American abstract art in the early 1940's not one joined the Hofmann School. They were either carrying banners different from his or they were struggling against the

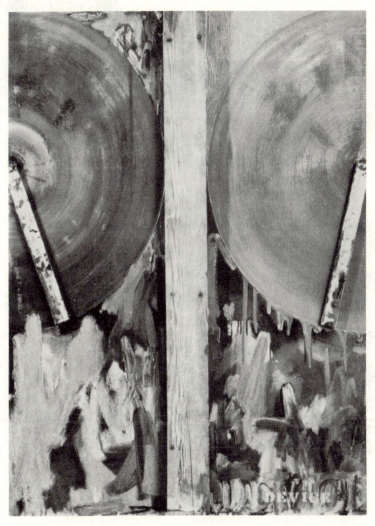

Jasper Johns, *Device*. 1962, oil and collage on canvas, 30 x 40. Ileana Sonnabend

". . . a handmade mechanism for painting Johnses . . ." (page 182)

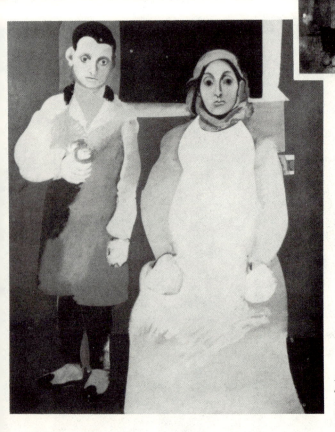

Museum of
Modern Art

Arshile Gorky, *The Artis*
and His Mother, 1926-36, oi
50 x 60. Coll. Whitney Mu
seum of American Art

"*. . . the identity of the artist is a paramount theme.*" (page 100)

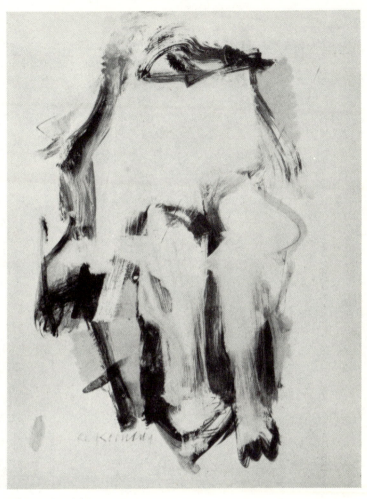

Willem de Kooning, *Woman III*. 1961, oil, 28½ x 21¾. Sidney Janis Gallery

What makes monsters is the irreconcilability of the forces that produced them . . ."
(page 118)

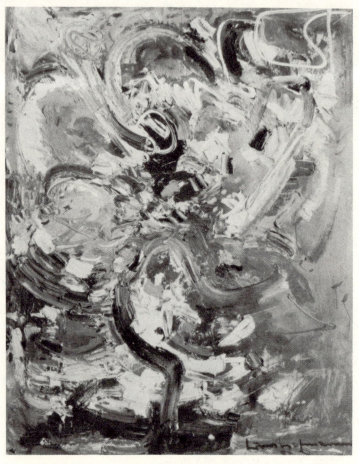

Hans Hofmann, *Liebesbaum*. 1954, oil on plywood, 60⅞ x 30.

" '*Dance the orange. The warmer landscape, fling it out of you, that the ripe one be radiant in homeland breezes!*' " (Rilke, page 158)

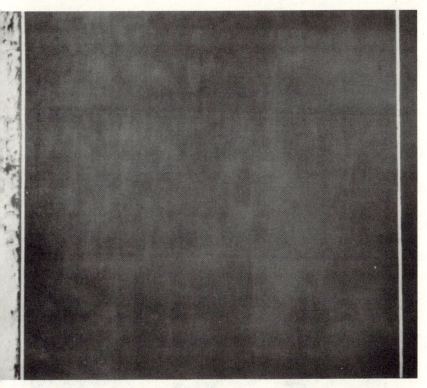

Barnett Newman, *The Third*. 1962, oil on canvas, 101¼ x 120⅜. Coll. David E. Bright

"*. . . the shafts quiver with the passage of vigor or of light . . .*" (page 174)

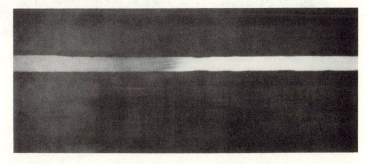

Barnett Newman, *Horizon Light*. 1949, oil on canvas, 30½ x 72½. Coll. Thomas Sills

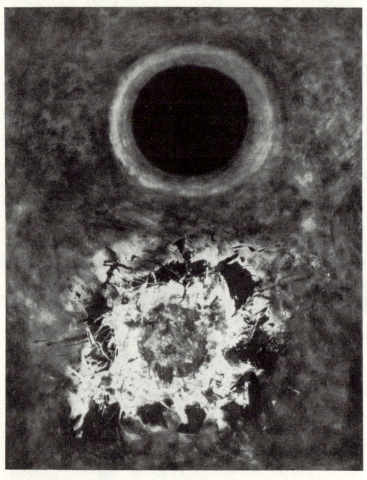

Adolph Gottlieb, *Coalescence*. 1961, oil on canvas, 228½ x 183. Sophie and Boris Leavitt

"... *fulfilled* ... *in becoming universal.*" (page 209)

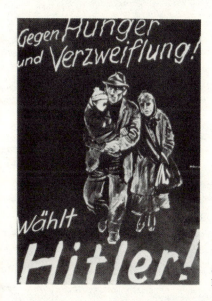

German poster: Against Hunger and Despair. New School for Social Research

*. . . Expressionism, banned as degenerate by the Nazis
. . . permeated their propaganda art . . ."* (page 216)

James Rosenquist, *Four 1949 Guys*. 1962, oil on canvas, 60 x 48⅛. Coll. Robert C. Scull. The Solomon R. Guggenheim Museum

". . . a vessel built to be kept empty." (page 221)

Alfred Jensen, *Interval in Six Scales IV and V*. 1963, oil on canvas, 50 x 56. Graham Gallery

". . . *art today is still sealed up in itself.*"
(page 261)

Andy Warhol, *Orange Disaster #5*. 1963, oil on canvas, 106 x 82. Coll. Harry N. Abrams. Stable Gallery

" '*I want everybody to think alike . . .*'"
(page 262)

undertow of historical determinism and wanted no part of any "system."* It is possible to claim that the School influenced artists outside its walls through ideas carried by its students—for example, Jackson Pollock through Lee Krasner who attended the School for years before Pollock and she were married. But effects at second hand cannot be gauged and are likely to have been of lesser weight than other factors in the environment. It is significant that of Hofmann's pre-war students, most of those who later achieved prominence—Vytlacil, Nevelson, Cameron Booth, Holty, Jensen, Sander—*studied with him before he came to America* (George McNeil is a notable exception). Neither financially nor as an initiating force was the Hofmann School a success. Its lack of impact on the leaders developing in those years is indeed proof that no idea, not even the best, can produce a new art if it is free of the adulteration of time, place, and situation.

Yet the very untimeliness of the Hofmann School was wonderfully timed to affect the critical decade of 1930-40 and thus to give it an indispensable role in the evolution of American art. The creative power of Hofmann's precepts lay not in having reduced to principle the best paintings of his time but in supplying principles to back up those paintings when they and the spirit that produced them seemed threatened with oblivion. Confronted with the brazen certainties of the collective will to social action, the innovations of twentieth-century art had begun to appear wispy products of arbitrary individualism which eccentric plutocrats acquired to shock their neighbors. The esthetic autonomy of Picasso, Kandinsky, Miró was taken as synonymous with irresponsibility. In Germany and Russia the "anarchic" fantasies of modern painting and poetry had been wiped away with a single stroke as vestiges of a social order without a future. In the United States, too, the insights of the masters of the century had already all but sunk out of sight under the bludgeoning of "serious" political and commercial exploitation of The American Scene (incredible as it may seem to today's up-to-the-minute art public, among New York City artists in

* See my *Arshile Gorky*, Horizon Press, New York, 1962.

the 1930's only a small fraction had ever heard of Brancusi, Kandinsky or Gris). The half-buried tradition of Paris vanguardism did lead here and there to sporadic experiments or to die-hard imitations (as with Gorky), but these were conducted as if illicitly—they lacked a conscience to set against the social prescriptions of the day.

It was just such a conscience, mounted on a solid theoretical foundation and enforced by the tangible strength of his own limitless conviction, that Hofmann displayed through his School. The Hofmann School was, one might say, an accreditation of modern art, a monumental certificate of reference—one which American painting might choose to ignore for a period but of whose values it would be compelled to take account in any effort to create a valid art. In sum, the School embodied those attitudes, methods, objectives of contemporary art which alone could inspire new acts of creation in painting and sculpture. Thomas Hess stated the matter in somewhat different terms while the School was still in operation: "Hofmann," he wrote in 1957, "convinces his pupils of the existence of certain Platonic verities; there is such a thing as Good Painting. . . . In the best meaning of the term, the Hofmann School is an Academy—a temple in which mysteries and standards are preserved."

In addition to conserving starting points and ideals the School spread a high quality of appreciation of twentieth-century art. This understanding was to lend support to the new American abstract art when it appeared after the war. Former Hofmann students in teaching and other positions from which they could influence esthetic judgment welcomed the unfamiliar work and were often among the first to collect it. At the University of California in Berkeley, where Hofmann began his teaching career in the United States, pupils from the Munich days—Glen Wessels and John Haley—and of the 1950's—Carl Kesten and Erle Loran—helped to build one of the strongest art departments in the country. Thus, apart from enlightening the artists who attended it, the Hofmann School reached beyond them to the revolution taking place in American taste.

We have been speaking of the School in its external relations, its place in its changing intellectual environment. Another element in its development is more difficult to describe. "The essence of my school:" Hofmann has written, "I insist all the time on depth, suggestion of depth." In its technical aspect this insistence had to do with the student learning how to organize forms behind one another on the single plane of the picture surface rather than causing them to recede through the illusory devices of perspective. But "depth" and the "suggestion of depth" also meant something more: they meant the psychology of the artist. "Art is a reflection of the spirit, a result of introspection, which finds expression in the nature of the art medium." The artist's own "volume" was contained in the two-dimensional space from which he elicited depth. In regard to the School and its teachings "depth" meant Hofmann's personality. It signified that large, openhanded individual who turned no one away—at times half the School was on "scholarships"—who hated and despised no one, who never sought revenge against spite. If art was a "reflection of the spirit," the "spirit" in this case was full of grand jocundity and intellectual expansiveness, endlessly vital, erotic, disciplined, self-indulgent, simple, boyishly tricky, a Dionysius determined to set himself down completely in his system of ideas. The School was an emanation of Hofmann but its boundaries were by no means his; he overflowed it and its teachings in the restlessness of his mind and the exuberance of his feelings. The "message" of this man was, above all, enthusiasm for the artist as a human type and for art as a style of feeling. This his students could grasp (whatever they missed of his thought) merely by being near him and by "watching," as the disciple of the Hassidic Maggid said, "how he tied and untied his shoelaces."

Beyond the Cézannesque formulas of depth, the picture plane and "push and pull," there was Hofmann's individual vision, to which his precepts paid homage but which they could never hope to encompass. This vision was the heart of the School—and of its problem of communication. Not long ago one of the oldest and most clearheaded of Hofmann's students recalled that during his first few months in class he had not the

slightest notion of what Hofmann had in mind when he criticized his work. He gathered that his teacher considered his drawings to be wretched, but on what grounds he utterly failed to comprehend. Subjected to this type of treatment, some students, my informant said, stamped out of the School in a rage and never returned. To the obstacle of his "English" Hofmann added a far greater one: he was trying to communicate the incommunicable.

He was content to think with his back to the life of the times because everything in front of him was, to use a phrase in the tone of Hofmann's painting titles, *bursting with life*. The object (model), the space in which the object was situated, the surface of the canvas or drawing paper on which the picture was to emerge, the medium by which the artist agitated that surface—each was to Hofmann a vital substance quivering with energies which it constantly drew in and sent forth. Below Hofmann's analytical approach lay a species of animism or fetichism that endowed with an independent life every element which the artist handled or contemplated; this apprehension of intrinsic vitalities, the "power to feel into the nature of things," was the axis of his entire conception. "Pictorial life," he wrote, "is not imitated life; it is, on the contrary, a created reality based on the inherent life within every medium of expression. We have only to awaken it."

The self-animation of the painter's materials becomes one with the act of the painter. "We must force it [color] to become a creative means. We do this in sensing the inner life by which related colors respond to each other through the created actuality of intervals. . . . An interval . . . is analogous to a thought-emotion fragment in the creative process through which an idea is made communicative."

For Hofmann "space sways and resounds . . . [it is] filled with tensions and functions . . . with life and rhythm and the dispositions of sublime divinity. . . . The plane is the creative element. . . . Out of a feeling of depth, a sense of movement develops itself. . . . The effects potentize themselves [we are almost listening to Whitman]. . . . Depth, in a pictorial, plastic sense, is not created by the arrangement of objects one after

another toward a vanishing point, in the sense of the Renaissance perspective, but on the contrary (and in absolute denial of this doctrine) by the creation of forces in the sense of *push* and *pull* [Hofmann's ultimate formula]."

Hofmann could never decide—perhaps the question cannot be decided—whether the artist conceives the painting or is subject to it. "A picture," he declared, "must be made, dictated, through inherent laws of the surface." If the picture is *made* by the artist it is not *dictated* to him and vice versa. But in its self-contradiction the statement reveals how Hofmann is equally tempted by the desire to act on his knowledge (of "the inherent laws") and by the impulse to surrender to the "force" set loose by a stain or a stroke on the canvas. This balance of contrary susceptibilities accounts for the vast swings in his paintings between strict planning and willful letting go.

The primary aim of Hofmann's teachings was to draw the student-artist, whether through reason or feeling, into the universe of the canvas, where the "awakening of pictorial life" would surround him with undreamed-of powers and, in conflict and harmony with one another, give rise to the "meetings," "bridges," "communions" of a continuous creative process that embraced all of its components, including the artist himself, in a singleness.

To induce such a renewal of the imagination, prose, even at its most eloquent, is inadequate. One will not apprehend the rip tides and rockets of vitality inherent in motionless entities and empty space simply through being informed that they are there. Given Hofmann's extremely limited means of communication—a cloudy metaphysical rhetoric plus alterations made on the student's work during criticism sessions—how could he carry over to his philosophically untutored Americans a poetic vision that translated into terms of painting-technique the "organicism" of the esthetic Bergsonians and the heirs of Gauguin, the Nabis and African anthropology among whom he had matured in Paris? Periodic expositions in writing, almost always badly translated, of his artistic program hardly improved matters. At best these could communicate only one segment of his insight after another. But as Hofmann spoke about the plane,

it would begin to seem the secret of the whole of painting; and the same for space, negative and positive, and for color, movement, relations. Thus a student stuck in the "volume" phase of Hofmann's teaching might hear much about "awareness of space" and that "there are higher things to be seen in nature than the object," yet he would go on "abstracting" from the model and build male and female golems. Or, captivated by the picture plane, he would fail to "differentiate between an active and a passive flatness," so that Hofmann would ruefully observe: "I have students who come to me painting in two-dimensional rhythms, an empty affair."

How all the aspects of a painting grow out of one another from a single center can be demonstrated only through model works. As we have seen, however, Hofmann did not wish to point to Cézannes or Matisses or Picassos for fear of propelling the student into imitation. Still less did he wish them to paint Hofmanns. For years he actually refrained from painting (though he did continue to draw) out of deference to his function as a teacher. Teachers who paint, he said, recalling one by whose indifference he himself had been hurt, forget their students in pursuing their own careers. Even when Hofmann did begin to paint again in the late thirties he kept his work out of sight as long as he was able from fear that his students would copy his paintings rather than seek to comprehend the thinking behind them. He wanted the student to receive his principles not in order that he might repeat Hofmann's application of them but that through them he might discover *on his own* the world and his own self. In rejecting the part of the master's work in teaching art, Hofmann seems to me to have been misguided, though from the most laudable motives. He put himself in the position of attempting the impossible: to teach a *science* of creation. In the teaching of art, imitation cannot be dispensed with; since in art as in action, the final meaning of an idea is in its concrete realization. In other words, thought cannot be detached from form.

In time Hofmann recognized his failure. "Motto:" he wrote, "the artist never is the product of the teacher—intuition and greatness of mind cannot be given." Recipes, yes; but that

tremblingly alive universe with its perpetually unfolding move-
ments—that could not be transmitted. Yet becoming convinced,
no doubt through repeated disappointments, of the futility of a
methodology designed to make others see and feel never pre-
vented Hofmann from trying again. I watched him in one of
the last years of the School in Provincetown go from easel to
easel and literally hurl himself into the drawing of each student,
no matter how mediocre, as if through his own concentration
he could snatch out of it some perception which, though barely
on the border of consciousness, might, once grasped, set that
plodder on the road to a developing vision. The teacher emerged
from the session dripping and exhausted like a Channel swim-
mer, while the students, most of them, stood with their mouths
open and with perhaps some of the old resentment at having
their sketches "spoiled" by this omnivorous master.

Hofmann had become a teacher to teach not painting but
the conditions of creation in painting. These conditions de-
manded that he lift up the student's spirit while enlightening his
mind: "I offered already at this time [the opening of the School
in Munich] the plastic basis of creative visual experience *and
the spiritual attitude demanded for its pictorial realization.*" (My
italics.) It was this spiritual attitude, of which his theoretical
and technical concepts could furnish only sporadic hints, that
at length proved to be the School's most valuable asset. For it
was precisely Hofmann's uncommunicable subjectivity that
enabled his School to merge its teachings of the thirties into
the creative afflatus of American abstract art of the next decade
and to pass on the new insights as phases of modern painting
tradition.

As with American painting itelf, tremendous changes took
place in the Hofmann School at the end of the War. The GI
Bill flooded it with students and brought prosperity and prac-
tical problems. The atmosphere of a cult was largely dissipated,
though Hofmann and his wife continued to be caught up in
the personal lives of students. Most important, the rise of the
new American art supplied the missing examples of the creative
possibilities Hofmann had been trying to communicate. The

Hofmann teachings now shone forth in a prophetic light. Not the Muse of social consciousness but the ideologist of picture planes and throbbings of space and color had been proven right about the direction of painting. Fifteen years after Hofmann's arrival in the United States the period in art history in which he had been immersed was suddenly drawn forward into contact with the present. His creative response to this phenomenon, which happily upset the equilibrium of opposites in which he had been held throughout his adult life, changed him at sixty-five from an embodiment of the values of yesterday into the teacher of the latest idea and into a young artist.

In form Hofmann's teaching conceptions remained substantially the same as before. But these concepts had been transformed from within by the references supplied them by the new American painting, to which Hofmann showed himself at once completely hospitable. The student could now interpret both the manic and the rationalistic in Hofmann's approach in terms of the abstract paintings and sculptures he saw in New York galleries rather than by researches into the School of Paris. In the emergence of Action Painting he could see illustrated Hofmann's intuitions of forces, conflicts, explosions of energy; while new works based on division of the surface, the juxtaposition of planes, the passage of light through pigment, bore out what he had been taught concerning the latent potentialities of the artist's medium. What Hofmann talked about in class seemed relevant to the qualities of painters as different from one another as de Kooning and Rothko, Pollock and Newman.

Yet within the flood of creative novelties Hofmann's lines with the past continued to hold ("I have never given up the object," he reaffirmed), thus maintaining the authority of study and principle. So that after the War the School, to its immense credit, was more truly an Academy, in the sense referred to earlier, than ever before.

The fundamental alteration of the School could best be seen in the paintings of its more gifted students after 1948, when the contemporary American work began to take hold publicly. The majority of Hofmann's later students owed more to Americans at work and to the intellectual environment of New York

than to the Paris classics or Hofmann's ideals of plasticity. Also there appeared an increasing volume of canvases that were directly derivative of Hofmann's own paintings. With their teacher's creations before them, students of the School could appropriate his animistic vision without being compelled to decipher his notions of Reality. Even some of Hofmann's closest and best sudents, like George McNeil and Cameron Booth, had to wait for Hofmann's own paintings in order to enter more directly into their teacher's imagination; by this approximation their work by no means suffered—I am thinking of McNeil's "Oblique Surge" and Booth's "Surging," paintings which courteously acknowledge their affiliation through the Hofmannesque word "surge."

During its first fifteen years in the United States, the School made modern art seem both teachable and worthy of being taught; for the next fifteen years it was a means through which the student could engage himself in the new with a maximum of stability. In their capacity for resurrection within the postwar American art, Hofmann and his teachings have demonstrated the creative power of a new tradition in an epoch when the old traditions have been collapsing or have become irrelevant, and when art without tradition suffers the inevitable doubt, guilt and inner weakness of that which lacks a sense of right.

HANS HOFMANN
2. NATURE INTO ACTION

Of all *liaisons dangereuses* none is considered more perilous to the artist than living with ideas. In that alliance, every passion is diluted by argument, every response of sensibility by examinations of purpose. The quiet exercise of talent is out of the question, and one may wake up any morning to discover that the conceptual bitch has run off with everything. For more than half a century Hans Hofmann has triumphantly survived this essentially young man's pastime, developing through it his power of inventiveness, vivacity, and assurance.

The canvases of Hofmann are demonstrations of concepts— and of getting away from them. A founder of automatism in American painting, he was led to his reflexes by theory and to the accidental by the recognition that the demands of consciousness can be too exacting for creation. Only a model of obedience to law could have been so insistent on acquiring for art the resources of chaos, or so alert to distinguish actual spontaneity from manneristic representations of the spontaneity formula. If in the act of painting Hofmann "wants not to know what I am doing" (as Elaine de Kooning quoted him as saying in an early article on him), it is not because he wishes to lay claim to revelation but because there is a not-knowing "element" in art that may be too far diminished by over-insistent intention. Hofmann's suspensions of thought are an homage to the immanent logic of the medium laid bare by his experiments. He is an Action Painter (not in all his modes) to whom an action implies responsibility to the mind and to something beyond it.

I distinguish in Hofmann's paintings three (or four) major phases, each of which points to a different conception of the term "abstract" art—though Hofmann does not close them off from one another but goes back and forth among them.

In the first phase, the artist's primary interest is analytical study of "Nature," as interpreted in the metaphysical lingo that more than anything German has remained stuck to him.*

* Catalogues of Hofmann's shows have often contained explanatory theses bearing such titles as "The Resurrection Of The Plastic Arts" or "The Color Problem In Pure Painting—Its Creative Origin." These how-to-do-it, or rather

Most deeply enmeshed in Hofmann's classroom labors, this "learning to see" period centers on a system for transforming visual experience into "plastic creation on a flat surface without destroying this flat surface." The union of brain and eye are saluted in his breeze-laden Cape Cod landscapes: "Truro River," 1937, and "Provincetown Harbor," 1938, are built of ragged-edged rectangles of vivid oranges, blues, yellows, the "color-bearing planes" holding depth under control with the aid of flying scrawls still used to outline objects. Components of these landscapes, no longer harnessed to representations of water and rowboats but with their look retained, are recognizable in differently specialized forms in the work of dozens of American contemporaries, including Hans Hofmann himself.

Still lifes of these years lack the strength and airiness of the landscapes. They incline towards crowding, even clutter, as if the artist's intellect had insisted that everything that presented itself ought to be taken care of esthetically and that no advantage needed to be gained through external economy. At this time Hofmann obviously requires the outdoors; he also seems freer of Matisse there. A dozen years later, with analysis of nature transcended by a succession of syntheses, the problem of How Much? has eliminated itself as Hofmann's interiors are swept clean by cerebral gusts.

In his later landscapes Hofmann continues to recall some of his early pictorial means, now transfigured by different aims. In "The Garden," '56, the rectangles of "Truro River," reduced to small slabs of pure color, have become a pavement of light through cliffs and jungles of fierce impasto; released from the dispositions of observed forms, they swirl in the rotating pull of massive discs long a feature of certain of Hofmann's paintings of the human figure (one might interpret them as "heads" launched in cosmic space). The circular movement engages itself in the substance of the heavy pigment in a

how-to-think-it, communications, whose point has often been left behind by the paintings being shown, are among the most congenial pleasantries of the contemporary art world. The last-named article, incidentally, begins: "The genuine value of a painting is greatly determined through its basic concept"— regardless of the growing irrationalism in his approach Hofmann has not neglected his courtesies to his mental partner.

manner different from Van Gogh's, a canvas like "Le Gilotin," '53, becoming a relief composed of hunks of charred velvet, strips of bluish silver elastic, clots of bituminized bananas.

Before such new "nature" could come into being the research into visual perception had to be superseded by another mode of imitation equally dissociated from copying. In Hofmann's second phase the dynamism of the picture takes precedence over the truth of the scene. Abstraction now results not from the translation of appearances into the alphabet of the medium but from the "automatic responses of the picture surface." The painter still starts with the model, but once his notations have begun working on each other the canvas is allowed to take over, the painter "thinks not" nor sets requirements but follows the intimations of the picture's brain with its dialectic of tensions and counter-tensions, Hofmann's "push and pull."

The effects of automatism depend of course on who is being automatic. Working at a speed that excludes meditation, Hofmann now seeks to be guided by the debate of pictorial knowledge with itself. The automatism is in the logic of the discourse: since this "plastic animation" has taken place, an opposing movement must reply to it . . . and so forth. When the painting quiets down Hofmann finds out what he has been thinking.

The tendency of this phase, very dominant in Hofmann's painting between 1947 and 1951, is towards constructions rigged of geometrical contours. These are at times effects of compositional intuitions ("Magenta And Blue"); or, seeming to originate apart from the visual world, they constitute emblems of psychic states or entities ("Perpetuita," "Germania," both 1951), like in impulse to, though not resembling, Kandinsky's later abstractions. "Ecstasy," 1947, an angular, machine-like projection of planes, and of lines employed as planes, is, in its kinship to metal and wire sculpture, rich in hints yet to be exploited: on the other hand, one is reminded of pre-dada analytical art—the "ecstasy" might have been that of one of Duchamp's bachelors.

With regard to the tensions it is capable of setting up in

our bodies, the medium of any art is an extension of the physical world; a stroke of pigment, for example, "works" within us in the same way as a bridge across the Hudson. For the unseen universe that inhabits us, an accidental blot or splash of paint may thus assume an equivalence to the profoundest happening. It was not inconsistent with Hofmann's rigorous conception of nature that he early began the exploration of accident in painting. But his remark on "The Prey," 1956, a canvas which arouses in him the enthusiasm of an indescribable reminiscence, shows how profoundly he has weighed the gifts of chance in art: "for this," he said, "you need to be in the rarest states." It is, in other words, by the magic of spirit that one "earns" unexpected successes in art.

If the ultimate subject matter of all art is the artist's psychic state or tension (and this may be the case even in non-individualistic epochs), that state (e.g., grief) may be represented through an abstract sign. The innovation of Action Painting was to dispense with the representation of the state in favor of enacting it in the physical movement of painting. The action on the canvas became its own representation. This was possible because action which carries the psychic into the material world is by its nature sign-producing; it leaves the trace of a movement whose origin and character are not ever altogether revealed—for instance, the act of love results in a correlation of bodies which, as Freud pointed out, may be mistaken for murder. Yet, once accomplished, the action also exists in the thing which it has transformed as by a scratch on a cheek.

In turning to action, abstract art abandons its alliance with architecture, as painting had earlier broken with music and with the novel, and offers its hand to pantomime and dance. To this transformation of painting belong such Hofmann masterworks as "Burst Into Life," 1952, and "X," 1955. "Liebesbaum," 1955, is a tree danced—in the scent of one of Rilke's nymphs.

> "Dance the orange. The warmer landscape, fling it out of you, that the ripe one be radiant in homeland breezes!" (Plates, p. 140)

In painting, the primary agency of physical motion (as distinct from the visual representation of motion, as in Delacroix or the Futurists) is *line*. As stroke or as figure (in the sense of figure skating) a line is the direct manifestation of an act, though of course it also has other functions in painting; for example, to define contours, to connect two points, to be a narrow plane between other planes. In its passage on the canvas each line establishes the actual movement of the artist's hand as an esthetic statement, and this is true whether it outlines a pony cart or belongs to the shading of a nose or is there without any external reference.

In Hofmann's Action Paintings, which include some of his most remarkable canvases, the strokes of color retain their separate identities within the picture situation and function as forces in conflict, instead of being changed by their width or length into mere relations of planes (Plates, p. 140). It is this that brings his Action Paintings into focus with those of Kline and de Kooning. Among the first to make compositional use of the free scrawl, Hofmann has not, in order to obtain linear momentum, turned himself over to calligraphy with its tendency toward monotony, but has known how to vary his line almost at will from wiry volutes to the broadest staccato jots. Nor has the immediacy made possible by Action Painting often seduced him into compulsiveness—nor into that depressing bogus decontrol fashionable in Europe. Weakness in Hofmann's painting occurs when the artist has moved so fast that the action on the canvas is finished before he has been able to get into it: compositions of this type lack development and turn into more or less lucky swipes of color. Weakness also appears when Hofmann loses his grip on the action and falls back on concept to bring the painting to completion: here the artist's undefined feelings are suppressed. The best Hofmanns hold the action from rhythm to rhythm in a superb synthesis of impulse and esthetic consciousness.

Action Painting restores art to an ethic beyond mass ideals and taste. The dialectics of Hofmann's morality balances on his struggle against the given, the struggle for the "creative" (his favorite word) as the sole reality—it involves putting into

practice his fixed romantic assumption that painting must be constantly prevented from becoming the means by which the artist repeats himself. Beginning again is not only the rule for each new canvas; it is the inner process which gives meaning to the picture.

No American artist can mount a show of greater coherent variety than Hans Hofmann. Fed by his tireless consciousness, constantly growing more concrete and inwardly responsive, his originality suggests no limits. Besides the innovations flowing from his enveloping approach to art and experience, he has been able to derive novel conclusions from reflections of his thought sent back to him by artists whose inventions have been in debt to his teachings or to talk about them. This latter kind of originality is today more rare than original originality —it is more rare for a man to keep up a continuing communication with himself through others, as Hofmann has done, than to build a unique mouse trap in the desert.

Elaine de Kooning

THE LABYRINTH
OF SAUL STEINBERG

Steinberg's line is the line of a master penman and artist; it is also a "line"—that is, a kind of organized talk. The pen of this artist-monologist brings into being pictures that are also words, e.g. the odd *birds* at a cocktail party. Or they are visualizations of things said, as in the drawings in his book, *The Labyrinth*, where people utter flowers, strings of beads, heraldic decorations.

Both because of his superb penmanship and the complex intellectual nature of his assertions, I think of Steinberg as a kind of writer, though there is only one of his kind. He has worked out an exchange between the verbal and the visual that makes possible all kinds of revelations. For instance, there is a drawing in which a triangle on one end of a scale weighs down an old patched-up, decrepit question mark on the other. Axiom: A NEAT FORMULA OUTWEIGHS A BANGED-UP PROBLEM.

To build his labyrinth, Steinberg had only to draw a line from A to B on the principle that the truth is the longest distance between two points: the result is an enormous scrawl within which the original two dots appear as the eyes of the Minotaur.

As if the relations between words and objects were not complicated enough, Steinberg has thrust between them the illusions of the drawing paper. "There is perhaps no artist alive," testifies E. H. Gombrich in *Art And Illusion*, "who knows more about the philosophy of representation." A long straight line keeps changing its pictorial functions—first it represents a table edge, then a railroad trestle, then a laundry line, until it ends up in an abstract flourish. Steinberg is the Houdini of multiple meanings: the line with which he creates his labyrinth and entangles himself in it is also the string that leads him out of it.

Logician of stereotypes and repetitive social situations, Steinberg brings to life dramas of abstract entities masquerading as people, animals, landscapes. All his formulas, comical mainly through their magical terseness, have deep contemporary reference. A sequence of drawings shows a serpentine line penetrating, or being swallowed by (Is it the same thing?), a cube

and coming out on the other side organized into a geometrical pattern—a spoof about Cubism, yet also a reminder of the forced straightening out of our ideas (our "lines"). Steinberg's dialectic, however, also recognizes that we desire this straightening: on the facing page, a roughly sketched cube dreams of one drawn with a ruler and with its corners lettered in ABC order. Then comes a sketch in which an artist's line leaves the canvas and fills up the room around him—the labyrinth again; while on the following page, the line organizes itself into a road map of success labelled with the motto inside the crest of the Pall Mall cigarette package: *per aspera ad astra* . . . I know of no American novelist or poet today who is saying these things more astringently.

In Steinberg's conceptual realm, words have the substantiality of things. Elaborating on the speech balloons of the comic strips, the series of word-visualizations mentioned above shows ephemeral persons enunciating huge constructions, solid grills, architectural designs; a dog barks a zigzag; while on a mountain of gibberish he is in the process of emitting gesticulates an orator who is a scribble.

Counterpointing this theme of the materiality of speech is that of words behaving as "characters," as in the incomparable group where SICK lies flattened out on a cot, HELP topples off a cliff, TANTRUM explodes into a rocket display.

Irresistible as a juggling act, Steinberg never satisfied himself with the merely entertaining—the reason, I should say, why his vein has shown no sign of running out. His translations of words into pictures and pictures into writing continuously scoop meaning out of platitudinous situations and set phrases. This is a labor of philosophy. Specifically, Steinberg is a philosopher of identity, a subject he dreams about all day and reasons about in his dreams. His illusionist double language is, in the most complete sense, an autobiographical record, notations of a prolonged research into the artist's self within surroundings at times menacing and always full of strangeness. And Steinberg reveals that meditating on who one is cannot be carried on by mere remembering and analyzing but involves a game with devices of the imagination that are not un-

like those let loose by mental disorder. Foremost among these
risky toys indispensable to poetic investigation is the device of
the projected self—the device of the mask, ancient device of
comedy and tragedy and symptom of the split personality. On
the jacket of *The Labyrinth* is a profile of the author as a
square-jawed Solid Citizen whose head is a cage out of which a
white rabbit peers fearfully through the eye socket. On the in-
side flap, Steinberg turns up in a full length photograph wear-
ing a mask of Steinberg drawn on a paper bag. Behind the solid
citizen, the rabbit, the caricature on the bag, is the unknown
Steinberg who watches the others—and who in the collabora-
tion with them is the creator of his drawings. Steinberg's fic-
tions make him visible to himself by exaggerating him: a living
face can be deadpan, but not as dead a pan, nor capable of chal-
lenging the world with so fierce a stare, as the same face drawn
on a bag.

Steinberg is present under disguise in most of his draw-
ings; in all, if one accepts the view that everything Steinberg
draws is Steinberg in contour (the exceptions are some beauti-
ful pen-and-wash drawings done for their own sake as well as
from a perverse desire to mislead). In the past, in addition to
being the little man at cocktail parties and art galleries, Stein-
berg used to be a cat. Lately, he has become a fish. As a cat
he was engaged in domesticating himself (an early book was
called *The Passport*). As a fish he's out to catch himself (an-
other meaning for the "line"). The axiom of one drawing might
be: THE FISH IS A SPHINX TO THE CAT.

Steinberg lives in a world of Steinberg (e.g., drawing of
the Trojan Steinberg into which all the little men climb), of
quasi-Steinberg (e.g., this author, through the formula, a Stein
is a Rose is a berg), of anti-Steinberg (scenes in Florida, Rus-
sia, the Far West). Anti-Steinberg is the mask of the unfamiliar,
including the crowd and public applause: a harpy queen is
determined to clamp laurels on the brow of a fleeing little man.
Drawings of monuments and glories end with one of the hero
with his foot on his own head. In another, the laurel-lavishing
harpy repeats her bid to Steinberg-laureate standing on a base
adorned with Steinberg *couchant*, the whole ensemble hang-

ing over an abyss. Such is fame, declares the artist-student of self, listening for the crash.

Since his drawings are themselves "words," their meanings flowing, as in Baudelaire's *Correspondences*, from sense to sense and from thought into materiality, captions would be super-fluous and Steinberg never supplies any. His images retain their silence, and this is a source of their pathos, even when the joke is strongest.

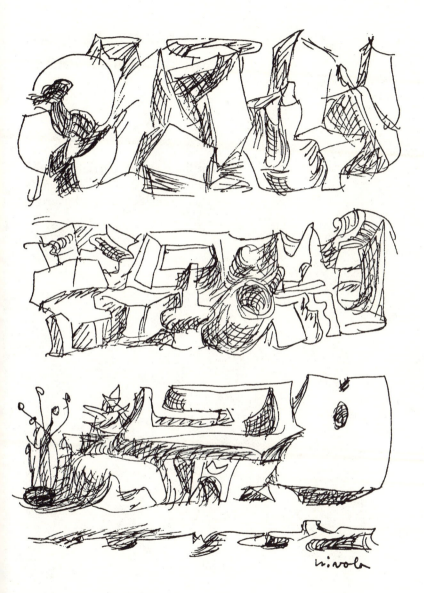

Constantino Nivola

BARNETT NEWMAN
THE LIVING RECTANGLE

"For it is only the pure idea that has meaning. Everything else has everything else." Barnett Newman—"The Ideographic Picture"

Although few would call Newman an "Expressionist," the outstanding characteristics of his paintings are also those of his personality. Newman is a man of taste, a man of controversy, a man of spiritual grandeur. Paralleling these attributes, his paintings are at once impeccable decor, an argument about art, forms of the "sublime" (a term he has striven to re-introduce into painting). If his qualities are taken one at a time, Newman may be regarded as a designer of roomfuls of beautifully colored and proportioned spaces: his expanses of blue, yellow, red, "envelop" the spectator, as if he had entered the eye of a precious stone. Or Newman can be seen as primarily a polemicist in art who, through his canvases as well as his letters to the press and his pronouncements in conversation and in lecture halls, supports a position "beyond Mondrian." "The geometry (perfection)," he has written of the Dutch abstractionist, "swallows up his metaphysics (his exaltation)." This is a brilliant way of emphasizing the emotional content of paintings as against those who would reduce them to a manner of handling. Or Newman may be appreciated as a "mystic" through whose canvases the onlooker levitates into cosmic pastures where emptiness and plenitude are the same thing. All of these identifications have some relevance. Yet taken by itself each has as much to say about the temperament of the beholder as about Newman and his work.

To comprehend Newman's art its triple nature must be grasped in a single movement of the mind. A graciously reserved invitation to the eye balances the intellect on pivotal issues of contemporary art (e.g., How far can one go with evenly brushed areas of color devoid of forms?), while summoning the imagination through an image that rejects images to a ritual stripped of myth. The joined responses mount and recede into one another. That is to say, they are *active* responses, difficult for the observer to hold in place psychologically (much as critical formulas may succeed in pinning them down), the difficulty being greater because the artist has refused to supply visual footholds. But the direction of the mind's movement as it passes through the sensuality of the painting as setting and

through critical speculations regarding Newman's intentions is toward the purity of wordless recognition—a process like that in Wallace Stevens' lyric, "The Ultimate Poem Is Abstract:"

> It is not so blue as we thought. To be blue
> There must be no questions.

"Triple thinking" is not common in art criticism and for Newman overcoming a piecemeal reception has been a slow process. When the first exhibition of paintings in his present vein was held in 1950, they were greeted even by artists as a decorative invention. At a party given for Newman at the Artists Club in Greenwich Village the night of the show, colored feathers found on the street were pasted in vertical bands on sheets of cardboard and segments of the wall. When Newman came through the door he was deeply moved to discover that he had at one stroke established an insigne. The reaction to his second exhibition a year later was to an even greater degree an appreciation of his paintings as setting, a response reinforced by white-on-white free-standing sculptures and by the show's announcement in which white lettering sank out of sight in a lake of whiteness. To the eye alone—that is, ignoring the metaphysical emotions which they generated *potentially*—Newman's paintings were of the esthetic order of Louise Nevelson's later all-black, all-white or all-gold room sections.

From its first public display, however, the art of Newman gave rise to maximum reflexes of repudiation and scandal, owing to the extreme simplicity of their means and their seemingly obvious derivations. What had Newman done but carry a step farther toward absurdity the purism of Malevich and Mondrian? The praise which his work received as a contribution to decoration was essentially a defense of it against the charge that it was nothing, a gimmick picked belatedly out of art history. Before Newman's pictures could be experienced in their uniqueness, both assault and apology had to be surpassed. For this, time was required. The paintings had to become familiar in their visual apartness from all others; only then could reflection about them clarify itself. Aware of the need to segregate

his paintings in the public mind, Newman chose perhaps the most effective strategy to this end: he ceased to exhibit for seven years—the Biblical seven, fancy suggests, in the light of such Newman titles as "Joshua," "Uriel," "Genesis," "Covenant."

Good taste needs no arguments, but the attempt to affirm a metaphysical reality gives rise to endless dialectical warfare. The synthesis of an ideal of the absolute with a version of "art now" which Newman had wrought in his paintings had to be dissociated from works by other artists to which as visual entities they bore unmistakable resemblances and affinities but whose objectives were entirely different. Only by clearing a ground of principle could what his art had to say be sharply limned within the gray common vocabulary of non-objective art. The present state of art criticism, with its mumbling counterfeit of the shop-talk of artists about painting "elements"—color values, light values, deep space, flat space—added to Newman's difficulty in isolating his "thought-complex." Besides distinguishing his creations from those of European predecessors, he had to establish their difference from contemporary American neo-Plasticism and even more strictly from the work of such once-close fellow-experimentalists as Mark Rothko, Clyfford Still, Ad Reinhardt. This task was to engage Newman in a protracted campaign of distinctions and clarifications not unlike that conducted by his celebrated ecclesiastical namesake.

Fortunately for Newman, verbal conflict is neither as distasteful to him as it is to some artists nor as beyond his capacities. Endowed with a rare strain of ideological persistence, he also has at his disposal a highly developed skill in disputation —these carry him at times to the border of hair splitting, though one who resists losing patience will usually discover that the particular hair was in need of bisection. This tendency of Newman to draw lines of division is, of course, an outstanding aspect of his painting.

Whether they fan out into lawsuits against landlords and "slanderers" or hold the fort on axioms of painting, Newman's dialectical bouts follow an unrelenting arc of logic that often carries them into Molièresque comedy. Nor, despite Newman's

passion, is the humor an unintended by-product. The following is his complete statement for a symposium on "Why I Paint:" "An artist paints so that he will have something to look at; at times he must write so that he will also have something to read." At a forum in Woodstock in which Susanne Langer was a participant he propounded the formula that, "esthetics is for the artist as ornithology is for the birds."

Yet Newman is deadly serious and, kept going for any length of time, his logic will be found blasting a path to his Idea. A prime example of Newman fighting both for the fun of it and in order to plant his mythic banner is his battle in *Art News* with the noted scholar Panofsky. The dispute involved a misprint of "sublimis" as "sublimus" in the Latin title of Newman's painting, "Vir, Heroicus Sublimis." Panofsky seized on the misprint to express his irritation both with the titles appended to contemporary works of art and with the works themselves. His letter to the editor left the suggestion that Newman's "*sublimus*" was typical of the ignorance of modern artists and it playfully quoted the observation of the medieval monk Aelfric that God is above grammar.

In his riposte, which occupies a full column, Newman chides Panofsky for slipshod reading, pointing to the fact that while there had been a misprint in the caption of the reproduction, the title had been given correctly in the text of the article. With this point he has won the argument, but Newman does not stop there. He goes on to defend the correctness of the *misprint*, citing dictionaries and ancient usages in favor of "sublimus," and concludes by heightening his polemic into a rousing profession of faith in art. "As for the matter of Aelfric, the tenth-century monk had a greater sensitivity for the meaning of the act of creation than does Panofsky. One would think that by now Professor Panofsky would know the basic fact about a work of art, that for a work of art to be a work of art, it must rise above grammar and syntax—*pro gloria Dei*."

Aimed at setting up barriers against the adulteration of his concepts, Newman's writings on art employ a repertory of negatives that cancels practically everything being done in art —among his differences from other purist-negators is his per-

sonal good will toward artists. Fifteen years ago he disposed of both representational art and formal abstraction. Painting, he argued, is neither imitation of objects in the artist's environment nor is it mathematical organization of lines, shapes, colors —neither picturing of everyday realities ("left to the toymakers") nor non-objective pattern (left to "the women basket weavers"). With nature and decorative design set aside, further distinctions were necessary: the abstract shapes must not be a derivation from "visual fact" nor "a purist illusion with its overload of pseudo-scientific truths."

What emerged after all this cutting away was the notion of the abstract shape as "a living thing, a vehicle for an abstract thought-complex, a carrier of awesome feelings . . . the abstract shape was therefore real." The most extremely rational art of our century had been rationalized over the border of rationality and converted into a "vehicle" for cosmic emotions.

That Newman's rectangles are real and living shapes means that they cannot be produced by external calculation but that the artist must enter into them as spatial indeterminates which he brings to certain dimensions in the experience of painting them, as one holds or cuts short an interval of breath. Art, said Paul Klee, is always seeking a "state in which abstract forms can become meaningful objects, or else pure symbols as constant as numbers and letters of the alphabet. Taken all together, these may become symbols of the cosmos; that is to say, they become a form of religious experience." Newman's paintings are in accord with this program.

The use by Newman of such words as "vehicles" and "carrying" implies a sense of movement; and despite their impassive appearance movement is the key to Newman's paintings. In a canvas just preceding his last style (*Two Edges*, 1948), motion is visibly rendered as ascent and descent by means of the brush marks and the angling of one of the shafts. To this painting might have been applied an early joke about Newman, that his vertical stripe was the closing of the doors of an elevator—did the car go up or down? In still earlier paintings ("Death of Euclid," 1947, and "Euclidean Abyss," 1946-47), the stripe *branched* upward as if carrying a stream of sap

or of light. Such literal associations were purged in the subsequent paintings. The rectangles became "real things" with unruffled surfaces pressing toward their edges in rhythms determined entirely by energies of color. Being without focus, Newman's canvases keep the eye in undistracted motion within compounds of pigment. In some, however, the suggestion of upward movement of the earlier paintings is retained through eroding the edges of the vertical band. It may be an exaggeration to say that in these the shafts quiver with the passage of vigor or light (equivalents in the lexicon of spiritualism) at varying speeds, but in one of Newman's less frequent horizontal compositions the color of the strip unmistakably shades off like the change in an electric band when a certain velocity is reached. That the movement in Newman's paintings is inherent in their forms separates them in intention from contemporary purist abstractions that aim to animate the eye through scientific juxtapositions of color areas.

The sentiment of the heroic (brought forth in such titles as "Ulysses," "Achilles," "Prometheus Bound"), the sentiment of the cosmic ("End of Silence," "Pagan Void"), the sentiment of the mythic ("Dionysius," "Queen of Night"), the sentiment of the primitive ("The Beginning," "Genesis," "Day One")—with Newman these are all one sentiment, experienced in his paintings as the sentiment of one-ness ("Onement #'s 1-4," "The Name"). In the last analysis, singularity is their subject, a singularity beyond human reach. In sum, Newman's paintings are a short cut to the unattainable.

Ludwig Sander

JASPER JOHNS
"THINGS THE MIND
ALREADY KNOWS"

The images in Johns' paintings are familiar* but without the grossness favored by the Pop artists. The American flag, the marksman's target, numbers, letters of the alphabet were not conceived to identify a brand of soap or to captivate infantile imaginations. The word "commonplace," which most critics apply to Johns' motifs, does not, strictly speaking, describe them accurately. There is nothing commonplace about an 8.

The symbols selected by Johns are separated from the banal by their abstractness and dignity, qualities which are also outstanding in Johns' personality. In the absence of his big grin, he reminds me of William S. Hart, the deadpan sheriff of the silent Westerns. Johns has Hart's long, flat poker face, thin lips and alert eyes slanting up at the outer corners. Like Hart he gives the impression of one who sizes things up, keeps mum and does his job. Johns' detachment is of the era of the beats, the cool cats and Bohemian Zen, as Hart's belonged to that of "Howdy, stranger" and the card sharp. With his level stare, Johns paints targets. Hart perforated his with a sixshooter.

In his first one-man exhibition in 1957, Johns' paintings produced an immediate impact, not because flags and targets have a popular appeal but, on the contrary, because these public emblems upset the prevailing relationship between painting and its audience. Abstract Expressionists and Action Painters conceived art as a series of experiments in self-illumination: the public consciousness had no part in the work. Indeed, ignoring the grandstand was evidence of the artist's integrity. This attitude corresponded to the isolation of American abstract art in the years following its emergence during World War II— it made one think of Apollinaire's phrase, "gestures among the solitudes."

By 1957, however, the situation had radically changed: the presence of an art public, socially heterogeneous but esthetically clamorous, had become a fact of artistic creation in the United States. Johns' star-spangled banner beckoned the new art lovers into the arena of art. More exactly, it recognized that

* "I went on [from the American flag] to similar things like targets, things the mind already knows, that gave me room to work on other levels."

they were already there—as, earlier, Rauschenberg with an ar-
rangement of unpainted canvases had taken jocular notice of the
crowds at art openings talking with their backs to the wall. In
Johns' paintings, symbols that spanned all intellectual and cul-
tural differences in the art public replaced the private signs
of the Abstract Expressionists. While other artists of the new
generation (Johns was born in 1930), still dealing with paint-
ing in and for itself, strove to extend Abstract Expressionism
through a "return to subject matter," or to surpass it through
a logic of formal development, Johns cut around behind the
art of de Kooning, Rothko, Pollock by way of the audience
which this art had brought into being. From this new vantage
point, Action Painting or the simplifications of Newman or
Still appeared in reverse as phenomena of taste. It is his relo-
cating of art within the mind of its public that connects Johns
with the World War I dadaists, despite differences of content
and intention.

Johns' original creative act lay in lining up the elements
of the game between artist and audience. With the values of his
predecessors turned inside out, he could make whatever use of
their art he chose; to revolt against them became unnecessary.
Thus Johns has freely appropriated Abstract Expressionist de-
vices: heavy impasto, impulsive brushing, broad paint strokes,
emphasized contours, streaks, smears, drips, the vertical band,
one-color masses, scraps of newspaper and other matter mixed
into the pigment.

In bringing the earlier art to bear on his ready-made sym-
bols, Johns, however, expelled its metaphysical and psychologi-
cal essence. Whereas the older artist, having inherited through
Freud and Surrealism the Symbolist conception of art as part
mirror image, part enigma, spoke of "getting into the canvas,"
Johns stepped resolutely back. With him the artist is no longer
the ultimate subject of the work. To underline the contrast it
is only necessary to compare Gorky's "How my Mother's Em-
broidered Apron Unfolds in My Life" with such typical titles
of Johns as "Grey Rectangle" or "Flag on Orange Field." The
adventurer or autobiographer in paint has been replaced by the
strategist of ends and means.

In Johns' hands the familiar Action Painting messiness, chance effects, "mistakes" and "accidents" discard expressiveness and enter into a planned disposition of esthetic elements. Here again Johns displays his affinity with Rauschenberg, whose most brilliant creation so far is his "double painting," which consists of an Expressionist composition, "spontaneously" thrown together of blots, spills, paste-ons—plus an exact duplicate on another canvas. Johns' usually shaggy surface acts as a mask of feeling that covers yet underscores an imperturbable rationality; it is through this dual disclosure that his paintings achieve their comic and esthetic shock, not unlike the effect of one of Ionesco's passages of intense nonsense logic. The vision of difficulty and struggle announced by Action Painting finds its antithesis as much in Johns' use of ready-at-hand painting techniques as in his use of universally available signs.*

Given the entirely different ends for which he employs Abstract Expressionist devices, it is superficial to interpret Johns' work as embodying a conflict between "painterly" painting and representational art. For Johns the paint stroke of a Kline or a Guston is as external a "thing" as the flag or the letter "Z"—in the graphite wash, "Two Flags," he "represents" an earlier large oil as if he were copying eyes and cheeks. Johns is essentially a poet of computations, like a medieval composer of acrostics, a builder of structures even when he builds out of mud. His motifs are, in every instance, formally simple: the flag of the United States is a rectangle which contains another rectangle with even rows of stars (each three superimposed triangles) and is divided into colored bands; the target, a circle which encloses other circles, thus also divided into bands; the digits and letters of the alphabet, made of curves, straight lines and angles which can be widened into massive bands, as in Johns' paintings of the number 5, or narrowed into lines, as in his "o Through 9" series. These rudimentary elements are usually disposed by Johns in trite symmetries that have reminded some observers of the primitives. A target or a number is placed in the

* "That's what I like about them," he explained about his type faces, "that they come that way." And "using the design of the American flag took care of a great deal for me because I didn't have to design it."

exact center of the canvas; two flags of the same size mounted one above the other fill an entire painting surface.

At times, however, Johns multiplies his elementary forms into schemes as arithmetically complex as a honeycomb or a project by John Cage. In "Grey Numbers" eleven digits are enclosed in boxes of uniform dimensions and follow the same order from side to side and from top to bottom. The four corners of the canvas are occupied by 9's and the same number begins and ends each row. An oblique row of 4's and 7's divides the composition into bands and forms triangles of the upper left and lower right corners. The broken lines of the 4's and 7's join with the 9's running in a diagonal from lower left to upper right to impart to the pattern a lateral upward thrust. In contrast to the numbers game of the composition each of the rectangular chambers is handled with a bravura of paint and encrusted newsprint as if it were a separate passionate experience.

In the logic of comedy the knottiest problem has an obvious solution, while what is customarily simple proves to be loaded with complications. The hard nut of modern painting is the problem of representing solid objects on a flat or two-dimensional surface. Johns' most joyous effects have been obtained by juggling the cliches of depth and flatness that permeate the art world. Is a flag a thing? No and yes. It is a mere emblem that can be stamped on something already there; unfurled, it is able to wrap itself around you. A target is a mark on a wall or a sheet of burlap, yet arrows stick in it and leave punctures. Letters of the alphabet can, of course, be inscribed on a plane surface without adding perceptibly to its thickness, but if painted in different colors they recede and come forward, and in a hurricane the police rope off sidewalks to keep words weighing a ton from crushing passersby.

Absolute terms to the theoretician, to the artist "depth" and "flatness" are there to be tampered with—since the abandonment of perspective by painting, the artistic means for such tampering have increased to the point where the distinction between "deep" and "flat" is about as useful in criticizing paintings as the distinction between nouns and verbs would be

in explaining *Finnegans Wake*. In paintings like "Open Road" and "Zurich" done in the late 40's, de Kooning used letters and numbers as part of his method of transforming the canvas into a surface as ambiguous as the sea's, with abstract shapes moving as objects and objects dissolving into signs. In drawings by Saul Steinberg line alone bestows on words the substantiality of things and even characteristics of human behavior: YES is a knight assaulting a rampart NO; "E" clamps a double set of teeth on the leg of an "A" and the top of a table in the shape of a "T" to act out EAT. Near the beginning of his career Johns puns on the figure in painting with a chaste white-on-white composition entitled "The Figure 1" in which the numeral occupies the center of the canvas in the haughty stance of a Sargent debutante. In the same year come the more celebrated paintings of targets on top of which are built rows of wooden boxes containing, in one, sections of plaster heads, in another, fragments of a hand, foot, nose, ear. With deliberately un-subtle literalness reminiscent of the child or the wise simpleton, these works declare: "the canvas is a painting; the casts in the boxes are sculpture; put them together and the problem of flat versus deep is solved."

Beyond their statement about art and their evocation of Louise Nevelson's pigeon-hole sculpture, the targets offer puz-zles to symbol readers, who may note that the plaster heads are cut off below the eyes, that the fragments have Freudian overtones, that above them are hinged flaps by which they could be put out of sight, and that the whole may thus be a comment on the current human condition. On the other hand, spectators who recall the clay pigeons of shooting galleries and the booths in amusement parks where at one time modellings of heads and even living persons were proferred as targets for throwing baseballs may find a sufficient richness of association in Johns' target assemblages without resorting to psychoanaly-sis or existentialism.

Other Columbus-and-the-egg solutions for the flat-deep dilemma are canvases which Johns has physically cut apart to receive balls and folded newspapers. The same problem in-spires him to paint a pattern, such as the map of the United

States, as if it were a scene in nature: why not? since whether it takes its subject from the real world or from a sheet of paper a painting will be nothing but a painting. Thus in "Black Target" the target is a wheel in a field, and in "The Figure O" the zero is a monumental gate; while "Slow Field" is explicitly a landscape in rich Impressionist colors though large letters are growing in it. "Tennyson," a painting overlaid like a curtain on two paintings, uses the solid lettering at its base to awaken ambiguous associations with a crypt and an open book covered with a sheet. In the "o Through 9" series Johns superimposes the digits upon one another to create Cubist-like structures but painted in an Impressionist manner like a forest of scaffoldings invented by painting. "Three Flags" makes related references to the layered space of Cubism, as well as to the "thingness" of signs, by setting flags of different sizes in front of one another as if they were boards and shading the edges to indicate the spaces between them.

If an emblem can displace room in nature an actual object can function as a sign in a work of art. With a plank affixed in the center of a canvas Johns produces a perpendicular band suggesting a painting by Newman. An open book covered with paint is both a "Newman" in the stripes made by the binding and by the thicknesses at both ends and a "Rothko" in its rectangular masses. With drawer-like rectangles incised in canvases Johns coordinates Impressionist brushwork with the mathematical compositions of the "hard-edge" school.

Counterpointing his comedy of flat and deep, sign and thing, are Johns' creations on the how-to-do-it theme which tell the spectator how contemporary paintings are made. Foreshadowed in the 1956 "The Canvas," in which an empty frame is outlined in the center of an over-all painting, so that what is seen through it is the picture that includes it, the subject of making a painting is taken up in earnest in 1959 in the series beginning with "Device Circle." Having established the target as a Johns insigne, Johns in "Device Circle" offers a handmade mechanism for painting Johnses: a square canvas with a stick fastened in the center which by being revolved inscribes a

circle upon a coagulated mass of bits of newspaper and globs and dribbles of paint. The title in half-painted-out letters underneath the circle yields the same monumental effect as in "Tennyson": "That's how to do it," it says, "but it's been done."

The didactic theme, reminiscent of the lecture on the spinal column which Julius Tannen used to demonstrate with a banana stalk, is carried on in pictures that contain printed directions for coloring in RED, YELLOW, BLUE, with or without actual use of these colors, plus such explanatory studio-flavored titles as "Shade" and "Small False Start." A more intricate art machine is "Viola": a new canvas with a hook on top is mounted on a larger canvas above an old stretcher, underneath which a cord connecting a protruding fork and spoon (the artist has to eat) will when snapped spring the canvas and the stretcher together and produce a painting. That was "Viola" in its preliminary stage. Now the machine has worked: the stretcher has leapt into the canvas and both are locked face to the wall as behind a cabinet door within the large canvas. Among other painting mechanisms "M," in which a paint brush is suspended on a wire to be operated by a pulley, seems to contain personal associations, while in "Fool's House" the target is inscribed on the canvas by a broom which, together with the attached cup, stretcher and folded towels, defines the subject as a corner of the artist's studio.

Drawing and sculpture supply additional possibilities for Johns' impassive interchange of signs and objects. The stripes of Old Glory are not unlike the spaces of a ruled pad—what more natural than for Johns to do grammar-school handwriting exercises in them? If from the up-and-down scribble there emerge Tworkov-like linear densities that function as masses so much the better. Johns' sculptured pieces epitomize his view that *what makes an object into art is its introduction into the art context.* There are various ways of doing this. You can paint on it, as in the beer-can-and-paint-brush bronzes, so that the thing becomes a representation of itself. You can transform its substance (the weighted beer can) without changing its

appearance. Through both material and placement you can give it the museum look, as in Johns' flashlight and light-bulb parodies of antique sculptural fragments.

The danger for Johns' objectivism lies in inventions that are merely attention-getting, without the factor of intellectual jolt. The "Coat Hanger" series *is* banal, and no amount of reflection on the uses of coat hangers will remedy their lack of quality. Some of the "0 Through 9" compositions come close in their pleasant coloring to advertising emblems of some printing company and (attention, Pops!) could be executed in neon tubes.

We mentioned that in "Fool's House," done in 1962, and in other of his studio paintings and collages Johns has moved towards personal references which were absent in the numeral and alphabet compositions, though some may have been involved in the early target collages. Recent paintings have been distinguished by an increased subjectivity (once again Johns seems to be going against a trend). "Diver" (1962) and "Land's End" (1963) anthologize the revolving stick, semicircles and stencilled lettering which he appropriated as insignia. But in both a new motif appears: an oblique bar terminating in blotted fingers like an arm thrust upward in a hail or signal for help. Another 1963 work, "Periscope (Hart Crane)," associates these water-titled canvases with the poet who met death by drowning. In an ironical closing of the circle that began with the conversion of the private signs of de Kooning and Gorky into a shared language, Johns' public symbols seem to be changing into metaphors of the artist's subjective state.

PART FOUR
THE AUDIENCE

Art can meaningfully assert its own nonsensicality.

16

THE ARMORY SHOW
REVOLUTION REËNACTED

If there is a single judgment on which the art world is agreed, it is that the exhibition staged at the 69th Regiment Armory on Lexington Avenue and 25th Street in New York in the winter of 1913, and repeated that year in Chicago and Boston, is The Great Event in the history of American art. For the public life of painting and sculpture in this country the Show is the equivalent of the storming of the Winter Palace by the Petrograd proletariat less than five years later. Or perhaps one should think of it as the Battle of Lexington Avenue, especially since it took as its emblem the pine-tree banner of the American Revolution. Whether in reference to the Ten Days That Shook The Art World or to The Shot That Was Heard Around It, the Show is customarily described in such terms as "bombshell," "explosion," "assault," "shock," "miracle." It was one of those upheavals about which it is said that after it "nothing was ever the same again." It destroyed the old rule and founded a revolutionary one. It supplied the "mandate" from which succeeding generations of vanguard critics, museum directors and art educators have continued to derive their authority—in answer to any challenge they have needed only to point to the fate of those who rejected the blue nude of Matisse or the descending one of Duchamp.

The organizers of the Armory Show were, as is often the case in genuine revolutions, innocent of radical intentions. They represented no advanced art movement, ideology or school. Their purpose was merely to mount another of those large amorphous exhibitions of "independents" which since the nineteenth century have served as the mass demonstrations or picket lines by which artists suffering from a sense of neglect or exclusion call themselves to the attention of the public. A year before the Show two dozen artists had met in a gallery on Madison Avenue and formed the Association of American Painters and Sculptors which sponsored the exhibition and a couple of years later fell apart. It included painters as far removed from each other esthetically as Maurice Prendergast and John Sloan; and Walter Pach summarized its attitude when he reminded the public that "the Association of American

Painters and Sculptors, as such, takes no stand whatsoever as to the merits and demerits of the works that it has exhibited." When the Association, in announcing its plans, attacked the National Academy of Design, its president promptly resigned. Thereupon—and this also indicates the temperature of its defiance—it elected in his place its most socially acceptable member, Arthur B. Davies.

What gave the Show its revolutionary momentum was the way in which its original aim was expanded in the course of actually putting the exhibition together. While the members of the Association were primarily concerned with displaying their work in an impressively large context, Davies, an esthetic internationalist if ever there was one, took literally some phrases of the group about showing living art without regard to its place of origin. Together with Walt Kuhn, Pach and others, he chose in Paris, Munich, Berlin, The Hague and London some five hundred paintings and sculptures that constituted a remarkable representation of the advanced line of development of European art since the last quarter of the nineteenth century. The official title of the Show became the International Exhibition of Modern Art, and it was the European contributions which, amounting to almost a third of the total, turned the Show into a kind of riot.

Since American art had been "international" all along, with American artists studying in London, Rome, Düsseldorf, Munich, Paris, the dynamite lay in the word "modern." By emphasizing what belonged to its own day, the exhibition proposed nothing less than to change the relation of American art to art history. In each art capital abroad American painters and sculptors had sought a quintessence of the European heritage, and this had landed them, together with other Americans traveling to cultivate their tastes, in the back seats of the academies. Hailing the present, the Armory Show now demanded that Americans place themselves culturally on the same timeplane as living Europeans. The implicit assumption was that America either had caught up with the European past or was ready to join with contemporaries overseas in cutting that past loose. The measure of esthetic importance would no longer be

the values of the academy but the activities of the international vanguard. In raising the banner of the new the Show announced a new system of cultural affiliations. International art forms would remain sovereign—nationalism was not an issue at the Armory—but instead of being monuments to the past these forms had turned into a clocking device that told America where it stood on the calendar. And the timing of the overseas art in the Show caused it to produce a rude awakening.

The replacement of art verities by art bearing an historical dateline made art into a subject of controversy. How far forward should art go? The question bore political overtones. It was evident at the Armory that this country lagged far behind the Europeans in creating new forms. The foes of modern art chose to regard this as a virtue. If the trend of European painting and sculpture since the 1860's had been, as Kenyon Cox put it, "down the easy slope to Avernus," the Americans were to be praised for refusing to budge from the Continental values that were being subverted on the Continent. The fiercest assailant of what he called "the 'modern' spirit in art," Cox, a pupil of Gérôme, found that "fortunately there is little necessity for dwelling on the American part of the show," since even the worst of it "seldom reaches the depth of badness attainable by Frenchmen and Germans." (It is typical of this kind of criticism that it is the "bad" art that it prefers to talk about.) Cox, who described Cézanne as not only "absolutely without talent" but "absolutely cut off from tradition," discovered one exception among the American innocents—Marsden Hartley, who in producing some abstract drawings had, Cox thought, carried modern art to its "logical end, for the real meaning of this Cubist movement is nothing else than the total destruction of the art of painting." By his ferocity Cox demonstrated that he represented *a* tradition, one that Cézanne had replaced with another and that Hartley had abandoned; amusingly enough, a more recent traditionalist of the wrong tradition, denouncing Hans Hofmann as the destroyer of art in terms almost identical with Cox's, held up Hartley as a model of sound abstract painting.

In contrast to Cox, Theodore Roosevelt, in a thoughtful

and fairly moderate appraisal of the Show, declared that "it is the work of the American painters and sculptors which is of the most interest in the collection." Defeated on the Progressive ticket in 1912, the Bull Moose found an affinity with the painting which some of the exhibiting Americans called "progressive," and he conjectured that the "extreme" European works, though of no value themselves, had been of help to the native sons. In sum, Roosevelt sensed that there was need to enter the modern world but he chose to do so at a reserved gait. In this he was at one with most of the American exhibitors. William Zorach recalls that "the members of the Association of American Painters and Sculptors were as shocked as the Academicians when they saw what they had brought over in their revolt against the older institution."

Roosevelt's moderation was, apparently, an effect of afterthought. Zorach testifies that at the opening the ex-President "waved his arms and stomped through the Galleries pointing at pictures and saying 'That's not art!' 'That's not art!' "—and another witness relates that Roosevelt interrupted Davies' explanation of Duchamp's "Nude" with "He is nuts and his imagination has gone wild." Before the Armory Show scandal in American art had related to pictorial subject matter, particularly nudity; on Lexington Avenue furies were aroused by new art forms. "Figure in Motion," by Robert Henri, which translated the realism of his teacher Anshutz into reporting, was as tangibly naked a female as could be confined to a flat surface. Yet the villain-hero of the show was not Henri but Duchamp and its main dish was not Henri's dark and indiscreetly shadowed nymph but the monochromatic construction which Roosevelt in condemning it called "A Naked Man Going Downstairs." That new art ideas evoked antagonisms deeper than Puritan inhibitions was itself a revolutionary phenomenon of the first magnitude. Cox was willing, he said, to forgo representation in "a Turkish rug," and Roosevelt was reminded by Duchamp's composition of "a Navajo rug" in his bathroom; what disturbed both was that the new art was not merely decoration but claimed to mean something. It was the Cubist *concept* that was the enemy, in that it held forth what looked

like a design to be an interpretation of visual reality, though the image on the canvas insolently declined, in Roosevelt's words, "to fit the facts."

This resistance to ideas was shared by the artists who backed the Show. Their enthusiasm for the new was distinct from any conscious attitude embodied in the new European art. What seems to have alarmed conservatives and progressives alike was its primitive element, on the one hand (Matisse, Brancusi), and its logical element, on the other (Duchamp, Picabia). Both were in conflict with American eclecticism. Embarrassed by the "extremes," the Americans could derive from the Show only a generalized feeling of liberation and the reassurance of the presence, elsewhere, of esthetic allies. Said Stuart Davis in his usually succinct style: "My personal reaction to the rowdy occasion was an experience of Freedom, no doubt objectively present in the mechanics of many of the foreign items on display." Each artist would have to explore the content of this freedom at his own pace. Charles Sheeler noted that after he first met the works of the Europeans that were shown at the Armory it took him nine years "to bail out and make a new beginning." For American art it would require another thirty years, another war and another crisis of values before it could embark on ideas of its own.

The most immediate and telling effect of the Armory Show was on the American art public. Actually, the Show was The Great Event in the history of American art education rather than in the history of American art. New collectors appeared, as well as dealers in contemporary painting, favorably disposed critics, dedicated appreciators. In setting up the new as a category of value, the Show had presented modern art as a *cause*. In the years that followed, this cause continued to win adherents. The result was the coming into being of the Vanguard Audience. While America's vanguard artists had hesitated before the choice offered by Matisse or Delaunay, the Vanguard Audience experienced no such discomfort; it could accept the new in its entirety, with all its conflicting assump-

tions or without any assumptions. Its excitement, repeated upon each unveiling of an unfamiliar talent, could develop a continuity and a rhetoric, could become, in short, the basis of a tradition, the tradition of the new, capable of evoking the automatic responses typical of a handed-down body of beliefs. For half a century this Audience has conducted the struggle for modern art in America, the campaign for whatever is declared to be art at any moment. It has seen wave overleap wave —the artists sponsored by Stieglitz and other modernists of the decade of the Armory Show yield ground before dadaists and Surrealists of the next; these in turn go down before the Social Realists of the 30's, who themselves are swamped by the Action Painters of the postwar years. Within all these displacements the concept of the new in art has held. Its popular support and professional leadership have been constantly augmented while the concept itself has grown more flexible and freer of limits. Today, the vanguard audience is open to anything. Its eager representatives—curators, museum directors, art educators, dealers—rush to organize exhibitions and provide explanatory labels before the paint has dried on the canvas or the plastic has hardened. Coöperating critics comb the studios like big-league scouts, prepared to spot the art of the future and to take the lead in establishing reputations. Art historians stand ready with cameras and notebooks to make sure that every novel detail is safe for the record. The tradition of the new has reduced all other traditions to triviality. Its opponents can bring to bear against it only the "Turkish rugs" and charges of "charlatans and dupes" of fifty years ago.

The Armory Show-50th Anniversary Exhibition, organized by the Munson-Williams-Proctor Institute of Utica, celebrated —on the site of the original and with as many as possible of the original works—the victory of the tradition of the new in American art. "Now, fifty years after the epic Armory Show," wrote Edward H. Dwight, Director of the Museum of Art of the Institute, in his preface to the Anniversary Catalogue, "the battle of modern art has been won." We are reminded of the

Kremlin's declaring on an anniversary of the October Revolution that the battle for Socialism has been won.

Recalling the "shock," "scandal" and "controversy" of the 1913 event, the Anniversary brought back in incontestable triumph Matisse, Brancusi, Picasso and, in the spotlight, Duchamp's "Nude Descending a Staircase," as well as the more prominent Americans whose reputations, it was hoped, would benefit from a new look. The atmosphere of heroic deeds with an exultant outcome was heightened by additional commemorative exhibitions held conjointly. The Whitney Museum presented "The Decade of the Armory Show," unlike Armory '63 not a reconstruction, but devoted to vanguard American artists of 1910-20, whether or not they were represented at the Armory or were working in the United States or abroad. Duchamp, now an American, was present with "Nude Descending a Staircase, Number 3." In the Catalogue, Lloyd Goodrich, Director of the Whitney, recited once more the saga of the uprising against the Academy, how the Armory Show was organized and how "in the next few years the whole battlefield broadened, the participants multiplied," until, finally, "the liberating influence of international modernism added its impetus to the vast forces in all fields that were transforming the America of fifty years ago to the vital and creative America of today." Mr. Goodrich as a revolutionary partisan is rather engaging, especially when he finds it necessary to remind the reader that "academic art had its own merits" and fell short only through neglecting "the more essential elements of form and design."

Also furthering the Anniversary was a re-creation of "The Forum Exhibition of Modern American Painters," held in 1916, and an exhibition of a collection of photos of "The Many Faces of Marcel Duchamp," accompanied by objects from Duchamp's home.

Taken together the Fiftieth Anniversary revivals had the character of a display of battle banners, sacred relics and founding documents in the glass cases of a government archives building. The original Armory Show was staged by artists as an educational event; the re-enactments were produced by art

officials and the Vanguard Audience as an event in the creation of American art. "Most of all," Milton Brown wrote in the Anniversary Catalogue, "the Armory Show affected the artists of America." This is extremely doubtful. Though not prepared on a "before and after" basis, the Whitney "Decade" exhibition presented evidence enough that such changes as were to be found among the Americans of the period were in the main the result of contact with European art *in Europe*. Nor was the speeded-up modernism that might have come from a temporary exposure to new pictures here always as much to the advantage of the artist as it might seem in the perspective of today's vanguardist tastes. The strongest paintings of the "Decade" exhibition were the groups by Alfred Maurer, two of which were done before the Armory and one seven years later, and those by Prendergast and Marin, neither of whom was affected by the Show. The abstractions of Sheeler in that period tended toward poster design and his best work is much less "modern" in the art-history sense. The 1914 still life by Arthur B. Carles, a beautiful painting done under 19th-century French influence, is superior to all but three or four of the Cubist-inspired canvases he did much later. Hartley, who took a long leap into abstraction, received his impetus in Munich and later subsided into a style closer to his temperament.

For the middlemen of art, the Armory Show is the ideal occurrence, one that fulfills their dream of affecting the creative powers of a nation by means of an exhibition—that is, by gathering, arranging and commenting on already existing paintings and sculptures. The Armory Show seems to lend weight to current attempts by museum impresarios and dealers to create movements in art by assembling works under significant labels. Hence it cannot be emphasized too often that the Armory Show of 1913 was the creation of artists, not of art educators and friends of art, though the latter have been pleased to adopt it as the "epic" incident in twentieth-century American art. Commemorating the fifty-year march of the principle of novelty, the Armory revivals represented the adulation of modern art as such. The occasion found its perfect symbol in Duchamp, a living embodiment of modern art who for

tion to which the art audience responds is counted as art, art has become one of the mass media. With *doing* replacing *making*, values in painting can be as completely dependent on audiences as they are in night club entertainment.

There is, however, an aspect of art that shields itself against the verdict of applause. I refer to the activity of the artist, which in acts of creation has a value distinct from that of the object in which it terminates. In such acts, dimensions of experience may be attained which are never entirely accessible to the spectator, including the artist himself as spectator. To grasp the work he must reach toward it in a creative act of his own.

To this chain of creation art owes its survival. By it the intrinsic tension between artist, work of art and art public is renewed—within the social organization of art or in opposition to it.

ments and the persistence of conservative picture-making, the trend of painting and sculpture toward "performance" is striking in its continuity. On occasion, work originating in this impulse extends past painting and repudiates it, out of impatience with inherited forms and the wish to pledge itself to the future. For most artists, however, a more complete action is attainable with a pencil or brush than with an instrument panel; they are suspicious also of means whose effect on the senses is so powerful as to reduce the spectator to passivity, in the manner of the movies. Another reason for "performance" painters to refuse to abandon painting is that, in action, limits, such as the rectangle of the canvas, serve as a counterforce. To avoid flabbiness, new or mixed genres are obliged to develop substitute constraints, in the form either of arbitrary rules of work or a code of inner rejections.

So "painting" remains. On the other hand, all traditional elements and values of art are subject to tampering. While it is still customary to hear paintings analyzed in terms of various depths of space, the picture surface as a fixed reference for the eye has become as irrelevant as the vanishing point. What should be the limits of tampering with the inherited ingredients of art is for each artist to decide. Is it legitimate to paste bits of newspaper into a painting like the Cubists or like de Kooning and Johns, or to cut out the canvas or affix a piece of driftwood to it like Pollock, but forbidden to insert a TV set into it like Wesselman or suspend a pair of boots from it like Rosenquist or affix the head of a goat like Rauschenberg?

To these questions aesthetics has no answers. The boundaries of painting are subject to dissolution both by the authority of the inner evolution of styles and by the functions of painting vis à vis the art public. The continued existence of painting as an art becomes increasingly at issue not through the behavior of aesthetic radicals but because of the absence of any objective check upon invention. As numerous 20th century artists have divined, the ultimate formal invention demanded by painting is the invention that does away with painting—why bother with timid reductive concepts? On the other hand, when any aesthetic inven-

tone of a locked room and of things spied through an aperture.

As with Pop, the human, as opposed to the didactic, side of Op and kinetic art is entertainment. Pop and Op meet in the new science-fiction sculpture that has lately been flooding the galleries, in games and in inventions that parallel fairground and circus exhibits. Plastic, metal and wood forms painted in kiddyland colors provide pseudo-scientific models of missiles, death-ray guns and outer-space travel. "The most romantic place on earth," an artist declares in his exhibition announcement, "is Cape Kennedy." A show of toys fabricated by well-known sculptors varies from Pop use of colored automobile tires to an Op-designed rubber ball and a scientifically weighted rocking horse by an outstanding kinetic artist. The repertory of illusionistic tricks displayed in the flickering and blazing of kinetic paintings turn an Op exhibition into a hippodrome of "magicians." The spectator, softened up by proofs of how easily his eye can be deluded, experiences a sheepish pleasure. No species of American art has been more attractive to children, and no art of the past twenty years has been greeted with more acclaim by people who admire an artist who "knows what he is doing." Op arouses, too, the enthusiasm of people utterly bored with painting and sculpture and convinced that it has no place in the rational and technological world of tomorrow. They see in Op an early phase in the liquidation of the old arts into "programmed" effects delivered by film and tape—a "theatre of the senses."

It would be intellectually convenient if the movement (or drift) of art toward playing for and upon its public took in all the significant painting and sculpture of the past twenty years. This is, of course, not the case. History, including the history of art, is not that single-minded. Motives, moods, styles overlap and co-exist. Alongside new art movements, and deep inside of them, old modes are revived and made to yield excellent and original creations.

In sum, the entire vocabulary of art styles developed in this century and earlier is in vigorous use. Yet despite cross-move-

beautiful works—for example, Tom Wesselman's "Great American Nude #66," in painting quality reminiscent of Milton Avery, but with an exquisite touch of humor in the resemblance of the nude's nipples to the rubber caps with which things are stuck on kitchen walls. Oldenburg has modelled everyday objects in styles ranging from the Action Painting of his "Seven Up" reliefs to the naturalistic rendering of the fading tints of a used tea bag modelled in plaster and as large as a tennis racket.

In addition to displacement, Oldenburg, Rosenquist and Lichtenstein exploit the blow-up, as does Alex Katz (not a Pop artist) in his wall-sized faces. Both displacement and juggling of scale are inheritances from Surrealism, with its tiny men and elephantine butterflies. Pop art took on most quickly with people acquainted with dadaism and Surrealism—and with people acquainted with nothing but eager to enjoy art easily after the strain of trying to respond to the riddles of Abstract Expressionism.

Another species of "cool" art, Optical painting, or "perceptual abstraction," attacks the individualism of Abstract Expressionism from the standpoint of scientific impersonality. The Op artists, however, retain, almost to a man, the will to the *active* work of art. "My aim," writes one, "is the multi-functioned behavior of clearly defined forms." The proponents of these patterned works in squares, circles, moiré, claim that they alone represent a "machine-age aesthetic" that celebrates not men but forces. In Europe, which to all appearances has taken the lead over the United States in this category of painting and sculpture, "anonymous" groups, conceiving art as an extension of research in visual-perception laboratories, experiment with film and light screens in controlling radiance, rhythm and the metamorphosis of shapes. "Op" art is far more extreme than Pop in subjugating art to the social power, this time the power of science. It has exchanged the billboard for the optometrical chart. With its nervous mechanics of line and color and its waving and quaking surfaces, there is something harsh and didactic about this art, even when its effect upon the eye is soothing. Its light is neither of the day nor the night but of neon. There is a prevailing over-

the creations of the artist and of the business-world artisan have tended to cross breed; at times their products have come so closely together as to be distinguishable only by the label and the place of display.

It is to the credit of Pop art that it brought this relationship between art, mass manufacture and mass communication into the open without fear of overstepping the line between the canvas and the showcard, the mural and the billboard. With Pop artists such as Oldenburg, Rosenquist and Warhol the studio is no longer the cell of the philosopher or the lair of the romantic "wild beast"; it has reverted to the workshop of the artisan equipped to carry out projects with efficiency and skill. But though the Pop artist voluntarily adopts the artisan approach of the worker in the mass media, he does not relinquish the independence of the "expressionist." He manufactures an image like a designer under orders, but he is his own "idea man" and his own art director. The freedom retained by the Pop artist in handling cultural stereotypes automatically lends to Pop art an air of irony. Why should Rosenquist, who quit painting billboards in order to practice art, paint art that looks like billboards? Does Lichtenstein enlarge comic strips because, as he has said, he has always been attracted to Mickey Mouse and Donald Duck? In that case, why not go to work for Disney? The answer to these questions is that the Pop artist has chosen to function simultaneously on two planes: the plane of mass-communication styles and techniques and the plane of art.

This plane is represented by the self-consciousness of Pop art about art history and its acceptance of conventional aesthetic values: harmonious composition, well-ordered space, neatly rendered surfaces, fluid drawing. Oldenburg, for instance, has insisted publicly that his enormous pie slices and canvas typewriters are actually experiments in form and color. Lichtenstein's Ben Day dots have inevitably reminded his admirers of Seurat, and his drawing of waves have evoked allusions to Hokusai. This pedantry emphasizes that the chief novelty of Pop is displacement: from the food store into the art store, from the ad or comic book into art history. The mixture of genres has produced some

mammoth canvases of Pollock and Kline as literal "arenas" for the duel of the artist with his emerging image. The viewer had been drawn into the action on the canvas as a collaborator in establishing its significance. In the Happening the image making of artists was carried over directly into the public event. The Happening thus became an alternative to painting—a rival medium that carries to its logical conclusion the "aesthetics of impermanence." (See Chapter 7.) But the logical conclusion most applicable in art is to avoid logical conclusions.

With the audience acknowledged as a factor on every plane of the artist's situation—by 1960 prices had begun to catch up with the magnitude of the public interest—art has been accommodating itself to its new position *in* society. As in the 1930's, but without the unrest and political conscience of that period, artists have been taking account of the powers that control their environment. Most directly pressing upon art for more than a century has been the presence of art's gargantuan double, commercial art—including printed and display advertising, industrial design, product packaging, teaching aids, visual entertainment from the comic book to the Big Screen.

Commercial art *is* art, not only in being unquestioningly received as such by most people but in belonging to a tradition— one might say *the* tradition—of making art that moves its beholders and satisfies their tastes.

Endlessly versatile, the commercial crafts appropriate from painting and sculpture each new style, "look" or device and adapt it to serve practical ends never intended by its originator, as in calendars made of Monets, linoleum designs and skyscrapers of Mondrians. At the same time, commercial art constantly challenges painting and sculpture to state what purpose they serve and why they should continue to hold their ancient privileges.

The artist's revenge has been to exploit for his own artistic ends the ever-present art of machine-produced objects and machine-reproduced images. Since Duchamp, some fifty years ago, presented his "ready mades"—shovels, toilet bowls, window frames—and the Cubists pasted bus transfers, theatre announcements and newsphotos into their compositions (see Chapter 15),

and to the changed social situation of American painting. Among the first to turn significantly from mythologizing abstraction was Larry Rivers, who had studied with Hans Hofmann and was imbued with the procedures of Gorky and de Kooning. Having caused a minor sensation with his early life-size close-ups of undressed friends and members of his family, Rivers undertook a truly popular subject, one he could count on to exist in the mind of every grade-school graduate: "Washington Crossing The Delaware"—this copy-book theme he painted in a *tachiste* style that the advanced would identify as ultra up to date. With his provocative nudes and "history paintings," Rivers was a forerunner in bringing back into art the common man (or in recognizing that he was already there)—not as a political abstraction, as in the posters and murals of the 1930's, but as one who, like the artist, found pleasure in pictures and exaltation in the notion of a masterpiece. Through painting the commonly known and appealing, Rivers provided a link between Action Painting and the "New Realist" or "Pop" art of street images and everyday objects: signs, ads, food, appliances.

Other links were the paintings and sculptures of Robert Rauschenberg and Jasper Johns. While Rivers took from Abstract Expressionism only what would enable him to satisfy his appetites, Rauschenberg and Johns re-examined this mode through the eyes of its audience (see Chapter 15). The audience-conscious art of Rivers, Rauschenberg and Johns was the pivot on which painting and sculpture swung from exploring the artist's own mind to analyzing and manipulating the mind of the spectator.

Another development out of Action Painting in the direction of Pop art was the Happening, to date the most extreme movement of painting toward the performing arts. Instead of "acting on the canvas," and trusting to the survival of the event in the traces of the pigment, painters and sculptors brought their personalities into play as actors before an actual crowd. As in Action Painting, the production of the art object was subordinated to the activity of the artist, now turned producer-director-actor. Action Painting showmanship had brought into being the

scenes or models in gypsy costumes. It is shocked neither by the morally outrageous nor by the aesthetically unfamiliar; the absence in a canvas of a semblance or a message causes it no mental anguish. The challenging "But what does it mean?" or the verdict "He's nuts!" (see Chapter 16), is heard no more.

The recruitment of a vanguard audience for painting and sculpture was bound to transform the conditions of their creation and, in time, the character of the work itself. Putting on a show developed a stronger appeal than the act of painting carried to a hesitant pause in the privacy of the studio. With the methods of Abstract Expressionism being taught in universities and art schools, with hundreds of young artists and art students repeating its catchwords—creative tension, self-projection into the unknown, the unfinished painting, ambiguous forms—and aping the personal as well as the technical mannerisms of the "masters," Abstract Expressionism took on the character of an Academy.

The ground had been laid for a reaction against the conception of art as a passionate affirmation of mysteries without a key. Opposition took several forms. The most obvious consisted of negating in principle the attitude toward art which was now being parodied in practice. Against the Academy of contrived emotional paint surfaces, it brought into being an anti-Academy of cool professionalism and thin, inexpressive pigments. Repudiating any intellectual role for artists, the reaction attacked the bohemianism of the Action Painters, their immersion in the disturbance of the times, their doubts about the future of painting, their rejection of formulas. It proposed as an alternative a formal aestheticism which extolled precision, objectivity, technical progress—it saw, for example, the contribution of Jackson Pollock as an "advance" on the space concepts of the Cubists but ignored the innovations in automatism and chance with which he had solved his frustrations. Claiming to be carrying forward the evolution of art as art, anti-Abstract Expressionism brought to the galleries an art of bland color patterns that resembled the abstract art of thirty years earlier.

In contrast to the program of pedantic formalism, there also appeared various creative responses to Abstract Expressionism

life through handling and color. Their works, though highly distinct technically—e.g., heavy impastos versus smooth, evenly applied zones of hue—were related in that a picture of either type could be "read" for its symbolism but had the deeper intention to communicate not a concept but a total psychic effect.

When an act loses its purpose it degenerates into play-acting and is performed not to produce a result but to win applause. As with all art movements, some of the practitioners of Abstract Expressionism saw it almost from its birth as an opportunity to charm. It is often very hard to tell desperation put on for show from desperation actually felt. The fake and the real become grown together and feed each other. By the middle of the 1950's the pervading acridity of the years immediately following the war, brought on by memories of the war dead, the return of the mutilated, the images of the death camps, of Hiroshima, had been largely dissipated. The feeling of crisis was no longer pressing, no longer *popular*. Many artists chose to forget it, except as a position to be assumed in interviews. To maintain the tone of the critical issues of the epoch in the midst of the lasting American prosperity, the displays of national power, the moratorium on politics, demanded a steady historical outlook possessed by very few. Other concerns seemed more relevant—for instance, the new status of art as a professional career.

Within a decade after the public first became aware of the "gestures in the solitudes" of the action painters, American abstract art was leading a cheering squad in the Rose Bowl. The art world had swelled to include hundreds of galleries, collectors large and small, contemporary arts councils in major cities, travelling exhibitions of the latest novelties, university art departments and museums, visiting artists and lecturers, as well as a host of specialists and service people: art editors, curators, art historians, archivists, biographers, publishers, columnists, TV and radio programmers, photographers, catalogue writers. Soon the art world could be said to include the White House and, with the passage of a Federal Arts Bill, even the Congress. Not only is the new public of prodigious size and growing rapidly, it is a sophisticated public: art to it means *modern* art, not Montmartre street

In the interval of painting the artist affirmed his identity on levels of experience extending from his self-awareness as an artist, his absorption of the art of the past, his feelings as an individual, his half-conscious intimations. The movements of hand and body brought into being a coherence of signs to which both he and the spectator could respond with fresh stirrings of the imagination in time to come.

The vision of art and the artist as mutually developing and defining each other was shared by most of the post-war pioneers. The new American abstract art was not the product of a school or an ideology, but its motive of creative action gave rise to certain common aesthetic features. Since the work was regarded not as an end in itself but as incident in the artist's continuous activity of creation, its nature was to be "unfinished," a condition characteristically expressed in sketchy composition, blank areas of canvas, messy surfaces. Preconceived ideas and even a definite style were shunned as fixing the artist in a vise of self-repetition. "Formulation of belief has a way of losing its brightness and of fencing one in," wrote Tomlin. "I fight in myself," said Still, "any tendency to accept a fixed, sensuously appealing, recognizable style." Artists sought forms carrying multiple meanings, as in the ambiguous figurations of Gorky.

The psychologically suggestive pantomime of the Action Painter was complemented by the myth-making imagery of other Abstract Expressionists, the sign-bearing tablets of Adolph Gottlieb and Mark Tobey, the later empyrean landscapes of Gottlieb, the lunar regions of Baziotes earlier canvases. Gorky's and Rothko's linear shapes automatically traced upon random washes suggested an inchoate mythology, as did the jutting shapes of David Smith's metal sculpture and the dripped-metal mazes of Lassaw. Rothko, whose post-political phase originated in a prolonged meditation on ancient myth and tragedy, later emptied his surface to surround the spectator with lofty panels that diffuse the hooded light of a grotto. The leaders of Abstract Expressionism were divided almost evenly between Action Painters, whose sign language arose spontaneously out of the act of painting, and myth seekers, who conceived or adopted signs and brought them to

ence—or by the absence of an audience. The history of American art in the past twenty years is outlined by the retreat of the Abstract Expressionist painters from the street and public places to the studio in the years following the war, and the gradual re-emergence of the artists and their successors into the contemporary landscape of mass communications, standard commodities and the laboratory. Almost all the originators of America's abstract art had been steeped in the political art of the Depression: Pollock had been influenced by Left-wing Mexican mural painting; Rothko had composed tableaux of the city poor; de Kooning had executed constructions for Artist Union demonstrations; Reinhardt and Motherwell had dabbled in Marxism.

The abstract sign-making and art as gesture which this generation introduced after the war arose from the need to re-direct bohemian and radical social action into the controllable arena of the canvas. The artist's will to change the world was replaced by the will to transform himself through the activity of art. This meant changing art, too. Instead of conceiving the contemporary as that which conveyed the social theme favored at the moment, the artist was moved to restore contact with the tradition of formal innovation that had spurred art since Impressionism—the tradition reflected in the title of Ezra Pound's book: *Make It New*. They turned specially toward the last of the vanguard European movements, dada and Surrealism. The crux of the matter, as Hofmann had been insisting all through the 1930's, was that art must be *creative*. In the popular view, the new is whatever carries the latest date: in art the new is a creation that changes art itself. Merely to apply existing styles and techniques to radical subject matter produces not painting but illustration, and with regard to art is reactionary. Hope for the artist lay not in finding a new formula for "stylizing" objects or ideas but in entering the historic stream of creative *activity*, whether carried on by the Florentine masters or by witch doctors of the Congo.

Having shed their social aims and their stylistic preconceptions, the American Abstract Expressionists sought revelations through fusing into the movement of the brush the energies inherent in nature, the artist, the material with which he worked.

part of his setting. The silence of sculpture has been converted into a rhetoric of everyday pathos.

Animated art and audience participation have expanded the psychic tensions produced by postwar American Action Painting into a panorama of public responses that range from the collective aesthetic thrills of fabricated environments, through Pop art slapstick and mimicry, to the mass hypnosis of optical and "kinetic" sensory manipulation. Half a century ago the Futurists, inspired by the new visual sensations of speeding in an automobile or observing the earth in the "aerial perspective" of an airplane, attempted to represent landscapes in motion. Current art, equipped with knowledge gleaned from psychological, photographic and color-chemistry laboratories, creates its effects of movement by operating directly upon the nervous system itself. Painting and sculpture pass from images that exploit the mass-media residue in our consciousness to visual contrivances that seize hold of our eyes and shake them like dice in a box or dive under the picture surface with them and drown them in a sea of afterimages.

The performance of artists as showmen to the crowds of the new American art world has caused some people to conclude that painting and sculpture have lost their bearing and are about to vanish into show biz. The fact is, however, that art as action and performances by painters embody the principle of continuity that links together the vanguard art movements of the past fifty years. The impulse to turn from the art *object* to the art *event* is present in the Dada and Surrealist demonstration that followed the World War, in the placards, May Day Floats and educational murals of the 1930's (with their slogan "Art is a weapon"), and in the interweavings of thrown pigment and fierce brush slashes of the Action Painters. Devising rôles and costumes was as characteristic of the 1940's as it is in the 1960's. Gorky performed with elegance the traditional part of the suffering genius dreaming of an idyllic homeland, Pollock in blue jeans and squatting on his heels that of the direct-action cowboy among dry big-city talkers, de Kooning that of the neat Dutch house painter, Clifford Still that of the Savonarola of aesthetic absolutes.

The character of a performance is determined by its audi-

proach of the spectator by graciously leaning forward to greet him.

Along with active art appears the artist-actor. In "Happenings" painters and sculptors build props, compose scenes and perform. Among younger artists it has become the vogue to complement one's painting by taking part in stage plays and experimental movies. Larry Rivers, who years ago proved himself a talented film comedian, performs professionally on the saxophone and designs stage sets—his latest creation, a mammoth assembly of paintings and objects representing the Russian Revolution, has the character of a backdrop waiting for its opera. Rauschenberg performs with a dance group, Warhol in films and in the public relations and fashion worlds. Oldenburg's giant hamburgers and his other canvas and plaster food sculpture belong to the family of props he produced for his Happenings. Art galleries have been converted into shooting galleries, bedrooms, theatres for "light ballets," *dolce vita* swimming pools.

Today's art is not merely shown; it puts on a show and solicits audience participation. Action Paintings invite the spectator's engagement in the artist's creative act. In Happenings cooperating audiences have been amused, tortured and mystified. Exhibitions endeavor to provide a total setting or, in the jargon of the art world, an "environment." Whether by standing before Rothko's tinted air curtains or Gottlieb's cosmic emblems or in a roomful of Newman's expanding rectangles—or, by contrast, in the midst of noise-making Pop objects and reliefs—the spectator is transported into a staged situation where he is enveloped by the art work rather than confronted by it. At times he becomes part of the artist's composition and himself a work of art— a game of ambiguities commented on with incomparable brilliance in the drawings of Saul Steinberg. The white plaster casts that George Segal makes of his friends and patrons transform them literally into sculptures. In this age without ghosts, a Segal is a solidified wraith, a materialized *alter ego*. It is the routine you in your absence from your routine. Rothko de-materializes the physical world and the canvas, Segal petrifies the human presence into mere appearance. His plaster gas-station attendant belongs to the order of the Coca Cola dispenser and tires for sale that are

It should be plain in this second half of the twentieth century that painting and sculpture have been striving to become something different than pictures on the wall or forms quietly standing in a corner of a room or garden. Traditionally, of course, works of art don't *do* anything, beyond presenting themselves to be observed. No doubt, most current art is still intended for contemplation—though "contemplation" seems an odd word with which to describe the scrutiny of an enormous Mickey Mouse. Each year sees new variations on Cubist construction and design, Impressionist, neo-Impressionist, Fauvist, Expressionist and primitivist "returns to Nature," adaption of folk and lunatic art, dream painting and geometrical abstraction. But the creations that have struck deepest into the public imagination as typical of the past twenty years show an unmistakable impulse to erupt into the life around them. Paintings swell into protuberances, are metamorphosed into free-standing cutouts, collect into themselves articles from the refuse pile or the five and ten. Sculptures crawl along the floor, join the collector's family at the dinner table, are electrified to blink on and off, emit sounds. Dali's quip about Calder's mobiles that "the least one can ask of a piece of sculpture is not to move," seems hopelessly out of date. Today, Calder's kite-suspension principle has been augmented by numerous other species of airborne art, as in the "magic" of a twisted strip of metal foil that hangs from the ceiling on an invisible thread and seems to rise slowly out of a looking glass lake.

In addition to art wafted by air currents, liquid-, motor- and electronically driven art now abounds between 57th Street in New York and La Cienega Boulevard in Los Angeles. A large exhibition of contemporary painting and sculpture is as likely as not to combine the features of a midway, an auto-racing arena, a children's toy garden. The contour of a mountain top is outlined by a blazing neon tube; objects flop hypnotically on eccentric gears; enormous perforated sheets bearing colored patterns slice rhythmically across each other; steel whips spun at high speed form the shapes of a changing urn; a brightly painted abstraction powered by a photoelectric cell responds to the ap-

MOBILE, THEATRICAL, ACTIVE

PART SIX

THE CONTINUING CURRENT

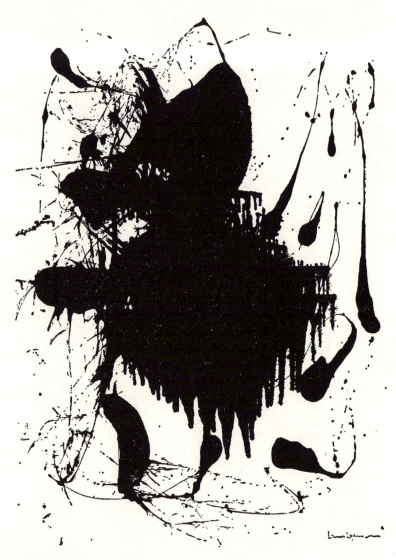

Hans Hofmann

Only last year he returned to the attack upon all varieties of imitative naturalism: "Every figurative attempt in the visual arts," he declared, "is positively to be condemned when made without consideration of the underlying esthetic principle of Abstract Art."

In sum, Hofmann's art is saturated with the twentieth century, its masters, its styles, its problems. With him the tradition of the new comprises positive principles embodied in a hundred years of masterpieces. By these principles art itself has been re-defined in accordance with a spiritual intentionality belonging exclusively to this age and capable of bringing forth new affirmations indefinitely. One may reject Hofmann's valuing of painting according to an esthetics of "abstract Art." What may not be rejected is his conviction that art is essentially creation. Anything can be a work of art, but its mode of production decides its meaning and its value. As stated earlier in this book, Hofmann became a teacher and remained one for almost half a century to teach not painting but the conditions of creation in painting. This is another way of saying that he saw art as that kind of activity by which the actor himself is transformed.

steeped in "error" as those of Renaissance science: traditional art, wrote Hofmann, "makes the picture surface into an immense hole in the architectural wall. Renaissance perspective has only one direction into depth. Depth does not answer back pictorially. This produces a sterile space which is the exact opposite of pictorial space." In eliminating the "hole" of perspective and thus allowing the entire picture surface to "answer back" at each touch of the artist's brush, modern painting has initiated a more active mode of pictorial creation than was possible before. It follows from Hofmann's appreciation of the genius of the twentieth century that that art is newest and most radical which most thoroughly penetrates this epoch's changed way of seeing, its revised ideals of artistic veracity, its original concept of a continually creative interaction between the artist and his medium.

Other contemporaries have also been aware that the new in art is decided not by the calendar but by the level of penetration into the condition and intelligence of the age—in a word, that the degree of newness depends on depth. It remained for Hofmann, however, consciously to conceive of modern art as a tradition that has developed specific means for bringing the new into being—a tradition in which the artist today can work as confidently as artists of other periods could in theirs. Painting, he declared in ending his Dartmouth speech, "puts me in a positive mood . . . This sounds simple but is actually the fruit of long research." The career of Hofmann has consisted of a continuous meditation on and enactment of the creative way revealed by our era. It was his conviction that he had reached the core of the new in the art of our century that enabled Hofmann to resist not only Social Realism but such other movements as Dada and Surrealism at a time when they had apparently occupied all the forward positions. This choice of his own historical ground has placed Hofmann and his art at a remove from daily developments; at the same time it has immersed him and it in an uninterrupted, history-charged battle to affirm the essentially innovating, the "entire new pictorial approach," as he put it, as against both trifling modernist mannerism and the artistic verities and grandeurs of other times.

downhill at a dangerous rate. Worthwhile as this project may be
—and the forcing of creation by promoters of novelty is perhaps
the most serious issue in art today—it cannot be furthered by
posing esthetics against history (a return to the strategy of the
academy). But values could be clarified through a better under-
standing of Hofmann's position on what actually constitutes the
new in art.

In the popular view, reinforced by the press and the mass
market, the new is whatever carries the latest date. Along with
this notion goes the belief that the most recent art condemns
earlier modes to obsolescence, as the latest model of a kitchen
appliance renders earlier ones out of date. Seen in these terms
the new is irresistible, since its appearance leaves no ground for
any other art to stand on, except that of nostalgia or stubborn
dislike of change. Moreover, each innovation, regardless of its
character, is valid, since it pushes out the frontiers of art and
enlarges the possibilities of creation. Those who sympathized
with the leafleters at the Museum might have been embarrassed
to recall a picket line of "Realists" at the same institution some
years earlier protesting the kind of art represented by Hofmann.
Was Abstract Expressionism now defending itself against being
superseded by the new Pop Art? In speaking of delectation and
timelessness the Museum catalogue evaded the issue of the new
which is upsetting the art world, but to do so it had to miscon-
strue both the meaning of Hofmann's art and its part in the
development of American painting.

The belief that art is whatever artists say it is and whatever
the public accepts at any given moment has been consistently
defied by Hofmann in his teaching as in his painting. His was
a defiance that demanded moral stamina, also a firm intellectual
standpoint. Hofmann's attitude toward art rests on his estima-
tion of the period in which we live. For him, the twentieth
century has been bringing to maturity an epoch in human his-
tory that has revealed new truths regarding nature, art and the
creative act. Through its superior insight, painting since Cézanne
has replaced the assumptions of Renaissance art, as deeply

artist's work and attitudes involves complex problems of critical analysis, as does investigation of the way in which many of his concepts meant one thing in regard to painting practice up through the thirties and something else after contact with the art that sprang up in the United States during the war. Hofmann's verbal pronouncements can be grasped only in terms of the evolution of his convictions in relation to the art around him, including his own; after all, his was thought always directed at the creation of pictures. In presenting Hofmann's writing without critical analysis, the Museum of Modern Art catalogue dodged its responsibility of elucidating how and to what extent these writings are relevant to the paintings. Compressed under topical headings such as "The Medium" and "The Picture Plane," and in a couple of instances accompanied by diagrams invented for the occasion, this presentation of "the basic premises" of Hofmann's philosophy encourages the false impression that the writings explain the paintings or even constitute formulas out of which the paintings arose.

Even more misleading was the stress on Hofmann's paintings as "a timeless art, transcendental and monumental," inhabiting a kind of Temple of Aesthetics from which the ghosts of history have been banished and which rears up in seclusion from the rushing traffic of contemporary painting and sculpture. As if in ironical refutation of this thesis, half a dozen young men and women distributed leaflets before the doors of the Museum on Hofmann's opening night. Signed rather ominously The Center (symbolized by a circle with a dot in the middle), these communications saluted Hofmann not for providing the delights of eternity but as representing values superior to those of "the present synthetically manufactured art." In short, Hofmann had been chosen as a rallying point in a conflict now dividing the art world, as all through the thirties he and his school had been the stronghold of a modernism different from that of the reigning Social Realism. His role has been, precisely, to function *in* history as a determiner of directions. The Museum's attempt to segregate him from art history was itself an act of art-historical politics; it arose from a desire to slow down the bandwagon of the new in art, which many believe has been carrying values

The switch from art history to esthetics in the organization and presentation of the Hofmann exhibition was emphasized by the catalogue accompanying the show: except through a brief introduction and a chronology, it modestly refused to trace the artist's development or place him in contemporary art. Instead, it devoted its text to summarizing "the basic premises of [his] esthetic philosophy which is a unique combination of mysticism, introversion, faith and intellectual precision." Apparently, the way to compensate for the arbitrary treatment which artists have been suffering at the hands of curator-historians is to put them to pasture in a park of pleasure and self-contemplation. Generous as this program seems, it is hardly likely to do justice to the outlook and thinking of individual artists; esthetic enthusiasm can carry one as far from an accurate apprehension of meanings as can blindly pursuing historical trends. No better illustration is needed than the choice of the word "delectation" to describe Hofmann's "purpose": with the mauve-decade timbre it has acquired in our time, it is about as inept a word to apply to this veteran painter-teacher as can be imagined. Nor are matters improved by characterising his thought as a blend of "mysticism,, introversion, faith and intellectual precision." Hofmann's "philosophy" is the product of more than half a century of striving to formulate verbally the nature of artistic *truth* as the rival of the truths of science. His concepts have far more to do with the Bergsonian intuition and *élan* of the pre-First World War Paris in which he matured than with religion (Zen was also cited in the catalogue) or gazing into oneself. Automatism as an experimental practice is not introversion, nor is spontaneity; as practiced by Hofmann, they are very nearly the opposite of turning inward. On the other hand, to denote Hofmann's vast metaphysical roundups as "intellectually precise" borders on unintended sarcasm. "The superlative in creation," declared Hofmann in his recent Dartmouth College address (the theme of which was once more the difference between scientific truth and "creative" or "intuitive" truth), "is of course not the result of a few isolated relations. It is the synthesis of all inter-relationships—wherein the result of *all* relationships finds expression." What statements like this mean in terms of the

freely as he is at the moment—and the psyche has its ups and downs.

Unique to Hofmann is the insertion of smoothly painted red, yellow or blue rectangles, into a multi-agitated surface as if to demonstrate that action in painting need not be dependent upon violent brushwork but can be attained also through the back and forth movement produced by relations of hue and scale. In "Pre-Dawn," 1960, and "Mecca," 1961, the conflict of means deliberately set up by the artist is resolved in motion poised on stillness (brought about by rectangles similar in color value and size), a state experienced in the situations denoted by the titles, but one which also reflects the dilemma of motion in an immobile medium like painting. In contrast, a canvas such as "Lumen Naturale," 1962, composed entirely of single-colored rectangles, is in the nature of an illustrated discourse on the visual effects of juxtaposing different quantities and values of light.

Among the paintings mixing surface action and geometry, "Memoria in Aeterne," 1962, is like nothing else that Hofmann has done. Dedicated to the memory of five American painters now deceased—Arthur Carles, Arshile Gorky, Jackson Pollock, Bradley Tomlin and Franz Kline—whose work Hofmann has admired, it is both pure mood and as explicit as a picture postcard. An area covering almost the whole of the large canvas is brushed in a cloudy brownish mixture streaked with red, yellow and blue, like waste paint on a palette (the abandoned painting tables of the dead artists?) or like a wall of earth seen up close. Upon this wall two vertical rectangular planes, one a scarred red about twice the size of the other, create a pictorial breathing space by their different suggestions of depth, while as panels they invite memorial inscriptions. The impression of being inside the earth is heightened by an upward movement toward the domelike mass that crowns the composition and which is flanked on each side by blues of flowers and the sky. But the brooding earth wall is changed into a lifting veil by a small edge of brightness that is as if torn out of the lower left-hand corner of the canvas. I cannot think of another painting that intimates immortal hopes by such strictly abstract means.

that was prominent in the Whitney retrospective, "Liebes-baum" (1954), introduced Hofmann's most exuberant mode, his Action Paintings. In this canvas nature turns into action under our eyes, the unmistakable trunk and foliage of the love tree flinging themselves into the dance of forms which in this style of painting has replaced the architectonics of earlier abstract art (see chapter 12). Among the late items in the show Action Paintings were dominant, featuring such model works in this manner as "Moonshine Sonata," 1961, "Summer Night's Bliss," 1961, "In the Wake of the Hurricane," 1960, and "Wild Vine," 1961. Unlike the Action Paintings of artists like Kline or Twor-kov, those of Hofmann are distinguished by the immense vari-ety of the motions that compose them; the traces of his actions range in force and physical density from mere wisps of tint to draggings and pilings of cement-like masses of pigment. Sometimes he is content with a canvas carrying a rapid balanc-ing of light washes, as in "Delirious Pink," 1961, and "Agri-gento," 1961, or he is drawn into a realm, like that of "Lava," 1961, which permits only consistently rugged impastos. Most often, however, he engages the canvas in an amazingly wide range of maneuvers; even in a composition like "The Prey," centered on a spontaneous image, Hofmann recalls his principle of the completely agitated surface by means of the border of white on white. Those who like to repeat that abstract paintings can be taken in at a glance should study the details of a major Hofmann.

The Rembrandtesque gold of "Lava," in which the yellow slabs of "The Garden" have grown more refined and somber, reveals Hofmann in his deepest mood, one that he has recaptured in a few paintings done since the Museum of Modern Art show. In respect to Hofmann it is important to keep in mind that while each canvas that the artist finishes and exhibits contains some-thing achieved, not all his work is on a comparable level of vision and feeling, a fact which Hofmann himself has not hesi-tated to disclose. Hofmann works from direct experience—visual intuitions, sentiments, moods—not, despite his tireless theoriz-ing, by dogma or system. Through his long apprenticeship, ex-periment and analysis he has liberated himself to accept himself

In an apparently dramatic departure from the usual practice of overloading museum exhibitions with art-historical pedagogy, the Museum of Modern Art presented forty paintings by Hans Hofmann chosen "solely for their beauty, profundity and monumentality; for the purpose for which they were painted—delectation." We shall discuss this "purpose" later. The show itself was a magnificent one. It had for some years been common opinion that Hofmann, now in his eighties, has during the past decade been growing steadily in vigor, freshness, spontaneity and depth. Perhaps for this reason, perhaps because the Whitney Museum had staged a Hofmann retrospective in 1957, three-fourths of the paintings in the Modern Art show dated from 1958-1963. Omitted were Hofmann's "learning to see" still lifes and landscapes of the thirties and forties, done in the presence of their subjects, the nature-study phase of Hofmann's work that went over subsequently into his luxuriant vegetable and mineral world made of animated paint.

While the show provided no opportunity to study the change from visual research to created "nature," it did anticipate another line of Hofmann's development, his automatism. In "Ecstasy," 1947, with its powerful linear swirls interlocked with curved and boxed shapes like a section of a machine jutting into the sky, the artist, instead of calculating equivalences between the scene and the picture surface, allowed his brush to be moved after the first stroke by the notations on the canvas as if by guiding signs. The magical element in Hofmann's practice exemplified by "Ecstasy" had already led him to be among the first in American painting to explore the possibilities of accident; he was the pioneer in defining the surface plane by means of dribblings of paint through which forms are visible. "Spring," 1940, and "Fantasia," 1943, were exercises in pictorial effects gained through chance by one who knows what he is looking for; while "The Prey," 1956, composed of blots, runs and splashes, ranks among Hofmann's grandest paintings; in it he touched the mysterious intersection of hazard and inspiration.

Another important early work in the Museum group, one

THE STABILITY
OF THE NEW

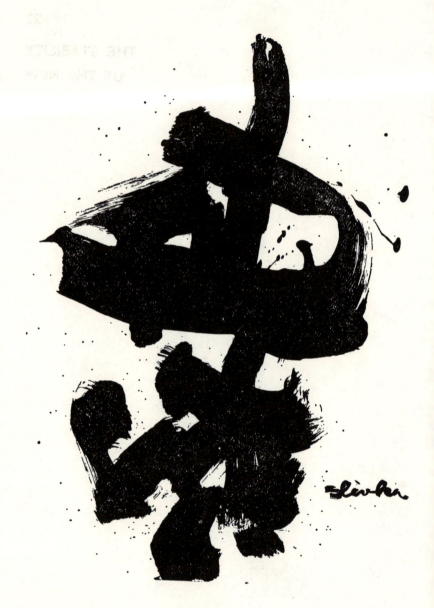

David Slivka

revivalist nature of current art is confessed in names that bear the prefix "new," or "neo" or "abstract" appended to earlier movements, such as Realism, Dada, Expressionism. The new work justifies itself as art by the authority of its ancestor, at the same time that it seeks to differentiate itself and to assert its originality. Original or not, revived art differs from its predecessor through change of historical content; the background of Neo-Dada is the new affluence, not war and revolution. Thus living and dead elements, creation and formula, are commingled in contemporary art, as in the art of the past, and put its novelty into question; the latest revived style is not necessarily newer than that of paintings done fifty years ago.

The dialectic of art movements may have been of little concern to American art in the days when native artists were genuinely isolated from one another and when following some European school or style only isolated them still more. The decisive development in American art since the war, however, is that we now have our own art movements. Not greater individual painters and sculptors—the leaders of Abstract Expressionism are easily matched in talent and intellectual caliber by American artists of the past—but the rays of a pervasive impulse have brought American painting to the forefront of world art. The loneliness once forced upon the American artist still haunts his vocabulary and his attitudes, and the absence of genuine public response lends credence to phrases about work executed on solitary "voyages of discovery." But these phrases no longer adequately describe the reality of artistic creation in the United States. Nostalgia apart, the ideology of individualism in art has only the effect of wiping out the tracks of communication in the creative process. American art today owes its character to that "mortal inter-debtedness" which Melville reluctantly conceded put him "down in the whole world's books."

longer sought for itself, is heightened; one of the mysteries of the movements, as of the great "periods" in the art of earlier times, is the creative assurance which they confer on previously commonplace talents. Far from constricting the artist's imagination, the movement magnetizes under the motions of his hand insights and feelings from outside the self and perhaps beyond the consciousness. The living movement is a common direction of energies rather than a set of concepts, and any definition of it will apply to individual artists in it only to a limited degree— to the best artists least of all. Matisse overlaps Fauvism, Picasso Cubism, de Kooning Action Painting. Yet it is in the formation by their works of the characteristic features of the movement that the works themselves become what they are. And while the individual artist keeps a remainder apart from the movement, the movement is also larger than the individuals in it. Its possibilities exceed its realizations; and it is this excess that allows the movement to be revived in times to come.

When a movement has expired there is no guarantee that a new one will take its place. Much of the best art of our time is the product of individuals left stranded by movements that have come to a halt and who keep looking back to great days of which each retains a different version. In the first decade of the twentieth century movements followed one another like waves on a beach. After the First World War the intervals between them lengthened; twenty years of raking over old art, from the Realism of Courbet to the city scenes of the Impressionists, divide Surrealism and Action Painting. A period without a movement, or invested with a dying one, is fairly certain to be characterized by repetitive work and critical chaos. Artists belatedly converted to the exhausted movement continue to piece it out with logical inferences; if the effects of thrown paint are esthetically valid why not those of paint scattered by bursting balloons?

Art in our day is surrounded by dead movements. Both in its inception and in its later stages of development each new mode in art since the war has derived from an earlier one. The

predictable force among artists. The terminated movement is the sum total of its procedures and the effects obtained through them; it is by these aspects that they are customarily represented in art books and survey exhibitions. In an active movement, however, methods of seeing and of handling materials are bound up with modes of thinking, feeling and human association (e.g., the prominence of certain models and mistresses) that constitute a way of life—on the Paris Left Bank or in loft buildings of downtown New York. Often, through a movement, new classes and social groups come to the fore in art, such as the "exiles" of the Paris schools of the early twentieth century or the immigrants who have played so large a role in American Abstract Expressionism. Studied apart from the life that animated it, the intellectual content of the movement is likely to seem insignificant. Dada, the creation of very young men, often came close to college humor. As a doctrine, Surrealism is less interesting than the canvases of Dali and Ernst, who may therefore be considered as owing little to it. "I don't think artists have particularly bright ideas," declared Willem de Kooning in an interview in the art-literary magazine *Location*. "The Cubists—when you think about it now, it is so silly to look at an object from many angles. Constructivism—open, not closed. It's very silly. It's good that they get those ideas because it was enough to make some of them great artists."

"When you think about it *now*." It is the backward glance that is deceptive. In the moment of its appearance Dada and its "silly" idea exemplified an esthetic probing of the irreparable crack in European civilization produced by the First World War. To restore the creative balance between movement and individual, the idea and the work, it is necessary to conceive both in the rhythm of time, place and situation that made them one. As an *event*, an art movement is a phenomenon of collective psychology comparable to quasi-religious enthusiasms in politics, social life or fashion. Like the cult and the fad, it follows a tempo of growth, decline and disintegration. In its hour of strength it is capable of transforming its adherents; artists abandon objectives pursued for years and allow themselves to be guided into unfamiliar territory. In the shared current, individuality, no

Yet to recognize that a painting is a painting requires no tremendous profundity, and the emphasis on the particular canvas as setting aside any general idea, outlook or mood can easily be overdone. Stripping a painting to what is visible within the frame may prove as destructive to that synthesis which every painting is as clouding it with ideological steam. The retinal particulars of a painting exist for the sake of the whole, which is individual in character precisely to the degree that it responds to the kind of intellectual situation that is called an art movement. The arrangement of colors and forms on the canvas never encompasses completely the experience that moved the artist to execute it, and the painted surface is always in some respects nothing more than a hint. An effect of "particularist" criticism is to divert notice from the stream which, passing from mind to mind, whether through words or through suggestions inherent in the handling of the medium, enters into the motive and meaning of the work.

Today it is fashionable to dispute the presence of the art movements in the creations of X or Y—except, that is, in speaking of paintings that one dislikes. Playing the artist as individual against the movement-as-formula has become a major ruse of art reviewers and promoters. To condemn a one-man show it is only necessary to describe the paintings in it as issuing from the same bin as those of other artists. A critic favoring a "return to subject matter" will painstakingly describe the virtues of a canvas by a mediocre figure painter, but confronted with abstract art will consistently discover that all cats are grey. For the champion of Pop Art, there is no Pop Art, only a concourse of independent creators; it is the others who carry placards. Never before this era of movements that deny themselves have so many utterly self-inspired personalities produced canvases so difficult to tell apart; never have so many valid talents been so frequently menaced with extinction through burial in a category.

An indispensable condition for appreciating the art of our time is to distinguish between a movement which has reached its end (and has thus become the province of researchers into style) and the same movement while it is still alive as an un-

individuality is embodied in it. Thus, having written a history of modern art in terms of its movements, Haftmann interprets these movements not as collective acts of the artists involved in them but as "patterns" which he has recognized "after the fact"—that is to say, the movements played no part in the conscious intentions of painters and sculptors, since "the individual modern artist was driven by a creative need for absolute freedom." For a painting to be seen as emerging from a web of imagination brought into being by many minds, including those of non-painters, as in the influence of Mallarmé on Cézanne or of Eluard on Miró, apparently compromises its status as an evidence of creative uniqueness. The current phrases about inner voices and building in terms of self are intended to shield the work against the taint of influences and collaborators: by means of them each artist segregates himself from his fellows as if under a glass bell. Solitude, the unknown, inwardness are, of course, facts of artistic creation, but they are today cited against the art movements not to epitomize creative experiences but as character references demanded by the reigning personalist credo.

No masterpiece is simply the sum of typical elements in a common method of painting. Creation involves factors that cannot be put into circulation, as well as factors that circulate but cannot be put into words. As against the closing in of art upon itself, the idea of a movement (even of a movement dedicated to wordlessness) presupposes communication and thus leans towards the verbally expressible. In art there is nothing wrong with formulas, providing they call upon profound feelings and are carried out to the bitter end, as by Uccello or Mondrian. It is, however, disagreeable to see works, especially works by non-doctrinaire artists, vanish into slots labelled CUBIST CONSTRUCTION, EXPRESSIONIST BRUSHSTROKES, ASSEMBLAGE. The practice of reducing paintings and sculptures to those traits by which the influence of a school is spotted is today exaggerated by the needs of mass education. To save art from being amalgamated into a series of technological systems it is no doubt necessary to keep recalling continually that the ultimate reality of art is the particular work.

occurred to a British portrait painter of the eighteenth century to deny the affiliation of his work with the national style; but an artist today who composes dream episodes on canvas is more than likely to shrug off forty years of Surrealist doctrine and example, and one who contrives erotic machines will keep mum about Dada and Duchamp. Indeed, the prevailing motive that prompts artists to make public utterances about their work seems to be to disavow any shared concept or manner. Of the catalogue statements by the painters and sculptors of the "Americans 1963" show at the Museum of Modern Art, not one acknowledged a school tie and in the three or four instances in which Constructivism or Expressionism or Pop Art was mentioned, it was in order to repudiate obvious connections with it. If the artists are taken at their word (or at their silence), the work of each is a creation out of the void; one speaks of "listening to the secret of our inner voice," another of "building things in terms of myself," a third declaims that "all theories must fall in the face of the fact of painting." Yet this was an exhibition that was one hundred per cent centered upon esthetic ideologies; every single item in it bore the unmistakable stamp of its origin in some worldwide art movement.

There are, it must be conceded, persuasive reasons for painting the other way when the name of a movement is mentioned. Overt forms of solidarity, in so far as they imply preconceived codes obediently followed, violate the passion for spontaneity and freedom inherent in modern creation; specifically, they recall the artists' associations and "action committees" of the nineteen-thirties which edged American art toward accepting direction from the outside. The reaction against any collective manifestation is stiffened by the individualism which has become the militant creed of the postwar West. That the artist is capable of creating a thing that is entirely his own is, we are often told, the essential meaning of art in an age of mass production and conformism. The ultimate function of painting in modern society, concluded Werner Haftmann in his massive *Painting in the Twentieth Century*, is to "minister to the silent zones of man as an individual"—a function which a work of art is able, in his opinion, to fulfill only to the degree that total

style: they tend to react similarly to the art of yesterday, to venerate the same achievements and the same master, to fumble with the same problems and scorn the same "easy solution," to employ similar technical means and to conceive the same function for art in the existing cultural environment. Thus Abstract Expressionism recognized a limited debt to Surrealist spontaneity, to the improvisations of Kandinsky, to the brushwork of Manet, to the calligraphy of Zen monks and thrown-ink Sumi paintings; in a word, it rediscovered the part of manual gesture in painting, and, assenting with fervor to the conviction of Cézanne and the Symbolists that art is a means of revelation and self-discovery, it enthroned ambiguity and the significance of the sketch, the blank area and the unfinished work.

In our era it is the art movements that make possible continuity of style, that stimulate interchanges of ideas and perceptions among artists, that provide new points of departure for individual invention. Artists like Rivers, Rauschenberg, Johns, seeking, a decade ago, to release their painting from the closing net of Abstract Expressionism unravelled the social, psychological and esthetic premises of this mode while applying its painting techniques to the American scene. In turn, their George Washingtons, their news photos and their flags, bearing the Abstract Expressionist imprint, provided the clue that led to the current exploitation of popular insignia and everyday objects. This development has, by contrast, affected the art of the past by giving new emphasis to the signs and advertisements appearing in Stuart Davis's adaptations of Cubism and in de Kooning's Action Paintings. The crisscross of the art movements through time and place binds modern art into a whole that constitutes the intellectual and imaginative background for individual paintings and permits them to be evaluated as both art and experience.

But though the art movements figure constantly in the discussion and exhibition of modern art, their active role in its creation is insufficiently appreciated. Artists most directly indebted to a movement hasten to dissociate themselves from it, as if from something disreputable; one is reminded of people who having supported a political line would wind up with, "But of course I'm not a Party member." It would scarcely have

Paintings of this century are usually readily identifiable as belonging to some art movement, or "school," such as Fauvism, Cubism, Surrealism, Action Painting. The movement, which comprises attitudes shared by artists in more or less organized contact with one another, as well as technical devices related to those attitudes, blends into or supersedes the stylistic heritage of a city or region; instead of "the Venetians" or "the Flemish School," our era presents practitioners of esthetic "isms." When, in modern art, a place label is still applied, as in "School of Paris" or, latterly, "New York School," it signifies not so much a home-grown way of painting as a cluster of styles either newly initiated in that locality or given a special inflection there—works in the same mode are also being produced elsewhere. Thus "New York School" comprises Abstract Expressionists, Geometrical Abstractionists, Neo-Dadaists, Post-Surrealists, all with collaborators throughout the world. What, if anything, artists possess in common through the bare fact of their residence in New York is a highly problematical question; perhaps it is a certain hardness of light, or a sense of largeness of scale, or a nervousness, forthrightness or crudity of execution. But to differentiate by these traits the art of New York from that produced in other American cities or abroad is a tricky undertaking; New York paintings have not always been glaring, spacious, discordant or casual nor is there anything to prevent a Dutchman or Japanese from mastering the "raw" American look, just as half a century ago Americans like Weber or Walkowitz found paint recipes for producing the flavor of Paris. Searching for continuity in the art of the United States, John W. McCoubrey, in *American Tradition in Painting*, found himself pursuing "those elusive American qualities that lie deeper than style." But while the influences of place have grown so intangible, those of the art movement are material, clean-cut and practicable. Even a movement which has not expounded its approach (postwar American movements such as Abstract Expressionism and Pop Art have avoided the group declarations of earlier twentieth-century schools) inspires in its followers a fairly uniform set of responses to the major determinants of

stated with adequate precision once terms are found that relate them to the *novelty* in the art that preceded them. The problem is whether such judgments will have time to take hold before the next wave of novelty breaks.

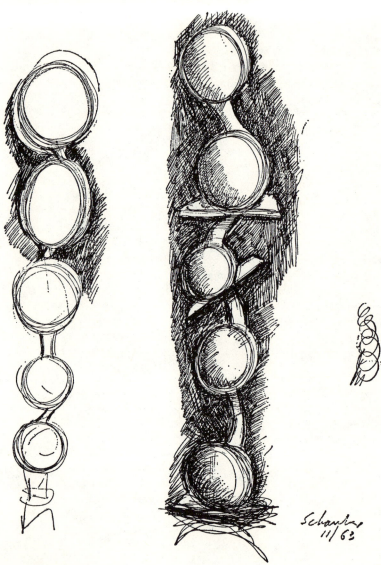

Louis Schanker

ness of the novelty and the possibilities to which it gives rise.

Art in our time, characterized by continuous experiment, belongs to the alarming realm of thought and action which since the Renaissance has elevated novelty as a value inseparable from its deepest aims. Pivotal terms in modern art are "experiment," "pioneer," "transformation," "avant-garde"—terms which formal criticism cannot do without but which originate not in the vocabularies of form but in those of the New World of science and exploration, the New Man of psychic rebirth, the New Order of revolutionary politics (the *Novus Ordo Seclorum* celebrated on the U. S. dollar bill). In all these, values identified with the new are implicit—the value of daring, of separation from the routine and trivial, of purging and purification. In the interchangeable lexicon of novelties, valuing the new in works of art is not at all the same as valuing new works because they are art. When the issue is discovery, the question, Is it art? is decided by the effects produced by the individual work. This supremacy of concrete qualities over the art idea is affirmed in the paradoxical concept of anti-art that keeps recurring as a slogan among twentieth-century artists.

New art can therefore be judged *now*, providing it be judged in relation to the whole complex of the tradition of the new, including its discoveries, revolutions, hopes lost and abandoned, as well as the incessant testing by artists of the expressive potentialities of forms and materials. In his memorable Commencement address at Yale, the late President Kennedy quoted Thomas Jefferson as saying that the "new circumstances" of American life demanded "new words, new phrases and the transfer of old words to new objects." In art criticism there is no substitute for an apprehension of what is psychologically, socially and intellectually modern in modern art. Nor can the appreciator of modern art be far removed from the exploring temperament of those who create it. By the measure of the twentieth-century context, to establish the value of the new art so disturbing to the critics offers no extraordinary difficulties. In fact, judging the new should be easier than it has been if the formalist schema are indeed being abandoned. Which new works are art and which are good, bad or mediocre can be

are prepared to perform for it, as when Lichtenstein paints for the knowing a Mondrian sprinkled with his own dots (see chapter 15).

Gagart included, there are values by which the new can be appreciated, but they are not, in the first instance, esthetic values. Form predominates in a work after it has become familiar to us; when the surprise or shock of novelty has passed we prize it for its beauty. It is, however, in their disquieting phase—when their strangeness causes them to seem outside of art—that innovating paintings work to expand our consciousness and sensibility. Esthetic values are then in a state of being violated or disarranged (not of being furthered, as appears to hindsight). Thus to appreciate the new *as the new* involves considerations beyond the esthetic. The key is the inseparability of form and content, especially in an era when multitudes of art-school graduates and professionals of the mass media have learned to manipulate an immense repertory of art styles for every conceivable end. New art is valuable for the novel state it induces in the spectator and for what it reveals to him about himself, the physical world, or simply his way of reacting to paintings. But to apply the principle of evaluating works by the actual effects induced by beholding the thing that wasn't there before is not intellectually restful, and to reach intelligible conclusions about such a phenomenon is even more difficult. For one thing, newness is a temporary quality and must be seized while it is still present; how long it lasts depends—in part, at least—on the spectator. More important, to value the new is to invite confusion, and what confusion is good for is not yet sufficiently appreciated among mass educators. A full grasp of the new is accompanied by a species of terror, of the sort not unknown to research scientists, explorers, mystics, revolutionists. The new that violates the good on the moral plane becomes itself a good in the neutral atmosphere of scientific and imaginative curiosity. One who values innovations may have to respect even those of a Marquis de Sade as a contribution to man's consciousness of himself. In the traditions devoted to exploring and transforming the human self and the human condition, the value of the new is measured not by pre-established standards but by the genuine-

extra-formal elements were *physically* introduced into paintings and sculptures. Should not the Action Painter's emotional or intellectual struggles *within* the canvas have offered as large a critical stumbling block to formal evaluation as a pair of rubber boots or a stuffed goat stuck to the outside of it? The fact is that formal criticism has consistently buried the emotional, moral, social and metaphysical content of modern art under blueprints of "achievements" in handling line, color and form. Perhaps advancing Gauguin's ideas of color or Cézanne's means of construction was what Picasso was "about" in painting "Les Demoiselles." I doubt, though, that anyone but an art historian would find it "stirring" on that account. "What forces our interest," Picasso has said, "is Cézanne's anxiety—that's Cézanne's lesson; the torments of van Gogh—that is the actual drama of the man. The rest is sham."

For everyone but art historians, form as a key to value has been functioning very poorly for several decades. Derived primarily from the Cubist strain in twentieth-century esthetic *theory* (as opposed to *the poetry of the Cubist moment* in pre-World War I Paris), formal analysis has been responsible for overstressing Cubist objectives in abstract painting and sculpture. When this critical method was confronted with American Abstract Expressionism, in its broad range from Pollock to Newman, it at first rebuffed the new works as disorganized, shapeless or empty, then grudgingly adjusted itself to translating them into constellations of technical minutiae. Splitting form from substance, this approach has prevailed largely through its usefulness in providing a coherent account of the development of modern art out of the art of the past. The effect has been to normalize the new and thus reduce antagonism to it. Formal criticism has been of the first importance in the public relations of vanguard art. Mr. Barr's pamphlet, intellectually typical of this sort of art appreciation and scholarship, educates its readers to be amateur art historians and to admire paintings and sculptures as contributions to the evolution of forms. In its perspective, present-day creation consists, as Saul Steinberg has remarked, of art-historian artists painting art history for art historians. Given this oddly schooled public, artists appear who

"one of the most important pioneering canvases of modern art and one of the most stirring after you understand what Picasso was about." Pioneering has, naturally, to do with new territory, and in being a "first" the "Demoiselles" has, or had, the virtue of being new. But to make it a good painting something more was needed. So Mr. Barr went on to point out that in "Les Demoiselles" Picasso carried forward Gauguin's "ideas of expression through color and form" and Cézanne's "construction by line and plane," while his drawing of the ladies' features was influenced by "certain prehistoric Spanish sculptures" and by African masks. By means of these associations with the history of forms, Mr. Barr demonstrated that "Les Demoiselles" was not only new but that it deserves to survive on its merits as a painting.

According to Messers O'Doherty and Messer, however, it will not do to summon formal tradition as a character witness for the new art of today. Their reason seems to be that paintings of the past few years have increasingly incorporated objects and images as the artist found them on the street or in an empty lot and without having subjected them to formal transformation or function, as in Cubist collages. With "nature" thus mixed into art the critic must choose either to rule out the new art or to discard his own formal values. Who's going to stand against the New? Yet if the formal values go, there are evidently no others to take their place, except the backward-looking ones of subject matter or morality by which advanced art has been condemned at first sight for the past one hundred years. Between the values and the art, O'Doherty and Messer opted for the art. But in doing so they felt obliged to declare that the apparent inapplicability of the formal yardstick to the newest art had suddenly made the question, Is it art? unanswerable. By thus forcing the issue of the formal approach, they have, to my mind, made an important contribution to critical consciousness, especially in view of the continual clacking of "vanguardist" critics about the formal beauties of soup cans and Coca Cola bottles.

It is ironic that the inadequacy of the formalist method for dealing with new art should have become visible only when

did not begin yesterday. We have lived our entire lives in transition; Mr. O'Doherty no doubt recalls the art-literary magazine of the twenties that took its name from that condition. The rising tempo of change during the past forty years gives us no reason to expect that there will ever be a period that is *not* a period of transition. If values are to exist it will not be through their being handed to us by a more stabilized era. They must be formed within the transition itself and partake of its character. Mr. Messer's "could be" and "need not be" demand too much detachment. The future does not come about of itself; it is the result of choices and actions in the present. Criticism, including art criticism, is a form of conflict about what shall be—as Baudelaire thought, criticism is polemical. If history can make into art what is now not art, it can also unmake what now is art. It is not inconceivable that Michelangelo, Vermeer, Goya, Cézanne will some day cease to be art; it is only necessary that, as in the past, an ascetic cult or some extreme ideology shall seize power and cast out existing masterpieces as creatures of darkness. But for history to unmake our art it must unmake us too, since we are also part of history and have some say about which of its possibilities are to be realized. Today's values enter into the art to come, as well as into forming the judgment by which it will be valued. The future may act as the umpire for the contests of the present but it cannot play its game for it. Those who ask for a delayed verdict on the art of today do so not because they are compelled to by destiny but because the values they have accepted until now have ceased to convince them.

Mr. O'Doherty has put the matter most succinctly. Speaking for American art criticism generally, he notes that its "measuring rod" for the past half century has been formal analysis, but that today "the formal approach is no longer the philosopher's stone that it at one time appeared to be." Until recently, new paintings could be "placed" and their value indicated by examining them in terms of line, color, spatial relations. Thus to explain the greatness of Picasso's "Les Demoiselles d'Avignon" Alfred Barr described it in *What Is Modern Painting?* (even to ask the question now seems over-optimistic) as

ably compressed dissertation on possibility and necessity, Mr. Messer advised the visitors to his museum that the new work they saw there might not be art now but that it might turn into art by the time their grandchildren came to see it—that is, if it were still there by grace of the broadening of the art concept. On the other hand, it might not ever be art if, through being by-passed in "the expansion of artistic boundaries," it failed to be brought under the cover of art history.

Specifically, Mr. Messer was referring to a show of Pop Art organized by his Curator. He knew what Pop was and that it was pop or popular, but he wondered, was it art? Mr. Messer might have solved his problem by inventing a new noun for the not-quite-definite product. Since he overlooked this escape route for the historian, I shall attempt to provide it. The art of ice-cream sodas, seven-foot toothpaste tubes, movie marquees, is hereby dubbed Gagart. Pop is art in being gag; art gag, that is —but whether Gagart is art need not concern the historian once he has the bin to put it in.

That art, in Mr. O'Doherty's words, is "currently without standards and criteria" causes one standard to prevail among modern art officials—the practical one of exhibiting whatever is most publicized as the new as promptly and as conspicuously as possible. The vacuum of values is filled by the activity of opening doors into the future. A museum of contemporary painting and sculpture has become, it would seem, a kind of hotel for candidates on their way to permanent quarters in the annals of art. The law under which it operates requires that nominees from any source be provided with accommodations. Mr. Messer, one felt from his statement, was reluctant to extend the Guggenheim hospitality to this particular exhibition, but confronted by its popular credentials was compelled to yield. (Where and how these credentials were obtained is a problem for both sociology and art criticism.)

To leave the question of values for history to decide may appear sensible in a situation where novelty has become the ruling principle. The present seems too slippery to stand on, perhaps the future will provide more solid footing. Unfortunately, however, the "period of transition" in art, as elsewhere,

spectacle of museum personnel, critics and professors of current art history being swept up in a race to identify themselves with half-emerged personalities and trends: curators touring the country as advance agents for exhibitions of neo-this or that; public and private buyers acquiring collections that amount to kits made up of the latest names; university instructors playing the part of sideshow barkers in front of the slides flipped through their projection machines. In the fall critical sights are adjusted to "After Abstract Expressionism;" by winter the theme has shot ahead to "Pop Art and After" (I am quoting titles of actual articles in recent issues of *Art International*, central organ of the Prophets Club).

The speedup in history-making has now reached the point where the interval of critical evaluation seems to have become superfluous. It is increasingly believed that all standards have gone down before the onslaught of the new and that the attempt to establish values in art may as well be abandoned. Brian O'Doherty reported that many people now think that it is more important for art to be avant-garde than for it to be good. Mr. O'Doherty himself went further: it had become, he claimed, more important for art to be advanced than for it to be *art*. "On the evidence of the past season," he wrote, "asking 'Is it art?' is simply out of date." Since we are living "in a period of transition" both values and definitions had better be left to the future. A similar position had been taken earlier by Thomas M. Messer, Director of the Solomon R. Guggenheim Museum. In a foreword to the catalogue of an exhibition presented by his institution he abdicated judgment of current art in favor of the processes of time. "The relationship between the *good* and the *new* in contemporary art," wrote Mr. Messer, "is intriguing and baffling. The realization that art and invention are akin is balanced by the suspicion of eccentricity. Out of this conflict arises the question: *Is it art?* And the answer: Yes and no. *Yes, it could be*, since the expansion of artistic boundaries is inherent in the creative process. *No, it need not be*, for no mode in itself assures us of artistic validity" (his italics). In this remark-

* *The New York Times*, July 7, 1963.

The rise to prominence of a new style or of work by an unknown artist used to be preceded by much critical discussion and evaluation. Today, the process often operates in reverse; first comes the popular attention, then the discussion and assessment. Novelties in painting and sculpture receive notice in the press as new *facts* long before they have qualified as new *art*. The public presence of images that demand elucidation exerts pressure upon art institutions and educators to exhibit and comment upon them. If the work continues to hold the spotlight, this comment takes place within a heavy drift toward approval. Dealers, curators, collectors become committed to the new art; critics eager to keep up with, and even ahead of, the flux of innovation discover features that link it to admired precedents. To deny the significance of the new product begins to seem futile, since whatever is much seen and talked about is already on its way to becoming a *fait accompli* of taste. By the mere quantity of interest aroused by its novelty, the painting is nudged into art history. Once there, its goodness or badness may still be debated, but unless the whole culture is under attack its status as art is secure. Having a place in art history is *the* value; through attaining this place, the work's own qualities become part of the standards by which the work is judged.

Basic critical issues that relate to new art must therefore be decided in the interlude between its first appearance as an innovation and its firm engrafting upon the historical trunk. There exists, one might say, a critical interval. To prolong the period of reflection and judgment-making is nothing less than to keep alive freedom of choice against the inertia of sheer fact. In our society the responsibility for holding open esthetic choice rests primarily on institutions of contemporary art: museums, university art departments, professional publications. It is up to them, in the interest of artistic creation, to dam the flow of journalistic human interest in art. How well they have been fulfilling this responsibility is indicated by the fact that the critical interval has been shrinking at a rapidly increasing rate; reputations are now being made in art as fast as on Broadway and in Hollywood. The past few seasons have provided the

THE NEW AS VALUE

PART FIVE
TIME AND VALUES

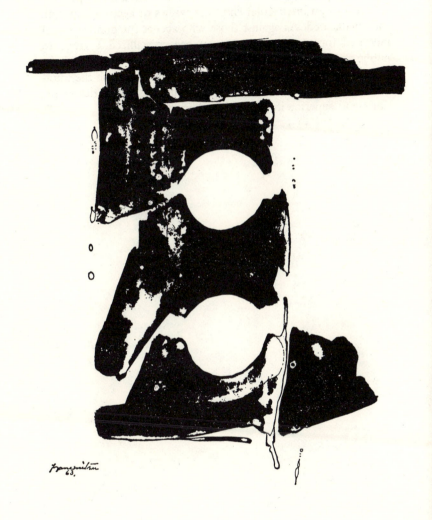

Matsumi Kanemitsu

who neglect the art "beloved by our people . . . as outdated." Innocent of political intentions, experimental art has revealed the dilemma of an intellectual élite that wishes to keep in step with the uneducated. As against those who accept the domination of inherited forms, contemporary art has crystallized a vanguard public in touch with global values. It has thus confronted the Communist Party, as it has politicians elsewhere, with the intolerable presence of a social formation that has closer ties to the times and superior intellectual authority.

On the other hand, some editorial writers wonder why the Russians raise so much fuss about art painted "by the tail of a donkey." What harm can befall the Soviet state if a few childish minds are allowed to exhibit canvases covered with pink and blue squares or splashes or dribbles of paint? Communism can hardly feel so feeble that it finds itself menaced by a brush stroke. A reporter on Russian culture in the United States Information Agency magazine, *Problems of Communism*, after telling of the huge crowds that attended "abstract" art shows in Moscow until the government shut the exhibits down, concluded that the zeal with which the Party represses modernism in the arts is "largely irrational."

The view that the Communists don't know what they are doing assumes the insignificance of experimental art and is another version of the opinion that the main political point of the modern-art controversy is the freedom to be whimsical. This attitude fails to take into account the history of experimental art since the opening of this century in its effect on previously existing art forms and values. What the Communists have called "formalist" art has undermined conventions in painting and sculpture, and with them the social conventions and stereotypes that they support. This is accomplished while still confined to the bohemian compounds and without the comparatively large audiences it attracts today. The Soviet chiefs do not exaggerate the threat of contemporary art to the Party image of life on both sides of the Iron Curtain. At stake is nothing less than the laboriously constructed Bolshevik fiction of the identity of the Party intellectuals, Lenin's "professional revolutionists," with the masses of the working people—the identity exemplified by the figure of the giant beneficent proletarian opening the gates to the little people in the German poster shown at the New School Exhibition. *Upon this identity of the intellectuals and the masses depends the entire position of the Communist Party*. The nature of the modernist threat was made clear by Khrushchev when, in reaffirming the "Leninist policy of irreconcilability with abstractionism, formalism and all other bourgeois distortions," he dwelt at length on his own village origin and his common-man tastes in music and painting, and wound up by attacking those

poster, and especially the torn or violated poster, commodity art can easily pass over into political art if the will and the slogans are present. In fact, without political content Pop Art is like a vessel purposely built to be kept empty.

Whatever the weakness of contemporary painting in furthering political causes, its own politics—that is, the worldwide dissemination of new art forms—has made it a political issue of astonishing magnitude. In the United States, members of Congress and representatives of patriotic organizations, hotly protesting the inclusion of advanced American art in international fairs and cultural exchanges, have compelled Presidents to issue policy statements on art and the State Department to mask its activities through private art institutions. It is in the Soviet world, however, that this "art without meaning" continues to bring forth a genuine crisis, disrupting ties between the U.S.S.R. and its satellites and increasingly demanding decisions by the highest political authority.

Since both leading contestants in the Cold War are opposed to abstract art, it is difficult to accept the usual Western interpretation that the issue is one of freedom vs. totalitarianism. Does Pollock, whose style is not acceptable to the Soviets, stand for freedom more, say, than Eakins or Homer, who *are* acceptable? Castro is widely reported to be friendly to experimental art; does this make him more of a libertarian than Truman and Eisenhower, who are passionately against it? If modern art be freedom, it's a freedom that few free governments are in favor of and that their most prominent organs of opinion condemn.*

* The conflict between the conservative sensibilities and beliefs of free-government representatives, on the one hand, and their conviction that innovations must be supported, on the other, is nowhere more clearly revealed than in their behavior toward contemporary art. Thus an understanding of the attitude of official democracy toward art casts light on its half-hearted position in regard to all phenomena resulting from the "boundless grinding collision of the New with the Old," observed by Carlyle in the whole fabric of society. Progressive politics, whether Liberal Democratic in the U.S., Labor in Great Britain, Socialist on the Continent, is doomed to a kind of chronic hesitation so long as it feels uneasy in the face of radical changes of form in modern life.

even the rhetoric of older vanguard pretensions to "revolution-ary" art has been largely dropped. Marcel Duchamp pointed out recently that in dealing with "the big mass against you," art is a "second-fiddle social expression." The artist goes no farther than selecting the subject and forcing it to be noticed: Rodin's "Burghers" only reminds its audience that in the artist, at least, the sacrifice of those Calais hostages still creates respect. The current interest of American artists in politics takes the form of occasional canvases with social reference. The social motive has always been present in Abstract Expressionism, though nega-tively; in such a painting as Elaine de Kooning's "The Burghers of Amsterdam Avenue," whose subject is a group of slum adolescents, it leaches through into the motif. Beyond this there is the contribution to social causes, e.g., the annual CORE sale, by artists whose work contains not a trace of any social theme (see chapter 2).

Of primary interest in the paintings for which G. Ray Kir-ciu was arrested in Mississippi in 1963 was the artist's use of the New Realist or Pop manner to comment on racial segregation. Pop or commodity art is directly related to the poster, but to the commercial not the political poster, and most of the Pop artists are politically indifferent. In Europe, too, collages of torn *affiches* are popular, also without political or social content; the posters are merely a source of free, ready-made materials bearing associations, colors, and textures of the city and indus-trial environment. Kirciu, however, took the New Realist tech-nique back to the fence and injected political meaning into it by writing and printing on the background of the Confederate flag typical segregationist scrawls found in public places. His attack on the segregationist mentality consisted entirely in repeating its obscenities and implying contamination through the sloppy surface of his canvases. Though suggesting a billboard, Kirciu's paintings were in the tradition of political art that holds the mirror up to the environment without offering directives for changing it. Their sole effect was to sharpen the focus on what the audience already knew and to disturb the precincts of art by bringing into them the noise and odors of the world outside. Kir-ciu demonstrated, nevertheless, that because of its closeness to the

nation and that period are concerned, a show of paintings and sculptures would be hard put to it to communicate as much of their inner as well as their public life.

The artistic propaganda poster is to all appearances a declining medium. With the perfecting of communications techniques, messages are increasingly integrated into the campaign strategy as a whole. Attention-getting by means of the image in line and color becomes less essential as TV, radio, mass-circulation publications deliver, through drama, news, novelties, sedentary audiences in place of the random passerby. The accelerated rate of repetition of messages reduces the role of the lasting emotional impression produced by the visual motif. In the United States, where information drives have reached maximum organizational development, esthetic expressiveness in posters is rare; emotional reaction is obtained through the subject of the illustration—a crying baby in a bombed-out ruin—rather than through style. During the war artists making posters for the government tended to be displaced by advertising-agency designers. Instead of reacting individually to the living issue, the organizational artist conforms his illustration to the particular slant decided upon by campaign coordinators after opinion surveys and motivational analyses. In sum, the social sciences are replacing art as a means for transmitting political ideas and influences, as they are replacing intuition and common sense as a means for reaching decisions. Art as a political weapon is, like other social powers, taken out of the hands of the individual and made part of a collectively controlled apparatus.

The political usefulness of painting and sculpture has been much in doubt since the close of the thirties, when artists swung away from their efforts to "educate the masses" and build "fronts" against Fascism and war. One of the discouraging factors had been the realization that art seriously devoted to obtaining social improvement tends logically toward the action-inspiring poster. Compared with the aggressiveness of the placard, even Delacroix' "Liberty" is essentially contemplative. One is aroused from within rather than propelled into motion. Today,

combined the most complex emotional appeals through visual means was the poster declaring, "AGAINST HUNGER AND DESPAIR! VOTE FOR HITLER!" The illustration consisted of a figure group of a father trudging with a child on one arm and his wife holding on to the other a step behind him, as if faltering from exhaustion. The figures were modeled in slashing white strokes upon a flat black background, and the eyes in the dulled, drawn faces were blind black masses, except for those of the father who with an upward stare accused the world, and whose vague resemblance to Hitler invited identification between the Little Man and his Führer. Another Nazi placard, "THE IRON GUARD OF THE GERMAN REVOLUTION," was a first-rate rhythmical abstraction of figures and banners; though purest Expressionism, this piece was so great a party favorite that it was reissued after 1933. Nazi posters continued to favor Expressionist techniques up through those which, anticipating defeat and the collapse of the Third Reich, accused the Jews and the democratic mobs of the Allied armies of responsibility for the war and the ruin of Europe. Apparently, in outlawing Expressionist painting the Nazis intended to gain for themselves a monopoly on images of strife, anxiety and disorder. Academic inspirational painting, the official Nazi style in art, appeared only in the few posters which promised unity and order, as when a modest, idealistic Hitler clasps hands with Von Hindenberg upon receiving the chancellorship.

The postwar West German posters were a return to the arty abstraction and symbolism of the middle-road Weimar parties; a shadow silhouette facing decorative strands of barbed wire brought from Adenauer's party the reliable old thought that "GERMANY NEEDS A STRONG GOVERNMENT!" The assaults upon the sensibility delivered by the walls of Munich and Berlin from 1919 to 1945 had lessened in fury. One no longer heard behind the posters the tread of the squads with armbands who battled through the nights to put up their *affiches* and desecrate those of rival parties. The postwar items did not, however, alter the total effect of the exhibition, which was that of a jungle of violent feelings and ideas, colliding rhythms, screaming colors, and edgy, aggressive shapes. As far as that

ganda against strikes and for enlisting recruits to fight the Poles in Upper Silesia. In contrast, an election poster issued not long afterward by the conservative Bavarian Peoples Party called for calm and a united Germany by means of an august monochrome in which an emblematic Frau Bavaria is surrounded by such symbols of stability as the cross, the owl of wisdom, the wheel of industry; here traditionalist design was in harmony with traditionalist politics. In the middle twenties, a period of temporary consolidation, the German Democratic Party, neither militantly nationalistic nor aristocratically folkish, represented in post-Cubist, International-style poster design a muscular Olympic runner with the rather comical determination that "NOTHING WILL SWAY US FROM THE MIDDLE ROAD," a program that described equally the party's politics and its art. By 1928, however, with the crisis gathering force, even the middle-of-the-road idea was expressed Expressionistically (and in a far superior picture) as a torrent of force striking a revolving target. When continued agitation, depression and unemployment whirled the Germans into the explosive election campaign of 1932, all the posters were infected with the prevailing wildness, and even the Bavarian People's Party presented itself as a bridge over a sea of blood. A Social Democratic poster pictured a worker impaled on a crown of spikes worn by a monocled Nazi Mephistopheles under the slogan "THIS IS THE SYSTEM FROM WHICH THE NATION IS DYING," but the temper of the Party was betrayed in the fashionably abstract handling of the motif and the absence of emotional charge. The Communist posters reflected a similar insensitivity. Typical was the gigantic, academically drawn proletarian, who represented the Party as "the vanguard of the working class" opening the gates of industry to masses of tiny workingmen marching under the banner of the hammer and sickle. The image, familiar to New Yorkers in the thirties, belongs to the code of party symbols that has varied with neither time nor place, and it was with this cliché that the Communists met the final test of 1932.

Of all the items in the New School exhibition the one that

discriminately; the choice among esthetic modes by a political
party is circumscribed by its philosophy, its methods and the
elements of the population which it aims to attract. It is hard
to imagine a Johnson campaign billboard in the manner of the
late Franz Kline, though in 1952 the Action Painters of the
Artists Club in Greenwich Village turned out placards for
Stevenson (how much these contributed to his defeat is not
known). Negotiations in the late twenties aimed at forming an
alliance between the Surrealists and Moscow came to naught.
In that instance, collaboration failed because the artists de-
manded an independent ideological status. Art, however, retains
a degree of autonomy even when artists have surrendered
theirs. Propaganda can be fully fused into art only when a
style has been brought into being by the same cultural factors
that produced the program it serves, as in medieval art.

In Thomas Mann's opinion German Expressionism and
Nazism sprang from the same root of emotional self-abandon-
ment. This gave Hitler's party an esthetic tool of maximum
efficiency. How Expressionism, banned as "degenerate" by the
Nazis in painting and sculpture, permeated their propaganda
art was made dramatically evident in the exhibition put to-
gether at The New School of Social Research by Paul Moc-
sanyi of eighty political posters of the period between 1919
and 1961. Expressionism, however, did dominate not only the
entries of the Nazis produced both before and after their con-
quest of power; its spirit hovered over the entire show. Politi-
cal ideologies have, as noted, esthetic affinities and prefer-
ences; on the other hand, being by nature opportunistic, politics
will attempt to convert to its own purposes whatever style
accords with the prevailing mood. In the poster display, Ex-
pressionism appear as the mood of German crisis and of crisis
political parties, but the Nazis' use of it was the most unin-
hibited. Two pre-Nazi posters, of the period immediately fol-
lowing World War I, employing the motif of death by starva-
tion, exploited the potentialities for hysteria of Expressionist
drawing and compositional dynamics—not, as one might ex-
pect, to obtain relief for war victims but for nationalist propa-

Direct appeals for action are rare in the painting and sculpture of our time. Most so-called political art, like Delacroix's "Liberty Leading the People," Rodin's "The Burghers of Calais" or Picasso's "Guernica," calls attention to events and situations about which something should be, or should have been, done. But what to do, the essentially *political* decision, is not indicated. The effect is to leave a residue of partisanship and indignation in the spectator which may or may not eventuate in appropriate political behavior. Political art of this type shades off into art satirizing current social attitudes, as in Daumier or in such a painting as Ben Shahn's "Save the Wrapper," which, showing a GI distributing candy to kids in a wartorn landscape, raises sarcastic but undefined inferences about our advertising and public-relations society. Since its application is so vague, the concept of political art ought perhaps to be widened to include another category of paintings and sculptures—experimental or vanguard work which is not political at all, and which is even devoid of any identifiable subject matter, but which becomes political through the upsetting effect on politicians of its unfamiliar forms, as in the case of abstract art in Russia.

The most indisputably political but least artistically motivated political art is, of course, the propaganda cartoon or the poster which urges the spectator to join or vote for the party. In poster art esthetic qualities are subordinated to the action message, which is usually made explicit through a caption or slogan. The expressive powers of painting—line, color, form, movement—are exploited to add an emotional dimension to a message unrelated to art and which makes use also of other arts—oratory, pageant, songs—as well as of activity outside the arts, such as mass meetings, fund-raising, deals with individuals and groups. In the political poster art openly appears as the kitchen help of politics: for this reason it is usually omitted from discussions of painting. Yet even when it is used as a tool or "weapon," art retains enough of its own character to convey independent meanings. Styles carry emotions of their own, apart from what is said through them. Art cannot be used in-

THE POLITICS OF ART

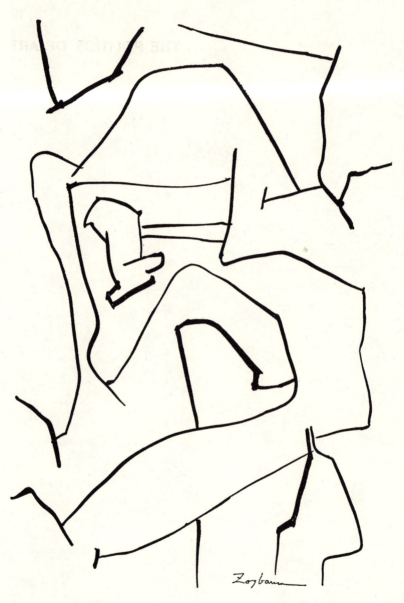

Wilfred Zogbaum

to other works of art fail to engage themselves with the actual historical moment in which the artist lives. Whatever meaning a "junk" sculpture may possess in London or Detroit, with their surpluses of manufactured products, a Mexican artist who exhibits a composition contrived of auto radiators and beer cans communicates chiefly that he is possessed by the tyrannical pace of world art and the fear of falling behind. One of the perils of globalism is a depersonalizing futurism.

The prewar Paris international was a token world capital conferring upon its artist-inhabitants a dream-like world citizenship. Present-day globalism also falls short of constituting an actual One World. The virtues of the current global art lie mainly in its development of a universal esthetic vocabulary and in its promise of a united human culture at some time to come. It is self-evident that painting and sculpture cannot return to earlier forms of academicism or to national or regional styles—even the all-powerful Communist Party is having difficulty driving Russian artists back from "cosmopolitanism." If the prevailing lack of content in art is to be surmounted it will have to be through the concrete consciousness of individuals which is inseparable from experiences of time and place, even though these may not be recognizable in the work. The distinction of American painting and sculpture since the war has been the comparatively large number of artists who have refused to satisfy themselves with mere variations on a theme.

vanced art enjoys the sponsorship of the social layer dedicated to intellectual, technological and social experiment. Even in the Soviet Union, an American reporter was told recently that the audience of the new "formalist" art, which is still subdued by periodic outbursts of government denunciation, is mainly composed of members of the "technological intelligentsia." The "accursed" bohemian and the exile clinging to his handful of compatriots in a foreign city have become equally figures of the past, as the artist and his art are integrated into the global drive for modernization. A modernist painter or sculptor in the most backward country of Africa or Latin America (and in the large international exhibitions such countries are now almost invariably represented) is synchronized with a world system to the same extent as the local oil refinery or airport.

"Art has become international," said Hans Hofmann recently, "almost too much so." It is logical that Hofmann, a Paris-Munich-New York modernist of the pre-World War I generation, should distrust the new globalism of which his work of the forties and thereafter has made him so important a part. The notion of an excessive internationalism has to do with the problem of content in art once localism has been left behind. For Hofmann, as for most of his contemporaries, art has been a means of investigating reality—"we must learn to see," he reiterated to his students for forty years. Works of art moving in orbit in the communications system and tending to merge into it—artists, for example, have taken to exhibiting paintings copied from reproductions in art books—hardly contribute much to seeing, except, at most, to seeing pictures. Global distribution makes art images available everywhere, but shorn of the experiential synthesis represented by the originals. Pictures relate to one another rather than to any visual or intellectual perception. The term for this is academicism.

Global academicism is furthered both by the elimination of the estrangement of the artist as bohemian (the immigrant artist has by this time been thoroughly integrated) and by the dependence of the artist and his public upon the news mechanisms to keep in touch with art. Works of art exclusively related

as a totality that echoes across the continents in the clue provided by a magazine photo. The individual note that succeeds in making itself heard is all the more dominant.

Released from place, and the traditional, sensual and political ties imposed by place, art tends to derive increasingly from experiences of art. Reproductions, slides, art publications and, to a lesser degree, the worldwide circulation of actual works, draw the artist situated anywhere into an immediacy of response to the global gallery. The tempo of art becomes a world tempo. The rule of simultaneity replaces that of the gradual exchange of styles characteristic of the old internationalism. Today the advantage of one capital over another, and of the capital over the province, is largely quantitative and practical: more works to see, more conversation, more interested spectators, more dealers and collectors. These may be decisive for the individual artist but in themselves they are insufficient to preserve particular qualities or to generate new ones.

Modernism in art is no longer the adventurous or defiant probe of a vanguard of artists and intellectuals occupying an enclave in a city busy with its own affairs. The isolation of advanced art from society has been overcome, largely, it would seem, through the increased instability of society itself. Today, extremist forms in art are everywhere accepted as a reflex to incomprehensibles in science and technology and to the bafflement of philosophy. Alexander Liberman, exhibiting his intensely calculated metal flexures and rinds of color, quoted in his catalogue the saying of T. S. Eliot that "what you do not know is the only thing you know," which had been echoed in Wernher von Braun's pronouncement that "basic research is when I am doing what I don't know what I am doing." One explanation of the acceptability of modernist art is that respectable professions have lately trapped themselves in the mysteries and confusions of bohemia. A somewhat more flattering one is that the prophetic vision of modern art has at last been acknowledged by the sciences. At any rate, in all countries ad-

visual qualities of *both* Paris and New York, while in that of the second the note of place had been entirely banished. With painters like Walkowitz (an artist still insufficiently appreciated) or the Soyers, Americanization had produced a kind of double nationality in addition to their original one. Throughout the twenties, an American artist was an American in Paris, if not physically at least in terms of sensibility. For the immigrant to become an American painter it was necessary for him to learn to paint like a Frenchman. The Alliance itself recognized this by setting up Travelling Art Scholarships supported by New York trade unions; to keep its immigrants from turning into second-class citizens in American art it sent them to Paris as émigrés. Walkowitz and Max Weber naturalized themselves as Americans by becoming Parisians who spoke *English* with an accent. That something of the Parisian physiognomy carried over even into the work of Americans who had never been there did not, however, prevent Alliance painters from arriving at a deeper apprehension of the New York scene than their predecessors of the Ash Can School who were less physically and psychologically part of the metropolis. In the hands of Moses Soyer or Saul Berman, New York romantic realism acquired a new intimacy and warmth of feeling. An unprecedented localizing of imported styles took place, which evinced itself primarily in the choice of and response to subject matter: fewer clowns, guitars, ladies of the avenues, landscaped terraces, more family life, storefronts, street life—bearded Jews, Italian peddlers, children—the Williamsburg and the Brooklyn Bridge.

With Gottlieb, Rothko, Newman, Nevelson, as with postwar French contemporaries like Soulages, Matthieu or Dubuffet, the sense of locality was entirely replaced by mythology, manner, metaphysics or formal concepts. For their art, the earlier requirements of actual or imaginative presence in a given environment had become meaningless. Their declaration of independence from Paris resulted not in the establishment of an American or New York "school" but in the end of any need for one. Their works fulfilled themselves in becoming universal. In the epoch to which they belong, art exists

de Kooning, Hofmann, Rothko, Albers, Lassaw, Steinberg, Vicente, Tworkov, Lindner, Hedda Sterne, Liberman, Lewitin, scores of others. Like the émigré, the immigrant feels himself to belong to more than one place. But the internationalism, or double nationality, of the immigrant is experienced more seriously. He did not come to New York to become an artist. He came, or was brought, to become an American—he came, one might say, for life. The differences which he must reconcile in his feelings of place are real differences, not merely differences in esthetic apperception. For the immigrant his new home keeps constantly prevailing against the old and diminishing it. He is in a process of transformation and his situation is necessarily a temporary one. Chagall in Paris could combine Russian-Jewish folklore with advanced Left Bank ideas in painting and retain both elements in his work. In regard to his background, the immigrant as New York artist has been strictly of New York in its changing relations to world art.

The distinction between the old internationalism and the current globalism was evident in another nostalgic exhibition, the Retrospective Art Show of the Educational Alliance, a settlement house on the Lower East Side. Founded at the height of the mass-immigration of the late nineteenth century, the Alliance very soon set up an art school of high quality which numbered among its students Jo Davidson and the later Sir Jacob Epstein. The School was reorganized a year or two after the Armory Show had brought international modern art to the United States, and it reached its peak in the late twenties and early thirties. The aim of the Alliance was Americanization—one of its tools was art. The immigrant as American artist was a byproduct. The retrospective presented New York artists of the Paris School phase of American modernism in art: Walkowitz, Baizerman, Evergood, Chaim Gross, Peter Blume, Isaac and Moses Soyer, Ben Shahn, plus New York School abstractionists of the global phase: Gottlieb, Newman, Nevelson, Schanker (Rothko and Lewitin also studied at the Alliance but failed to supply paintings for the retrospective).

The essential difference between the two groups related to the role of place in their work. The first group displayed

da Silva (Portugal), Hayter (England), Sam Francis (USA), Alechinsky (Belgium). Unfortunately, some painters in the show—Kandinsky, Wols, de Stael—were no longer alive, but the group could easily have been doubled without sacrifice of quality (among the Americans one missed Man Ray, Joan Mitchell, Paul Jenkins). In terms of numbers, Lefebre made, or could have made, his point. Paris is still on the map as a place attractive to artists who are not Frenchmen. Giacometti still holds to his evening round among the cafés of Montparnasse. Yet the exhibition spoke in the voice of the twenties and was primarily an expression of nostalgia. None of the artists included works in a manner to which postwar developments in Paris are vital, as, for example, Picasso and Giacometti were once influenced by Surrealism. Among the younger artists, most maintain intellectual and esthetic connections with other places and times, Alechinsky with a group in the Low Countries, Sam Francis and Riopelle with American Action Painting, Matta with his early intuition of Duchamp, Da Silva with hers of Cubism. Living in Paris, they tend, like artists in other capitals, to be jet commuters among the art bazaars of the world, and wherever they fail to go their paintings go for them. The work of an artist like Riopelle is equally at home in Amsterdam, Paris, New York or Los Angeles; and on a visit to the United States the artist may avoid wasting time by working in a friend's studio in Manhattan or the Hamptons. Today, the latest art appears everywhere simultaneously—it even rains its influences on the other side of the Iron Curtain. Local color, visual, emotional, cultural, has largely departed from painting and sculpture, nor does there exist any longer such a thing as "foreign" art. Today's canvases appear as if out of the same workshop and bear few, if any, marks of place origin. Being a "Parisian with an accent" has become a purely linguistic condition without relevance to the artist's work.

Probably New York cannot equal the Paris guest book of artists. It has, however, an international of its own—instead of émigrés, immigrants. As against Parisians with an accent, New York offers its roster of naturalized Americans: Gorky,

day and that of Paris yesterday continue to be drawn almost as a matter of course. The term "New York School" raised the implication that a successor to the School of Paris, or an equivalent to it, had been formed on this side of the Atlantic. In an article on the "The State of the Arts," Mr. August Heckscher, then Special Consultant in the Arts to the White House, wrote that "men and women in other countries seeking the most novel and significant developments in these fields look to the United States. An exhibition by Calder or Tobey (to name only two of those whose work has won plaudits abroad) creates news and excitement, the way the latest developments in the Paris art field would do for so long."

I don't know who is "excited" by Calder after all these years, but to present America today as the heir of Paris is seriously misleading. Internationalism in art of the early twentieth-century type has been dead for thirty years, since the decline of Surrealism as the last of the Paris art movements and the fading of Parisian light-heartedness under the glare of the Depression, the ·War and the Occupation. The earlier internationalism has been superseded by a global art whose essence is precisely the absence of qualities attached to any geographical center. In the present globalism, there is no opening for a "new Paris." Mr. Heckscher should have known that "creating news and excitement" is not at all the same thing as providing the all-but-indispensable world experimental laboratory of its time, which was the unique function of Paris in the first decades of the 1900's.

Paris itself can no longer fill the place of Paris. To reaffirm the importance of that city for "men and women in other countries seeking the most novel and significant developments" in art was the motive of an exhibition at the Lefebre Gallery "dedicated to Paris and to the painters and sculptors from all over the world who work there." Lefebre gathered some two dozen "Parisians with an accent" from more than half as many nations of Europe, the Americas, and the Far East, who are part of the French scene in postwar painting and sculpture. The list included Picasso (Spain), Giacometti (Switzerland), Matta (Chile), Hartung (Germany), Riopelle (Canada), Vieira

As noted in Chapter 1, a fairly uniform modern-art "package" today constitutes the production of all countries in painting and sculpture, except those in which governments interfere. The package contains X percentages of the following: modified Cubist canvases and sculptures (in stone, wood, metal); Action Paintings in varying thicknesses of pigment; canvases bearing expanses of one or two colors terminating in hard or soft edges; free-standing constructions and reliefs incorporating found objects or having the character of fragments of rock or ore; compositions of planes in wire, cord, plexiglass; commodity ("Pop") art, relating to mass consumption, marketing and entertainment; motorized and other gadget art. To check on world production of items in these and related categories, art lovers may consult issues of such multinational periodicals as *Art Internationale* or *Cimaise*. One suspects that there are artists who through these publications are able to estimate the level of supply of their own countries in each stylistic category and who govern their output accordingly.

All standard contemporary modes can be traced historically to the art movements of prewar pre-Depression Paris—Cubism, Fauvism, Primitivism, Orphism, Dadaism, Surrealism—plus such developments of them in other European capitals as Futurism, Expressionism, neo-Plasticism. In fact, Mr. Roger Shattuck maintains in *The Banquet Years* that *modern* art was born in Paris on the night of May 31, 1885, during an orgy stimulated by the funeral of Victor Hugo (considering the current fondness of the New York art world for anniversary celebrations, why not a revival of this event on Fifth Avenue?), and that it was nourished to maturity on jubilant bistro dinners. It is undeniable that for about half a century a special relation existed between "modern" and "French" regardless of where the works were actually created.

Many people are convinced that international art is still centered on Paris. Others are equally convinced that the axis of international creation and exchange has shifted to New York. Comparisons between the influence of American art to-

INTERNATIONAL ART
AND THE NEW GLOBALISM

Perle Fine

democratic society. In the United States, for example, despite impressive institutional advances since the 'thirties, there are still cities, including university centers, where not a single representative painting of this century is on permanent public display—overflowing art classes are compelled to rely entirely on the library and files of slides. In short, the majority is condemned to mere learning.

In part, the shortage of art works is owing to poor distribution—good paintings have no market until they are singled out by the masterpiece cult of the popular media and the museums. But if all the paintings moldering in cellars and studios, or being destroyed through re-use of their canvas, were put where people could see them, there would still not be enough to go around.

In any case, to restore the balance between the work of art and the creations of the printing presses, immeasurably more paintings and sculptures are needed—and this means more artists. Perhaps they are on their way through do-it-yourself, though this also results in more art books.

It is easy to condemn the predominance of art books over art works as typical of the breakdown of "organic" experience in our mass civilization and its replacement by knowledge or by an illusion of knowledge. It is equally easy to acclaim the spread of art publications as a sign of mounting public understanding and the means of a general elevation of taste.

Both these interpretations seem to me somewhat beside the point. The fact is that art's relation with society has been changed and thereby the character of art itself, past and present.

Given the new reality of art as a document, it is futile to apply the standard of an aristocratic contemplation untroubled by the questioning mind. On the other hand, wider knowledge of art is no evidence that art is taking on a larger part in contemporary life, since experience of art can only come from looking at works, and this, since it leads to engrossment in the particular, has, as indicated above, more to do with ignorance than with knowledge.

For a sound art education we need to augment our knowledge through art books and develop our ignorance through works of art.*

Such an education can, however, hardly become universal, given the present extreme shortage of paintings and sculptures in relation to the tremendously enlarged requirements of

* When Frank Lloyd Wright's Guggenheim Museum building opened, it was criticized on the grounds that its inclined ramp was not conducive to contemplation. The question of contemplation was also involved in the Museum of Modern Art's drive for twenty-five million dollars to allow, among other things, paintings and sculptures to be presented in separate rooms, what one might call contemplation cubicles. The odd thing is that this notion of contemplation should be trotted out by experts and officials intent on mass education—apparently, they are aware of no contradiction between contemplation and art history. Thus Mr. John Canaday of *The New York Times* attacked Wright for expecting people to contemplate pictures while standing tipped at an angle, yet a few weeks later this same critic expressed a preference for an historical arrangement at the Museum of Modern Art over its projected isolation of works in meditation chambers. The matter ought to be faced once for all: do we go to a museum to contemplate paintings or to learn about them? Frank Lloyd Wright, in putting the public into his *machine for having seen paintings*, had no doubts on this score: give the contemporary museum-goer the whole story in a single descending movement and out before he knows it. To Mr. Canaday's sentimental complaint, he might have retorted: Yeah, but who contemplates?

alescence of art and comment is exemplified by the art book, in which the artist and the historian-critic compete for the last word.

As the painting is swallowed up in interpretations of it, the disparity between its physical reality and its published image vanishes or, as we have indicated, the advantage comes to lie with the latter. The actual work becomes at length simply the mold from which handier copies have been made: its fate is either to serve the various uses of the museum or to be collected as a relic of the artist's person, like fingernail parings or a hand-written manuscript.

By extending its influences beyond the material environment of the work, that is, by setting itself afloat as "culture," art has succeeded in achieving value with a public unable to prize it as a possession.

In America the interest in painting, especially since the War, enormously exceeds the buying of it. The market is for Art, not for works of art—there are collectors for whom any work by So-and-So will do. Everyone has heard of sales of unseen paintings consummated over the telephone.

This generalized interest feeds on anything—as the Directors of the Museum of Modern Art have demonstrated with the successful marketing of their membership "package," which for a single fee supplies admission to exhibition openings (the second opening; the first is for especially invited guests), tickets to film showings, service in the terrace cafeteria, discounts on art books.

In addition to being a thing to learn, art has become something to do; and the art book is one means by which the individual painting is rescued from its corner and brought into the *program*.

The art book, then, is a phenomenon of the modern conversion of art into an aspect of intellectual culture open to all, rather than, as formerly, a source of delight and of taste-cultivation for an elite or an implement of ritual.

in our epoch has brought forth a succession of enigmas—and this, too, has served to enlarge the role of the art book. One could appreciate, or believe he could, a nude of Couture or a scene of Veronese without the aid of commentary. In a modern painting, one hears inside the frame echoes of the demand made upon painting that it expose its essence. Confronted by the canvas, one awaits the deciphering of the text.

Thus no exhibition is complete without its catalogue in which "statements by the artist" or summaries of interviews with him are increasingly featured. Important shows more and more take on the character of art books, presenting wall-scale duplicates of the publications that will result from them.

Doubling as museum director and author, the historian has turned the *actual* museum into an imaginary museum where the paintings themselves function as illustrations to bring out the critical or cultural concept: the "periods" of Cézanne or Brancusi, The Nude Through The Ages, Abstraction And Nature, Eurasians Under Thirty. In the retrospective show or the show built around a theme, the painting appears as an enlargement of its own reproduction, like the blow-up of a fingerprint. When the exhibition-as-art-book has been dispersed, the pictures in the catalogue remain as the permanent representations of the works shown.

The liberation from "literary subject matter" boasted of by modern painting and sculpture has been accomplished by their transformation into literature. With images of genre and fable eliminated, the painting as a whole has become a *word*: one wants to know what the work "says."

For clues the public turns to the "personality" of the artist and devours biographies and novels and film romances of artists' lives as seasoning for its monographs and "studies." Insecure in the face of art's mysteries the audience appeals to their human source—and is told by the artist to go back and stand in front of the canvas.

But while the painting is supposed to speak, it has become nothing else than what is said about it. In a painting of Pollock or Still, "criticism" is ground in with the pigments. This co-

involved in tracking down individual creations, art-book art has one overwhelming advantage over the raw product of the studio: *it appears in a context of knowledge.*

A book on Piranesi or Matisse, on Zen washes or Szechwan reliefs, "covers" its subject or a defined portion of it. Through it you have not only "seen" Piranesi, you have "placed" him, once for all. Aided by text, chronology, bibliography, lists of major works, you know more; perhaps most important, you know that you know.

Looking at paintings will not guarantee an equivalent mental gain. On the contrary, suggesting an infinity of creations, with endless possibilities of discovery in each, the direct experience of art contributes a lively sensation of ignorance.

It seems to me that the current vogue of art books arises from an appetite for knowledge which the book is better suited to satisfy than are art works themselves. It coincides with the emergence of art as a branch of learning and as a source of data for other branches of learning. Images in paint, metal, stone, have been made objects of investigation by historians, anthropologists, psychiatrists. He who has learned how to *read* a work of art will find in it valuable matter about individuals and societies. On the other hand, he who depends, as his grandfather might have done, on the normal processes of his social environment to introduce him to the paintings and sculptures that form part of his culture will end with neither art nor knowledge.

This is another way of saying that art has become part of "language"; it is a writing of sorts; and there is a growing difficulty in detaching the work from meanings of a literary and theoretical order. A painting now seems *to belong* in a book, instead of in its hiding place on a ceiling or in the gloom of a cathedral.

Pressed for disclosures by the social and historical sciences, art has also become a question to itself. The interrogation of painting by painters which has been the major force of creation

Among the many new series of low-priced art books that have appeared in recent years, one published in Paris bore the significant title of *Cahiers du Musée de Poche*. It was perhaps inevitable that Malraux' museum of the imagination should be supplemented by one of the pocket. Neither contains real works of art but only images of them—that is to say, images of images. In this form art becomes portable enough to be packed into the head or stuffed into clothing.

How else could one keep pace with its frantic expansion? Each year more art is dug out of different times and places, to say nothing of the increasing production of new works on all continents. The total "museum" grows ever larger; no one is equal to tracking its contents across its global dimensions. The only solution is to render them into a material that permits their simultaneous delivery everywhere. Without the transmutation of substances, even the professionals would soon be hopelessly out of touch.

Moreover, as the world of art keeps swelling, so, too, does the art world. Through cultural programs in all nations, additional segments of society discover in art pleasures not unrelated to the picture stories and treasures of childhood. While the actual audience of paintings and sculptures is still pitifully small, the potential audience of art, or at least of the art idea, includes nothing less than the whole of humanity, from bishops to inmates of prison therapy wards.

The art in an art book is a collection of substitute images. As "objects" these are, of course, less than satisfactory: the plates lack the scale, materiality, surface, aging, environment, etc., of their originals—their color, even at the very best, is, inevitably, off.

But is it as a poor substitute that the public of the art book accepts the work in it? Or is the imaginary museum of reproductions more suited to its tastes and its needs than the original paintings and sculptures?

In addition to dispensing with the time, cost and fatigue

17
ART BOOKS,
BOOK ART,
ART

decades has produced no art. Armory '13 has been appropriated for ritual use in the campaign of taste improvement and cultural recruiting. Mr. Dwight makes this clear when, after announcing victory, he warns, like all cheerleaders, that "the battle goes on as before." No doubt—it must continue until the Vanguard Audience includes everybody.

The struggle of the modern artist is different from the campaign to make modern art prevail. In his effort there can be no steady advance; the rising prestige of the tradition of the new merely confronts him with new problems, new obstacles. While an institutional buffer and a devoted audience now intervene between original works and the grosser forms of public contempt, ridicule, ignorance and libel, the intellectual and psychological estrangement of the artist has not been materially reduced—it may even have grown deeper. What was lacking in the Armory '63 Show was precisely this pathos of the artist visible in "the rowdy occasion" of fifty years ago.

Also absent were the troubled thoughts of the original exhibitors concerning art in our time, the doubts which have continued to oppress artists of this century and which have been responsible for many of their innovations. The Vanguard Audience that sprang from the show and was empowered by it is impeccably radical: it is prepared for change in any tempo, it is infinitely impatient, its appetite for novelty outstrips the capacity of art to satisfy it. The problem of the Armory Show organizers—that of bringing the new out of the shadows—is not the problem of art in the nineteen-sixties. It is no longer necessary to uphold the new as a banner but rather to study it for its content. Today, the Vanguard Audience itself is a major problem of art.